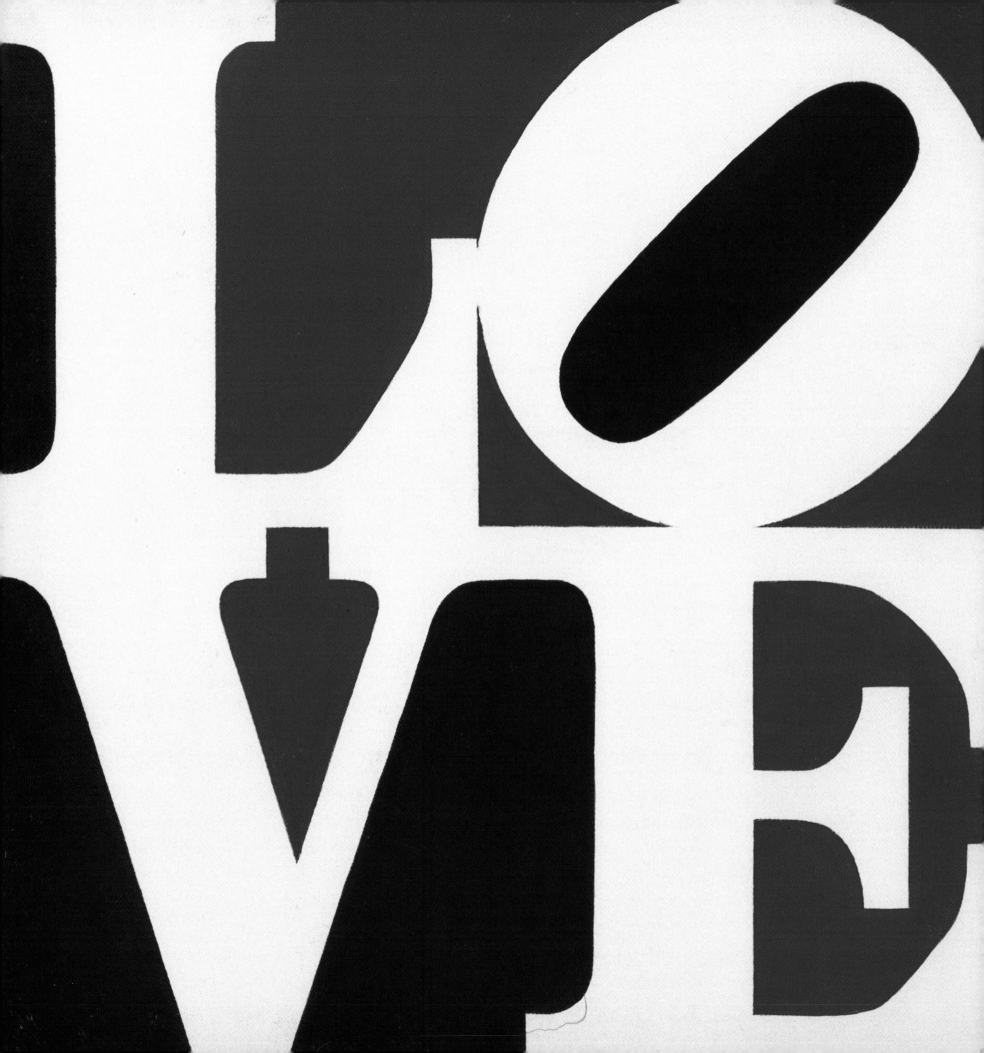

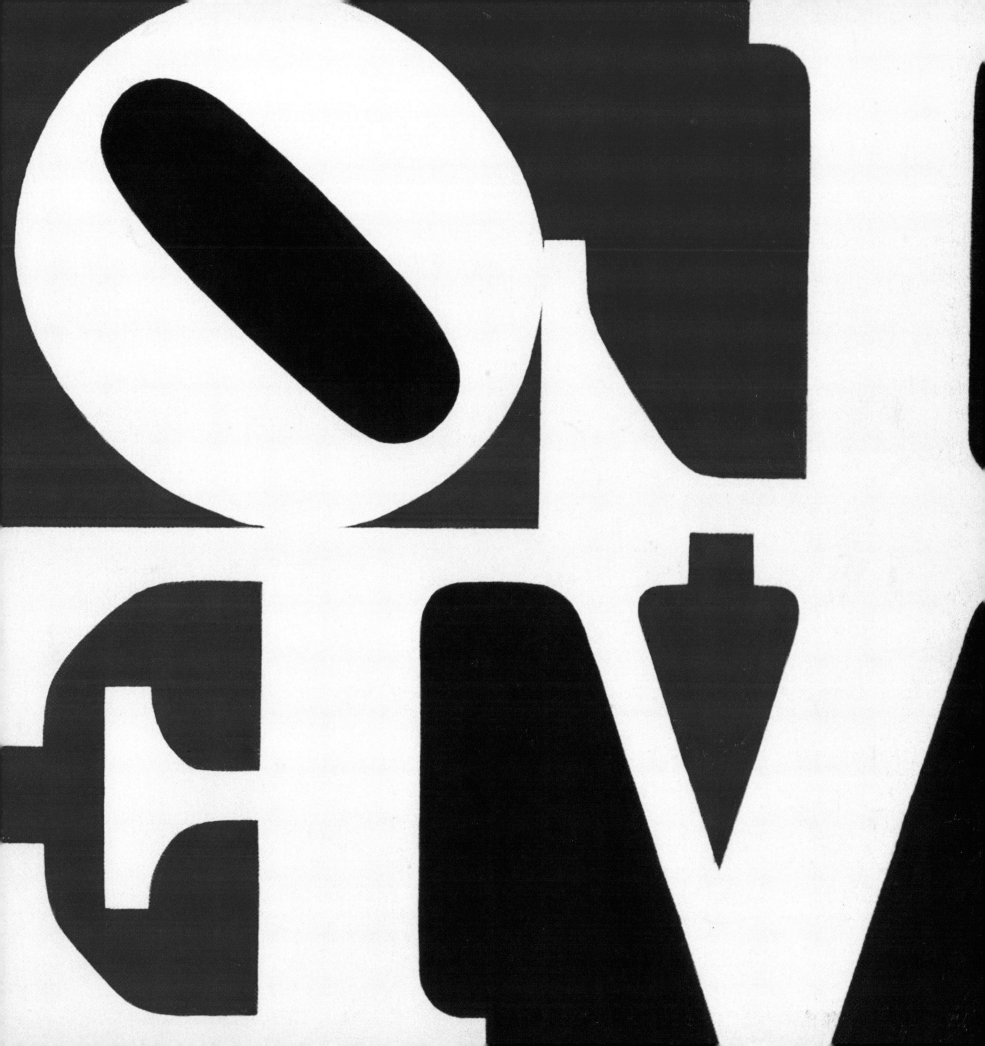

This catalogue was produced in conjunction with the exhibition
Love and the American Dream: The Art of Robert Indiana,
organized by the Portland Museum of Art, Maine.

Portland Museum of Art
June 24 – October 17, 1999

Marietta / Cobb Museum of Art
November 23, 1999 – January 30, 2000

**This exhibition and catalogue are made possible
by the generous support of Scott M. Black.**

**A major grant has been provided by The Richard Florsheim Art Fund,
with additional support from Portland Press Herald / Maine Sunday Telegram.**

Edited by Fronia W. Simpson
Designed by Michael D. Ryus, MdR design
Printed in Verona, Italy, by EBS

Published by the Portland Museum of Art
Seven Congress Square, Portland, Maine 04101

Distributed by the University of Washington Press,
P.O. Box 50096, Seattle, WA 98145-5096

"Eternal Love" ©1998 Susan Elizabeth Ryan
Library of Congress Catalog Card Number: 98-68099
ISBN: 0-916857-17-4 (softcover)
ISBN: 0-916857-18-2 (hardcover)

Front cover:
The Demuth American Dream No. 5
1963, oil on canvas
five panels, assembled: 144 x 144 inches.
Art Gallery of Ontario, Toronto.
Gift from the Women's Committee Fund, 1964.

Frontispiece and pages 134-35:
American Love
1968, oil on canvas
two panels, assembled: 12 x 25 inches.
Herbert Lust Gallery.

Back cover:
The Great Love
1966, oil on canvas
four panels, assembled: 120 x 120 inches.
Carnegie Museum of Art, Pittsburgh.
Gift of the Women's Committee, 67.23.

Contents

Preface

Robert Indiana has devoted his lifework to investigating two basic ideas: Love and the American Dream. These concepts are parallel yet separate, intertwined yet engaged with a search for cultural and personal identity. The painting *Love* is the most recognizable image produced by any American artist, yet its creator is less recognized than his creation. The American Dream is Indiana's favored subject, yet his investigation of it extends beyond those works that are designated as part of the series. This exhibition and discussion of the work of Robert Indiana bring these icons and ideas into focus, uniting concepts that have preoccupied the self-designated "American painter of signs" for decades.

Acknowledgments

This study of the work of Robert Indiana could not have been accomplished without the full cooperation of the artist. His generosity and willingness to share his thoughts and working process have been an invaluable guide. Susan Elizabeth Ryan, who contributed an insightful essay to this catalogue, has been a vital resource to me and all those interested in discovering Indiana's work—her ideas and example have driven me toward deeper understanding of the artist's concerns, and my essay is indebted to her. Another strong influence has been my reading of Robert L. B. Tobin's essay in the catalogue for the monographic exhibition he organized for the University of Texas at Austin in 1977. This document is an insightful chronicle of his personal and professional ideas on Indiana's works, from the vantage point of a friend and collector. I have also benefited from lengthy conversations about Indiana's work with Herbert and Virginia Lust, Todd Brassner, Patricia Nick, Simon Salama-Caro, and John Wulp. The lenders to this exhibition (listed on page 132) have generously allowed works in their possession to be included, and I am grateful for their cooperation. I would also like to thank the following people for their assistance during the planning of this exhibition and catalogue: Holliday Day, Alison Dubin, Marisa del Re, Dennis Griggs, Linda Hardberger, Heather Lammers, Melville McLean, John Rexine, Edna C. Southard, and Adam Weinberg.

At the Portland Museum of Art, I have profited greatly from the cooperation and intellectual expertise of Director Daniel E. O'Leary, a great student and champion of Indiana's art, who has contributed an essay to this catalogue as well as innumerable insights on the artist and his works. My understanding of Indiana's art was increased by his active and enthusiastic participation in this project. I greatly value comments on early drafts of my essay by Jessica Nicoll, Susan Elizabeth Ryan, Keith Shortall, Jessica Skwire, and Kenneth Wayne. Elizabeth A. Barry, with the help of Susan Elizabeth Ryan, compiled a complete bibliography for this volume, as well as providing valuable editorial support, and Maya Shinohara, curatorial intern, executed key research in preparation for the catalogue. Fronia W. Simpson added her considerable talents as editor, and Michael D. Ryus is responsible for the handsome design of this catalogue.

This exhibition and publication would not have been possible without important organizational contributions by Jessica Skwire, curatorial assistant; Beverly Parsons, registrar; and Dee Smart, registrarial assistant; and the expert hanging and lighting of Stuart Hunter and Gregory Welch, preparators.

I am grateful for the generous support of Scott M. Black without whom this project would have not come to fruition.

Aprile Gallant
exhibition curator

The Journals of Robert Indiana

Daniel E. O'Leary

More than any other artist of his generation, Robert Indiana is a virtuoso of numbers and words. His highly graphic images often celebrate defining moments in American history, culture, and current events. He has also religiously documented the events of his own life, amassing an enormous range of autobiographical material. Indiana's collection of records and memorabilia, preserved in his Star of Hope Lodge on the island of Vinalhaven in Maine, includes hundreds of thousands of items: gallery brochures, invitations to openings, reviews, newspaper clippings, letters, photographs, and dozens of volumes of sketchbooks and journals. Indiana's journals for 1959–63, the years when he established his distinctive style of colorful and provocative word-images, contain his most detailed drawings and prolific notes.[1] The journals chart his daily progress toward his signature style and provide a crucial resource for understanding the evolution of his work. This essay explores the function of the journals as essential elements in the genesis of Indiana's mature style.

Indiana's journals not only document his most famous images; they also record many altered, lost, and destroyed works. They harbor the secrets of his personal life and reveal the nature of his anxieties and amusements.[2] They log his visits to galleries, museums, and artists' studios, and record his insights into films, plays, and current events. They capture the character and pace of the New York art world and frame it within the larger context of American contemporary culture. The journals are fundamental to an understanding of Robert Indiana, both as an artist and as an individual.

The artist's early works in New York City were abstract paintings based on circles or organic shapes and found-object constructions. His journal for 1959 and 1960 recorded many of these works, which served as experiments in a search for a new aesthetic.[3] Indiana observed in his journal for January 24, 1959, that his painting *The Source* seemed indebted to both Arp and Motherwell. On January 31, 1960, he wrote that an early 1960 abstract painting was inspired by the snake plants in his loft. A painting recorded on February 17, *Blue*, was also a free-form work that demonstrated the artist's interest in organic patterns. By contrast, *Agadir* (Figure 1), painted in March, was a response to an earthquake in Morocco that destroyed a city and most of its inhabitants. The painting, a geometric arrangement of four large orbs in two rows, marked a significant turning point in Indiana's career. It was his first painting to address a contemporary event.[4] Also in March he painted *Image of Man*, a cryptic field of green with indentations of white. By the final months of the year, he had become accustomed to working on one canvas each month, which he referred to, for example, as his "October painting." Sometimes, as in November, he made several works identified with the month. His two paintings for December were variations on the leaf patterns of corn plants. The paintings of 1959 and early 1960 had archetypal themes, in contrast to his later paintings, which were literal and specific.

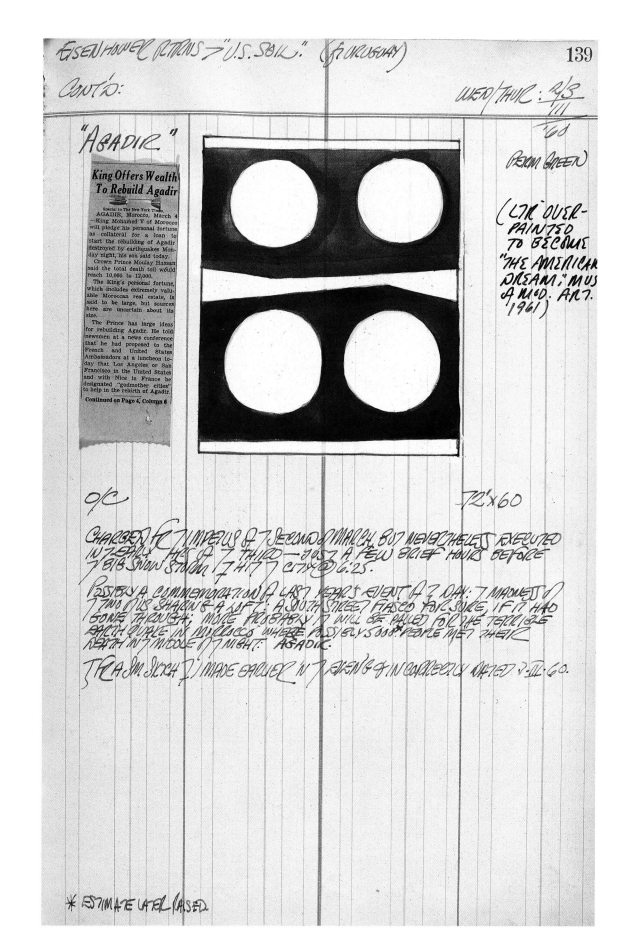

Figure 1

Journal entry for March 2–3, 1960;

drawing of *Agadir*,

ink and watercolor on paper.

Collection of the artist.

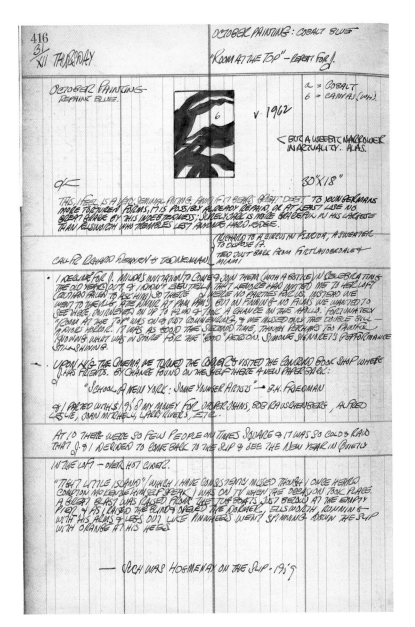

Indiana's journal entries demonstrate his avid interest in the New York art scene and reveal his interest in the works of numerous artists. An entry for February 27, 1960, elaborates on an uptown gallery tour to see "Cleve Gray at Staempfli, Jasper Johns at Castelli, Sugaï at Kootz, Rosenthal at Viviano, and Milton Avery at the Whitney (a beautiful show)." On March 25, 1960, Indiana visited a French Gallery show of Barnett Newman's work and spoke with the artist: "He proceeded to guide me through his show, carefully picking up the chronological thread and putting me on the right track." On April 22 Indiana returned to the French Gallery for a Morris Louis show. His comments on Louis suggest Indiana's goals for his own art: "Even more meaningful to me—more instructive than Barnett Newman. . . . He is very much an artist of image, magic and mystery." On August 28 Indiana recorded an excursion "to Spring and Mott to see Louise Nevelson's fabled building: the floors and floors phalanxed solid by her late somber work (The Bee and her Boxes). Her early paintings (very ego-directed)."

The journals reveal the artist's efforts to free himself from the influence of other painters living on Coenties Slip, particularly his close friend Ellsworth Kelly. In his journal entry for January 24, 1959, he questions the integrity of his most recent painting: "the total effect is, here, too 'Kelly' for comfort." An entry and sketch for December 31, 1960, show that Indiana had reworked his "October" painting (Figure 2): "This is, I feel, a very seminal painting, and if it bears great debt to [Jack] Youngerman's more tortured forms, it is possibly already repaid, or at least loses no great grace by that indebtedness; surely Jack is more graceful in his largesse than Ellsworth, who trembles lest anyone hardedge."[5] The use of stenciled letters to create words, which Indiana first applied to his sculptures and later to his paintings, became the essential strategy in his efforts to escape Kelly's influence.[6]

Figure 2

Journal entry for December 31, 1960; drawing of "October" painting, ink and watercolor on paper. Collection of the artist.

The journals also chart Indiana's work on numerous relief and free-standing sculptures during 1959 and 1960. He salvaged rough beams from demolished warehouses in the Coenties Slip neighborhood, altering them to form enigmatic, found-object sculptures. Indiana noted that by February 10, 1960, he had made "almost 20 constructions." Many were freestanding sculptures with names or titles stenciled on their surfaces. Indiana called these pieces "herms," creating both an apparent link and an implied tension between these works and the classical sculptural tradition.[7] His entry for May 27, 1960, recorded the discovery of the material for a herm: "A new construction started today with the beam section that J[ohn Kloss] and I carried over from Water St.—a beautifully weathered specimen." The entry for December 7, 1959, noted that his sculptures enabled him to work despite the limitations of his finances: "now many construction ideas come to mind, and as long as I haven't money enough for canvas and stretchers, perhaps it is just as well."

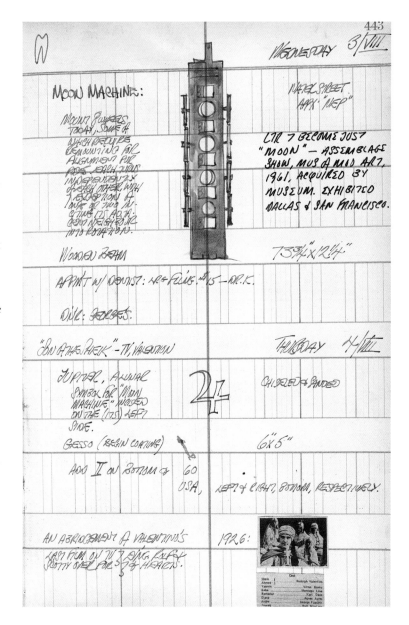

Figure 3
Journal entry for August 3, 1959;
drawing of *Moon Machine*,
ink and watercolor on paper.
Collection of the artist.

The titles for the relief constructions, such as *Sun and Moon, Zenith,* and *Wall of China,* as well as the titles for the herms—*Hole, Orb, Soul, Two,* and *Moon Machine* (Figure 3)—are often poetic or generic. As in the case with the painting *Agadir,* a few titles refer to historic events. *French Atomic Bomb, Jeanne d'Arc,* and *U-2* each address a specific occurrence or personage. Indiana's herms provided an appropriate medium for utilizing stenciled letters to impose a forceful presence on his work. The herms, with their single, monosyllabic words that imply cryptic messages, can be seen as the direct precursors to Indiana's later paintings.

Indiana's daily journal entries provide an encyclopedic record of his tastes and pastimes. Thousands of entries register his activities for the day, his meals, and his reactions to current events, newspaper articles,

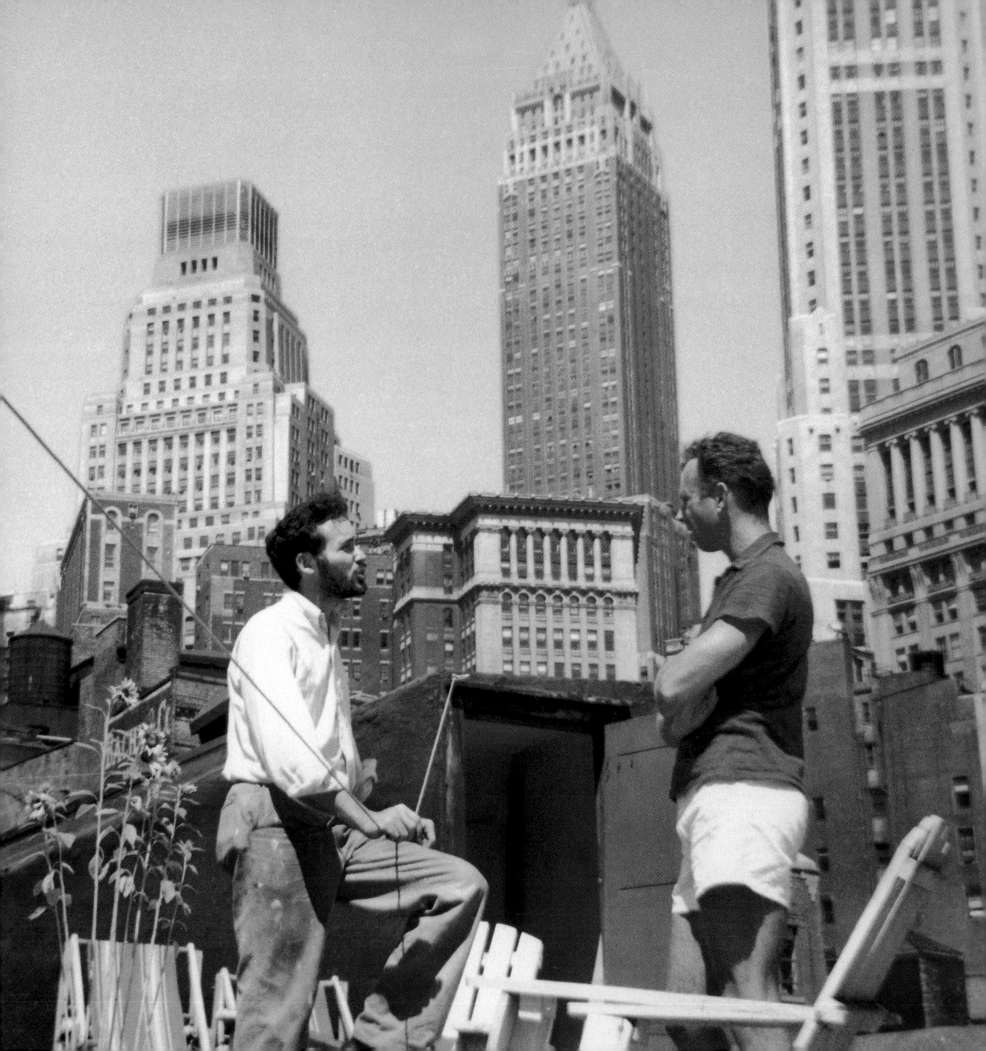

theatrical and musical performances, and television broadcasts. The journals are a litany of Indiana's cultural interests:

Stravinsky's *Firebird* on radio—1.10.59

Beethoven's Fourth Symphony on radio—1.24.59

Verdi's *Macbeth* at the Met—2.21.59

Wozzeck premiere at the Met—3.5.59

Reading Melville's *The Confidence Man*—4.8.59

Leonard Bernstein in Moscow—[*New York Times* article]—8.26.59

Hamlet—"Very fine even on TV"—9.2.59

Seamen's Ship Museum—1.27.60

The Tempest—2.3.60

Glenn Gould at Carnegie Hall—2.13.60

Van Cliburn at Carnegie Hall [*New York Times* article]—2.18.60

Leonard Warren dies on the Stage of the Met tonight (*Del Forza del Destino*)—3.4.60

Pasternak attends Bernstein Concert—8.11.60

Paul Taylor Dance Concert—"2nd row seats"—1.14.61

The Miracle Worker. Anne Bancroft and Patty Duke. See both backstage—1.24.61

"Omnibus" broadcast of four plays, two by Saroyan, one by Beckett, one by Albee—3.7.61

Eugene Ormandy at Carnegie Hall—4.18.61

Henry IV, BBC television production—5.5.61

Often a journal entry displays a headline across the top of the page, linking the day to a major event:

Danish Ship Sunk by Iceberg (95 Aboard)—1.31.59

Elizabeth Expecting Her Third Child: First to a Reigning Monarch in over 100 Years—8.8.59

Eisenhower at Chequers—8.30.59

Russian Rocket Lands on Moon—9.13.59

Kruschev Arrives Washington: Noon—9.15.59

French Atomic Bomb Explodes over Sahara—2.13.60

Chessman Executed—5.2.60

Kennedy—Democratic Nominee—7.13.60

Johnson Chosen as V.P. Candidate—7.14.60

Kennedy Elected—11.8.60

Revolt in Algeria—4.16.61

Grissom (2nd U.S. Astronaut) vaulted and dunked—6.21.61

Robert Indiana and Ellsworth Kelly, Hemingway Shoots Himself—7.2.61

Coenties Slip, circa 1959. Russians Orbit the Earth for 24 Hours—8.6.61

Russia's Atomic Explosion—9.1.61

Eichman Sentenced to Hang—12.14.61

Mrs. Woodrow Wilson Dies—12.30.61

Marilyn Dead—8.6.62

Many of the public events and themes that later became the subjects of Indiana's most famous paintings were first recorded in his journals. By late 1960 the dense, reportorial content of the journals began to dominate the focus of his paintings. Indiana's engrossment in the contemporary world included an avid enthusiasm for popular culture, particularly for films:

The Mystery of the Blue Room—"with Paul Lukas!"—9.2.59

The Seventh Seal—"Bergman's most pretentious film yet, was an experience"—1.20.60

Moon and Sixpence on television—1.27.60

Anna Karenina (1935)—"Garbo & Basil Rathbone"—1.28.60

The Horse's Mouth—"Guinness—knew the book. Neither art nor film came up to my expectations. The depiction of London, however, in all its gray bleakness, punctuated with those red double-decker buses, was worth the price of the movie."—2.10.60

Witness to Murder—"an awful old Stanwyck movie"—2.15.60

The Red Dust (1932)—"Jean Harlow and Clark Gable (But not to forget a memorable, transgressed upon Mary Astor)"—2.23.60

The Picture of Dorian Gray—"An interesting change of pace from today's realism dramas"—3.8.60

Queen Christina (1933) "Garbo"—6.30.60

Interview: Mike Wallace and Gore Vidal—9.2.60

Diabolique—"Simone Signoret"—12.9.60

The Virgin Springs—"a moving experience: fantastically realistic"—1.7.61

The Wild One—"with an awful Sinatra film: *Pal Joey*"—1.10.61

Institute of Beauty—"The late, late show brings back Mae in her first film. A New York speakeasy"—1.16.61

Dinner at Eight—"Jean Harlow. Wallace Beery. John and Lionel Barrymore. Classic."—1.20.61

Moulin Rouge—Ferrer, TV—2.23.61

Butterfield 8—"Elizabeth Taylor"—2.25.61

I'm No Angel, (1933) [with newspaper advertisement pasted in the journal: "first NY Telecast—The Late Show"]—3.14.61

Lucky to Be a Woman—"Sophia Loren and Charles Boyer"—5.7.61

Tarnished Lady—Tallulah Bankhead—5.8.61

La Dolce Vita—"Fellini's vaunted masterwork"—5.10.61

The Light That Failed—"An attempt to watch but couldn't bear. 1939. Ronald Colman"—5.28.61

Bolero—"Paramount with George Raft, Carole Lombard and Sally Rand doing her [drawing of a fan] dance as Annette"—5.29.61

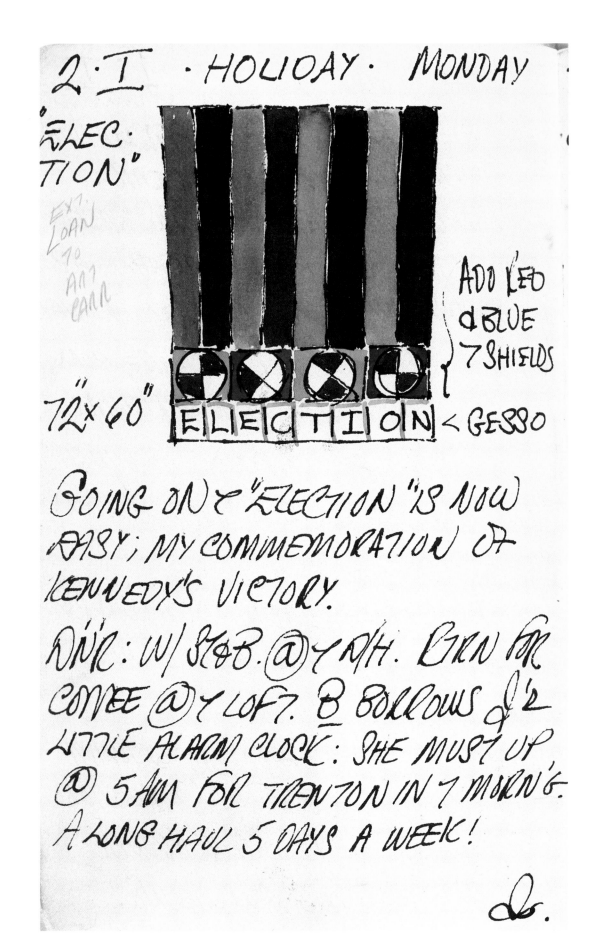

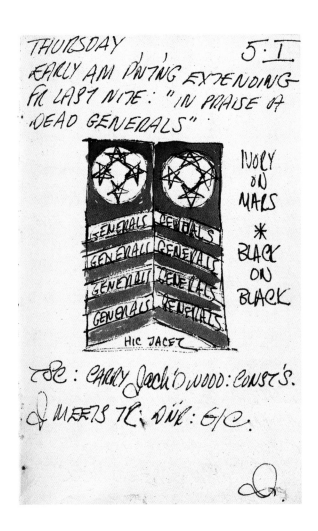

The journals contain references to trips, consumer products, and the words of popular songs. They underscore Indiana's particular fascination with three pastimes: *I Ching*, Monopoly, and Scrabble. The first was a frequent activity when entertaining visitors: "Studio visit: Andy Warhol with John [Ardoin] and Norman [Fisher]. Having never heard of *I Ching* I gave him a reading. Watched 'Godot' again. Dinner for Andy, John, and Norman—a red spread on my work table" (April 4, 1961). Indiana also recorded dozens of Monopoly games with guests and neighbors on Coenties Slip. It may not be mere coincidence that his mature paintings resemble—in their boldly worded titles, colors, and proportions—the individual lots on the Monopoly board. Indiana's journals also mention frequent games of Scrabble and include notes on specific words he played. His tendency to comment on Scrabble games in his journal peaked in the fall of 1960, coinciding with the appearance of words in his paintings.

In the final months of 1960 Indiana returned to the approach he initiated with *Agadir*, creating another painting named for an actual place. *Terre Haute*, a reference to a city in the artist's home state, anointed a specific location with a powerful graphic identity.[8] It was the first work to reveal Indiana's growing obsession with American themes, a preference that would dominate his work for the next two decades.

The journal for 1961 records a period of rapid transformation and reveals the sequence of ideas that launched Indiana's new style. His first work of 1961, *Election* (Figure 4), described in the journal on

Figure 5 left
Journal entry for January 5, 1961;
drawing of *In Praise of Dead Generals*,
ink and watercolor on paper.
Collection of the artist.

Figure 6 right
Journal entry for March 19, 1961;
drawing of *The American Dream*,
ink and watercolor on paper.
Collection of the artist.

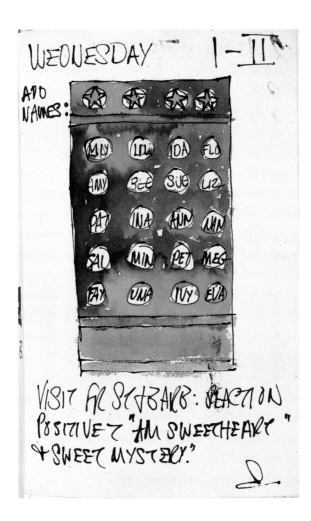

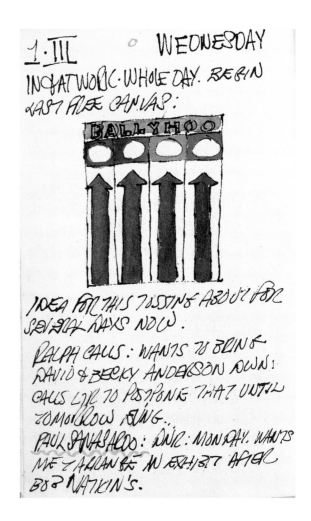

Figure 7 *left*

Journal entry for February 1, 1961;

drawing of *The American Sweetheart*,

ink and watercolor on paper.

Collection of the artist.

Figure 8 *right*

Journal entry for March 1, 1961;

drawing of *Ballyhoo*,

ink and watercolor on paper.

Collection of the artist.

January 2, 1961, as "my commemoration of Kennedy's victory," acknowledged Indiana's fascination with contemporary American politics.[9] Containing four circular shapes that suggested "the computer memory tapes viewers saw spinning during TV coverage on election night,"[10] *Election* was a cryptic reference to Kennedy's victory over Richard Nixon. A similar obscurity characterized *In Praise of Dead Generals*—a painting sketched in Indiana's journal on January 5, 1961 (Figure 5). The work repeated the word *generals* eight times in a chevron pattern above the phrase *Hic Jacet*.[11] Indiana used a similar pattern of word repetition on February 14 and February 21 in his sketches of *Eidolons*. The word *eidolon*, meaning "image" or "phantom," was diagonally stenciled sixteen times to form a V-shaped, or chevron, pattern. As his note in the journal suggests, Indiana appropriated the word from a poem by Edgar Allan Poe. *Eidolons* was his first step in creating paintings that incorporated passages from American literature.[12]

Indiana's growing enthusiasm for stenciled words and phrases inspired him to alter or entirely revise many of his paintings of the period 1959–60. A number of journal entries for January 1961 record Indiana's extensive reworking of *Agadir*. Two references indicate his goals for its revision: "Very apt to become the American Way (Lenore's stencil). . . . Yin and Yang considered in four different aspects but rejected in turn" (January 11). "This once green and white painting was the object of most of my thoughts these last two days, since it is long overdue for transmutation" (January 12). Two sketches show the addition of stars to the painting. With the first, Indiana stated: "*The American Dream* decided for old *Agadir* painting"

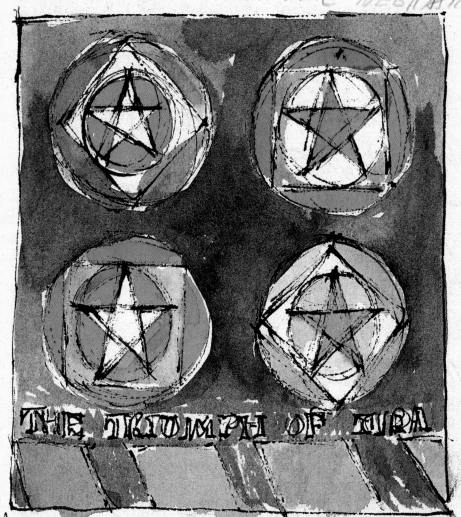

The Triumph of Tira

Figure 9
Journal entry for March 1, 1961;
drawing of *The Triumph of Tira*,
ink and watercolor on paper.
Collection of the artist.

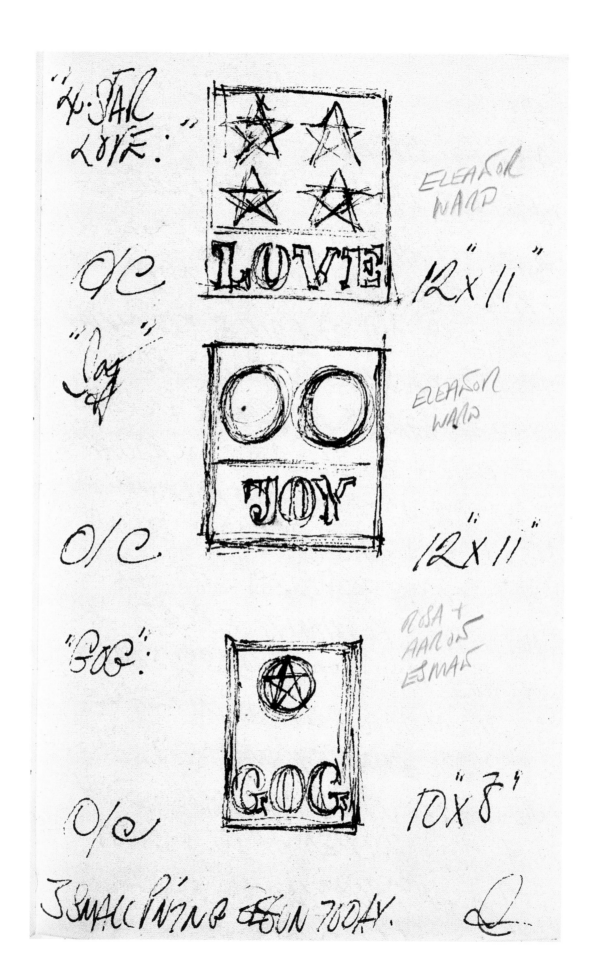

Figure 10

Journal entry for June 5, 1961;
drawings of *Gog*, *Joy*, and *4-Star Love*,
ink on paper.
Collection of the artist.

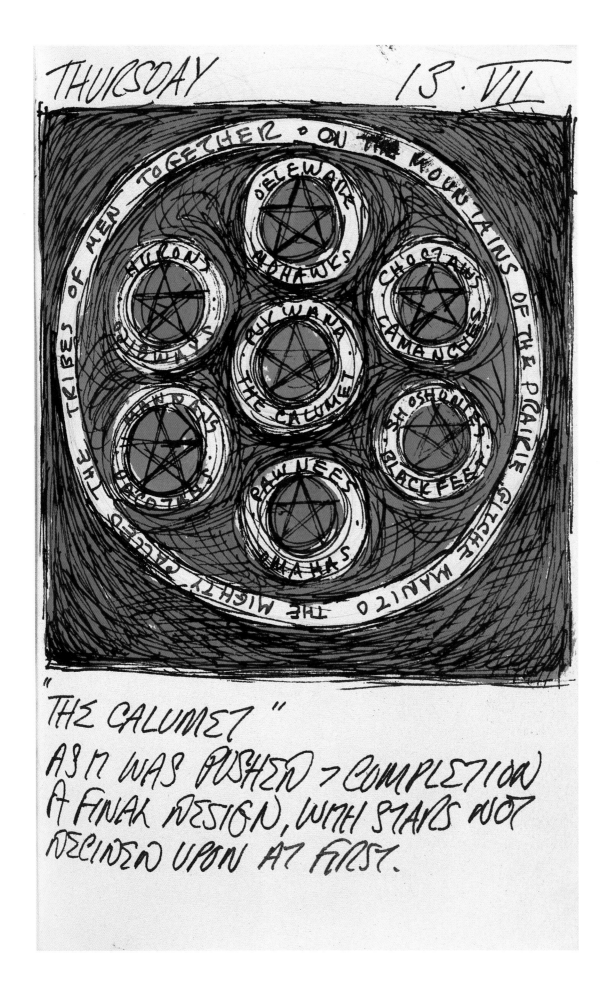

"THE CALUMET"
AS IT WAS PUSHED > COMPLETION
A FINAL DESIGN, WITH STARS NOT
DECIDED UPON AT FIRST.

Figure 11

Journal entry for July 13, 1961;

drawing of *The Calumet*,

ink and watercolor on paper.

Collection of the artist.

(January 13). With the second, he revealed his source for the painting's imagery: "very much a reference to the pinball machine" (January 17). Entries for January 24 and March 8 record additions of the words *tilt* and *take all* to the painting.

Indiana's Sunday, March 19 entry presents a final drawing of *The American Dream* (Figure 6). He had transformed the original abstraction of *Agadir* into a series of numerical and verbal references, preserving the four dominant circles and the irregular horizontal line separating them. Indiana once explained that the irregular line, when it was part of *Agadir*, was a reference to the fault line between two tectonic plates.[13] In *The American Dream* the fault line from *Agadir* remains, enforced by the word *tilt*, adding to the inherent tension and irony of the artist's comment on America. Indiana exhibited the painting in April at the David Anderson Gallery, where Alfred Barr saw and purchased it for the Museum of Modern Art, elevating Robert Indiana to national and international prominence.

While working on *The American Dream*, Indiana also recorded his progress on a related painting, *The American Sweetheart* (Figure 7). On February 1, 1961, Indiana entered his first sketch of *The American Sweetheart*, a work that employs a design of 21 circles in seven rows, which he had used in 1959. He now elected to fill each of the circles with a stenciled, three-letter female name. On March 1, 1961, Indiana recorded *Ballyhoo* (Figure 8), a painting he later described as a parody of the art world.[14] On the same day he illustrated *The Triumph of Tira* (Figure 9), a work he had started late in 1960 to celebrate the character played by Mae West in *I'm No Angel*. The latter painting underscored Indiana's decision to make popular culture a dominant theme in his work. On May 11, 1961, Indiana's journal recorded *Le Premier Homme*, a shift from cinema to space, celebrating the exploits of the Soviet cosmonaut Yuri Gagarin. Indiana's earlier citation on April 12 had observed: "Russia sends first man into space (and brings him back alive and breathing): Yuri Gagarin."

While Indiana was creating numerous large paintings about current events and American culture, his journal for the year also documented smaller, more minimal works. Three such paintings were sketched on June 5, 1961: *Gog*, *Joy*, and *4-Star Love* (Figure 10).[15] The last represented Indiana's first flirtation with his enormously popular *Love* paintings. Several years later he transformed this initial concept—splitting the word *love* into two rows of two letters and arranging them in the position occupied by the four stars—to create one of the most universally recognized images of the 20th century.

On July 4, 1961, Indiana continued his series of celebrity paintings with *Papa*, his response to the death of Ernest Hemingway. His entry for the day notes that the painting was "a strange unconscious tribute to Hemingway. On the surface certainly not my favorite author by a long shot." On the next day Indiana's tendency to link his paintings to American literature became far more pronounced. He moved beyond the single-word quotation of *Eidolons* and the allusion to Hemingway in *Papa* with *Year of Meteors*, a schematized presentation of a passage from Walt Whitman's *Leaves of Grass*. The painting introduced a

new form in American art, Robert Indiana's "literary paintings." His second work in the sequence, *The Calumet* (Figure 11), appeared in his journal on July 13, 1961. The note accompanying this adaptation of phrases from Henry Wadsworth Longfellow's *Hiawatha* summarized Indiana's intention: "keeping very much within my framework of America." The stenciled letters that had first appeared on his herms and expanded in his political and celebrity paintings now grew into quotations celebrating American literature.

Later in July Indiana broadened his "American framework" to include a painting on slavery in America, a literary painting inspired by Herman Melville's *Moby-Dick*, and two paintings that celebrated verses from a traditional 19th-century American spiritual.[16] In December Indiana added sketches in his journal for *The American Reaping Company* (December 4) and *The American Gas Works* (Figure 12; December 13). The year 1961 concluded with the theme that began it, the American presidency. His entry next to the drawing for *A Divorced Man Has Never Been the President* proclaimed the work "very much a 1961 painting" (December 31). Throughout the year, Indiana had directly addressed his own era, embracing politics, entertainment, and current events, building an iconography that was emphatically American.

Many of Indiana's works that celebrate public figures and events should be considered as innovations in the tradition of history painting. Indiana's canvases commemorate individual and national milestones, giving the viewer the opportunity to contemplate real events. In this sense *Agadir* was Indiana's first history painting, followed by paintings of political history, literary history, and celebrity history. Indiana became a specifically American artist in the sense that he addressed himself exclusively to American themes, inviting his viewer to ponder symptoms of the American situation.

Indiana recorded every milestone of his career in the journals. He carefully entered the details of visits by patrons and dealers. A visit by Alan Stone scheduled for July 28, 1961, and postponed until the following day was tersely described as "frustrating." The next day the journal continued: "the total effect of yesterday's dismal viewing was depressing and I sailed into a funk of idleness today" (July 30). On November 13, 1961, Indiana recorded: "Leo Castelli to visit today," and later: "a huge banging below. . . . City removed door to my studio . . . and very quickly and methodically removed my gas meter, made a few brief comments, and sealed it up. Leo and Ivan's visit a little later, really an anticlimax. They leave me a *Botanica* sign." On December 10, 1961: "Martha Jackson comes down for a look at my new work. Mink and blue sneakers (J[ohn] appalled.) Makes notes and picks out constructions but decides on nothing."

On December 18, 1961, Indiana attended the opening of the *Recent Acquisitions* exhibition at the Museum of Modern Art, where he found *The American Dream* "hung very handsomely on a room divider next to a very dark Bruce Conners box. . . . Ellsworth [Kelly] was with a Frenchman whom he introduced and [Alfred] Barr whom he did not. I introduced myself to him and he was immensely warm and cordial. Liked my comments (thought them as much a 'masterpiece' as my painting), liked *Dream*, and was concerned about the price I got, how it was hung."[17]

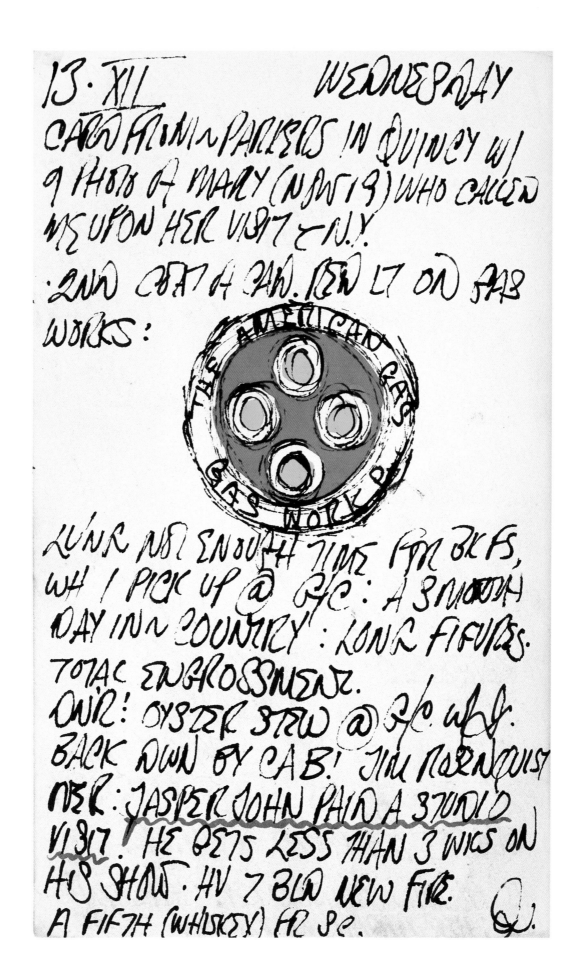

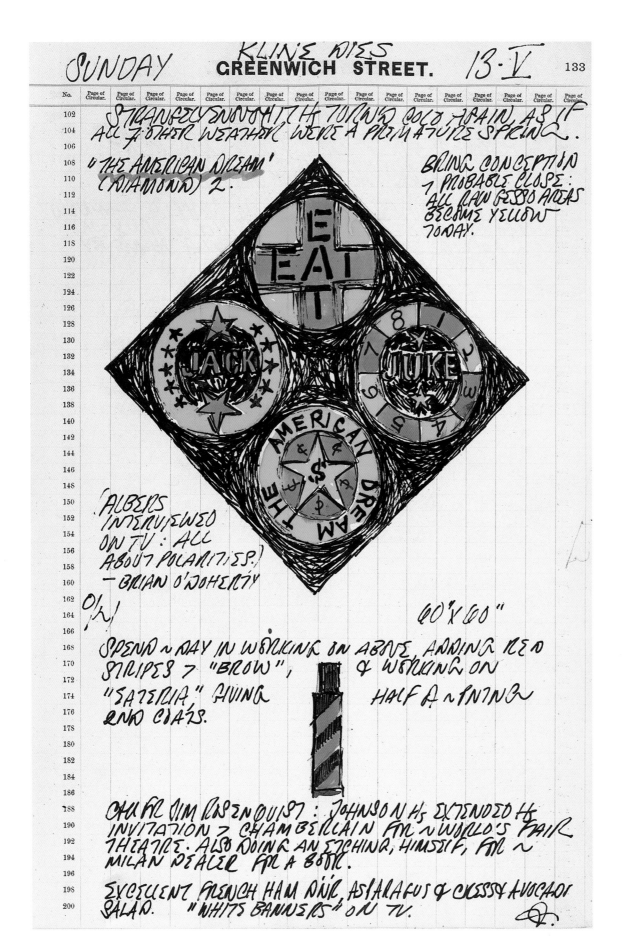

Figure 13

Journal entry for May 13, 1962;

drawing of *The American Dream (Diamond)*

ink and watercolor on paper.

Collection of the artist.

In addition to being the log of Indiana's career, the journals provide a window on Indiana's life as a New Yorker. At times he began his daily entry with an eloquent assessment of the weather, light, or mood of the city. The journals demonstrate his acute sensitivity to seasonal change and frequently contain references to the way the ginkgo trees outside his windows reflected the passage of time: "I noticed that this morning the ginkgo trees are almost budded and their slender branches are rough with this turgid greenness" (April 12, 1960). "Jeanette [Park] is now littered with the fallen yellow leaves of the ginkgo, and now fall weather alternates with a stubborn summer's holdout" (September 30, 1960).

The journals show that Indiana's signature style resulted from his sweeping decision in late 1960 to abandon his earlier approach to painting and instead explore his daily fascination with history, politics, and popular culture. During the following year Indiana rapidly pursued alternatives created by the inclusion of letters and messages in his work. Throughout 1961 he repainted many canvases and developed numerous new works that dynamically presented single words, phrases, or inscriptions. The journals reveal each step in his efforts to introduce American history, literature, politics, and popular culture into his paintings. By 1962 Indiana had established an adaptable approach that enabled him to produce paintings and sculptures that were visually and intellectually fluent. His drawings of paintings and sculptures in his 1962 journal increased in scale (Figure 13), perhaps underscoring his growing delight and confidence in his new style.

Indiana's strategy of creating canvases that were signposts of American culture earned him widespread recognition. Along with his growing success came a tendency to neglect the daily regimen of his journals. The pages for the final months of 1963 were left almost entirely blank, punctuated only by four brief references in November to the assassination of President Kennedy. At the same time Indiana began to create paintings that functioned as autobiographical markers. As his art became increasingly self-referential, his paintings took over the role of framing and expressing his experience, perhaps alleviating the need for private journals. As Robert Indiana emerged as an American icon, his paintings became his milestones.

Notes

1. Indiana kept three journals that were meticulous records of his life and work during the period 1959–63. The first, which covers the years 1959 and 1960, is a large, hardbound ledger with lined pages measuring 17 $\frac{1}{2}$ x 11 $\frac{1}{4}$ x 2 $\frac{3}{8}$ inches, by Findler and Wibel Stationers and Blank Book Manufacturers, 146 Nassau Street, New York. The ledger, which has 500 pages numbered by the publisher and dated by Indiana, contains 95 drawings documenting paintings or sculptures and hundreds of daily entries. The flyleaf bears the stenciled inscription, "1959, Coenties Slip, New York City." Indiana's journal for the year 1961 is a smaller, softbound sketchbook with unlined pages measuring 8 $\frac{1}{8}$ x 5 $\frac{1}{4}$ x 1 $\frac{1}{4}$ inches, with no manufacturer's label. It contains 384 unnumbered pages, 97 drawings, and hundreds of entries. The journal for 1962 and 1963 is a large, hardbound ledger with lined pages measuring 15 $\frac{3}{4}$ x 10 $\frac{3}{8}$ x 2 $\frac{1}{4}$ inches, with the title *Metropolitan Association Fire Underwriters Index of Streets and Avenues in New York City South of One Hundred and Thirtieth St. Vol. III, 1887*. The volume contains 566 numbered pages with headings that are the names of New York City streets in alphabetical order, 117 drawings, and numerous notes. Hundreds of newspaper clippings, letters, photographs, postcards, and postage stamps with designs that apparently intrigued Indiana are preserved in the journals. The entries are written in large, cursive handwriting or printed in capital letters. Indiana has frequently stated that he discovered the large ledgers in an abandoned loft on Coenties Slip. It had been his habit prior to 1959 to keep written journals or diaries that were separate from his sketchbooks. In 1959 he began to incorporate his drawings within his daily records. It is this combination that makes the journals for 1959 through 1963 particularly interesting.

2. Each day of the year was assigned a page in the journal although it might ultimately be left empty. At times a surge in activity is apparent near the end of the month, as though the artist were striving to meet his goals for the period. Nearly 40 years later, Indiana will express regret at seeing an empty page, recognizing it as proof of a nonproductive day or a lapse in his daily journal activity. Conversation with the artist, September 19, 1998.

3. Indiana's 309 drawings in the journals are either final records of completed paintings or records of his revisions to works in progress. They are not preparatory sketches but rather documentary drawings. Occasionally they were drawn in pencil, but more often they were completed with layers of watercolor and gouache.

4. Next to his sketch of the painting in his entry for Wednesday, March 2, 1960, Indiana pinned a newspaper clipping with the headline "King Offers Wealth to Rebuild Agadir." To the right he drew an abstract sketch of four white orbs and the dimensions of the painting: 72 x 60 inches. Below the sketch he printed the notation: "the terrible earthquake in Morocco where possibly 5,000* people met their death in the middle of the night: Agadir. *estimate later raised." In 1961 *Agadir* was altered to become *The American Dream*.

5. Indiana had studied and admired the work of Ellsworth Kelly and Jack Youngerman, both residents of Coenties Slip. Indiana's journal entry for February 15, 1960, records his visit to the Museum of Modern Art to view the work of both men in the exhibition *16 Americans*.

6. This liberation was enforced by a disparity of taste. Indiana was intrigued by the vitality of letters and words, but Kelly was not. "Kelly abhorred the idea of words in paintings." Conversation with the artist, October 10, 1998.

7. The name *berm* evoked the classical tradition of terminal figures that acted as architectural markers or milestones and displayed abbreviated anthropomorphic features.

8. In 1960 Indiana painted canvases that cryptically referred to his home state: *Red County* and *Brown County* were abstract works named for counties in Indiana. He painted over his February 1960 painting, *Blue*, to create *Terre Haute*. The journals indicate that the repainting of *Blue* was the first in a series of alterations to older works that signaled Indiana's rejection of his previous style.

9. Although the sketch for January 2, 1961, is the first reference to *Election* in his journals, Indiana had in fact begun the painting the previous November, quite soon after Kennedy's election. A small sketch of the painting in one of Indiana's record books—*The New England Calendar for Engagements, 1960*—was entered on Thanksgiving Day, November 24, 1960. Indiana had previously charted Kennedy's rise to power in his journals: "Kennedy—Democratic Nominee" (July 13, 1960) and had preserved newspaper clippings in the journals with photographs of John F. Kennedy as a 10-year-old boy and as a Navy officer.

10. Conversation with the artist, October 9, 1998.

11. The Latin phrase declares "here lies." The journals reveal that the chevron design for *In Praise of Dead Generals* had been adapted—like so many of Indiana's paintings for 1961—from his 1960 abstract painting *The Bridge*, which appeared in his journal on October 30, 1960.

12. Indiana placed the name *Poe* in parentheses next to his sketch of *Eidolons*. The evocative word appears in Poe's poem "Dream-Land," which begins, "By a route obscure and lonely, / Haunted by ill angels only, / Where an Eidolon, named NIGHT, / On a black throne reigns upright, / I have reached these lands but newly / From an ultimate dim Thule— / From a wild weird clime that lieth, sublime, / Out of Space—out of Time."

13. Conversation with the artist, October 10, 1998.

14. "*Ballyhoo* was my comment on negative and overdone aspects of the art world, including Abstract Expressionism and Mr. Greenberg. In the 1920s there was a magazine called *Ballyhoo*. I have a copy." Conversation with the artist, October 11, 1998.

15. The sizes of the three works were recorded in the journal as 12 x 11 inches or 10 x 8 inches, in noticeable contrast with larger works such as *Ballyhoo* and *The American Dream*, which are 60 x 48 inches and 72 x 60 inches respectively.

16. Indiana sketched each work in his journal: *The Fair Rebecca* (July 17), *Melville* (July 20), and a red and a green version of *God Is a Lily of the Valley* (July 25, 28). Concerning the last two paintings, Indiana later explained that they arose from a serendipitous occurrence: "I had been working very late at night in my loft and listening to classical music, probably radio station WQKR, when they played this haunting spiritual. I have never come across a printed copy of the text." Conversation with the artist, October 10, 1998.

17. Each artist whose work was accepted for the December 1961 *Recent Acquisitions* show had been asked to submit a statement on his or her work. Indiana's journal entry for December 11 recalled this task: "have spent the day filling out three pages of questions, culminating with my philosophy towards society and art."

Gene Swenson:

Is Pop America?

Robert Indiana:

Yes. . . . It is the American myth.

For this is the best of all possible worlds.

An American's Dreams

Aprile Gallant

The "American myth," otherwise known as the "American Dream," symbolizes the desires of the dispossessed.[1] The concept of the American Dream looms large in the history of the United States. It unites and divides our thoughts on what this country is and what it should be. America is, at its core, a country of outsiders—from the Pilgrims searching for religious freedom and self-determination, to recent immigrants fleeing political, economic, and social repression in the lands of their birth. The Dream is passed from

generation to generation and made anew by each American; each Dream is a melding of individual desires and common cultural ideals. The Dream can also have a sinister connotation—false promises and unfulfilled aspirations—the ultimate con game perpetrated by a mythology that paints America as "the promised land." Yet this mythology also holds out the possibility for an individual to reconstruct him- or herself—a chance to create a new life. As both an artist and a person, Robert Indiana is preoccupied with all of these aspects of the American Dream. In 1954 Robert Clark

(Figure 14), born in Indiana, arrived in New York. Within seven years, he would become Robert Indiana—painter of the American Dream, a Pop artist on the rise. Indiana's engagement with the conflicting ideas contained within the American Dream—individualism and belonging, freedom and social responsibility, reality and aspiration—would occupy him until the present day. Despite the fact that he has designated only certain paintings as part of the *American Dream* series, the psychological, social, and historical issues contained in this phrase are the basis of his mature work.

The details of Indiana's early years have been chronicled by critics and historians as well as in the "Autochronology," Indiana's own list of significant occurrences in his life since birth.[2] The economic hardship of the Great Depression resulted in a chaotic early life for the artist, which was exacerbated by his father's financial and personal failures and his mother's restlessness. The Clarks moved often (by the artist's recollection, they lived in 21 different houses before he turned 17), and his father finally left the family in 1938. The young Robert Clark first formally studied art in high school (although he decided on a career as an artist at age six), and then in classes at the John Herron Art Institute, before enlisting in the Air Force at 17. When he had completed his military service, he enrolled under the G.I. Bill at the School

Figure 14

Robert Clark, circa 1929.

of the Art Institute of Chicago, after which he won a scholarship to the Skowhegan School of Painting and Sculpture in Skowhegan, Maine, and a yearlong fellowship to study in Edinburgh, Scotland. After this training, the young painter moved to New York.

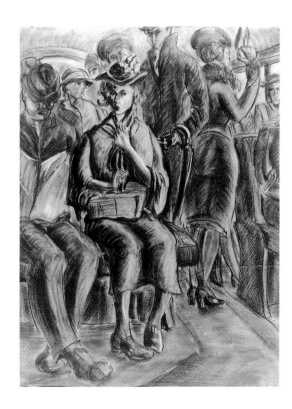

The roots of Indiana's approach to art were planted in high school, where he made paintings resembling the mean streets in the works by the Social Realist painter Reginald Marsh (Figure 15). He claims that "what didn't happen to me in art school" was, paradoxically, the signal event of his training.[3] Throughout his four years at the Art Institute he never found a mentor among the faculty or a way to treat pictorially the subjects that interested him as an artist. From the beginning, he concerned himself with contemporary themes that are legible to a wide audience. The critic Mario Amaya noted Indiana's belief in Pop as a "new Ash-Can School,"[4] and the artist proclaimed in 1961: "I want to be a people's painter as well as a painter's painter."[5]

The formation of Indiana's mature painting style began during the time of his friendship with Ellsworth Kelly, whom he met in 1955. Kelly had just returned from four years in Paris and was painting in a reductive, hard-edge style based on his observations of nature. Kelly became Indiana's artistic example, a mature painter to observe and engage in discussions about art. In 1956 Indiana moved to Coenties Slip, a waterfront street on Manhattan's Lower East Side. Kelly soon followed; as did the painter Jack Youngerman; his wife, the French actress Delphine Seyrig; and the artists Lenore Tawney, Charles Hinman, Agnes Martin, and James Rosenquist.[6] This group formed Indiana's first "community" as an artist, a vital safe haven in which he could develop his work. It was during this time that the content and form of Indiana's art became more symbolic and abstract, probably owing to Kelly's influence.

In 1961 Indiana had his first major show, a two-person exhibition with the painter and sculptor Peter Forakis at the David Anderson Gallery. Indiana showed 12 works, including a painting entitled *The American Dream.*[7] The purchase of the painting by the Museum of Modern Art in New York in 1961 was instrumental in launching Indiana's career, leading to his inclusion in the exhibitions *Recent Acquisitions, Painting and Sculpture* and *The Art of Assemblage* at the Museum of Modern Art and *New Realists* at the Sidney Janis Gallery the following year. The critical discussion surrounding these exhibitions irrevocably branded Indiana a Pop artist. He was labeled a "sign painter," his works compared to the anonymous billboards and road signs that signaled the expansion of American commercial culture. While these were vital visual influences, the crux of Indiana's art can be traced more to his historical, political, and personal interpretations of the American Dream.

Figure 15

Woman on a Bus, 1945, gouache, graphite, and watercolor on paper, 26 x 20 inches. Collection of the artist.

Developing a Language

Indiana's fascination with the American Dream predates its appearance as an overt subject in his work. The mid-1950s, when Indiana moved to New York, witnessed an explosion of interest in all things "American," from history, music, and art to studies defining the emergence of a unified American culture.[8] Indiana was already keenly interested in literature, poetry, film, music, and history, all of which give subjective impressions of real or imagined experiences. These disciplines are also dependent on interpretation by an audience and its connection to the artist or author. The model of the other arts he loved provided Indiana with an approach to the subject of his art, and he began mining American culture for significant material that would speak to diverse audiences on multiple levels. As Indiana explained in an interview with Donald Goodall in 1976: "[I]s an artist talking to himself or is he trying to communicate to other people? I suppose he's doing both, but sometimes one doesn't know for sure which is more important. I really have tried to do both."[9] During the late 1950s, Indiana turned to his surroundings for ideas.

Some of Indiana's early paintings, such as *Ginkgo* (1958-60; Figure 16), were drawn from abstractions of nature, like Kelly's—but with no primary color and broader textural effects. Indiana's early paintings also

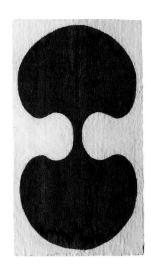

retain a personal connection between the artist and his subject. In doing so, he straddled the approach of the Abstract Expressionists, whose content was wholly personal, and the artists of his generation, like Jasper Johns, who sought universal subjects, like the American flag. In the catalogue for his first retrospective at the University of Pennsylvania, Indiana describes the ginkgo trees that grew in Jeanette Park, below his window on Coenties Slip: "The ginkgo leaf: the new form though of prehistoric Oriental botanic origin, not a tree, but a fern, which—in the not humid enough climate of New York—unable to have normal prehistoric sex, the female specimen throws off a foul-smelling seed as if in anguished protest."[10] The ginkgo became a potent symbol for the artist; he empathized with this displaced being, surviving in a new form. *Ginkgo* depicts two leaves connected at the stem end, one atop the other. The artist refers to this formation as "yin/yang" and points to its origin in a reading of the *I Ching*.[11] The concept of yin/yang concerns feminine and masculine compatibility—each fulfilling the other and together creating a whole person. The double ginkgo combines two of the same forms as a complementary pair similar to yin and yang.

The double ginkgo leaf preoccupied the artist during the late 1950s, emerging as the central motif of *The Sweet Mystery* (Figure 17). The title is taken from a synthesis of sources, including a phrase from the writings of the British author Cyril Connolly, popular song lyrics, and contemplation of the meaning of the *I Ching* and symbolism of the ginkgo leaf. The artist describes the title as encompassing "life and death. The hereness and not hereness," and "a song breaking through the darkness."[12] The phrase *sweet mystery*

Figure 16

Ginkgo, 1958–60,

gesso on wood,

15 $^1/_2$ x 8 $^7/_8$ inches.

Private collection,

courtesy Simon Salama-Caro.

Figure 17

The Sweet Mystery, 1960–61,
oil on canvas, 72 x 60 inches.
Private collection,
courtesy Simon Salama-Caro.

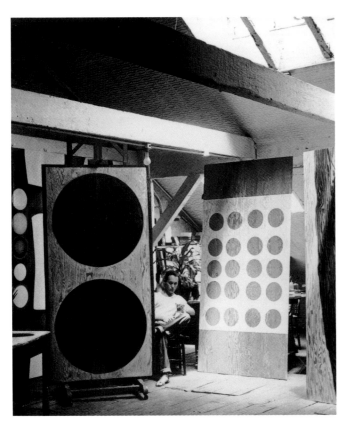

also alludes to love or emotional attachment, which is appropriate to the symbolism of the double ginkgo leaf. The heat of the yellow and red in the picture, highlighted against a black background, alludes to passionate union. The references to life, death, and salvation indicated in the artist's description of the title also signify his belief in the reformative nature of human connection, symbolized by the joined ginkgo leaves. While this image has many private associations for the artist, it engages its audience by inviting viewer interpretation.

The circle, or orb, also emerged as a surrogate for the artist—eternal and self-contained. The "orb" paintings, which consist of thinly applied gesso on plywood panels, also refer to liturgical subjects Indiana discovered while working at the cathedral of St. John the Divine in 1958. *Starvosis*, a large, multipanel drawing in printer's ink on 44 connected sheets of paper, uses the ginkgo, circle, and sprouting avocado seed, among other biomorphic figures, in a crucifix-inspired image that suggests natural and spiritual regeneration (Figure 18). According to the artist, these explorations were designed to "invest [these universal symbols] with a new form."[13] The symbolism, as in the treatment of the ginkgo, embraced both cultural and personal readings, qualities that would become more intertwined in subsequent works.

The First Dream

The American Dream and its sister painting, *The Triumph of Tira*, mark the first dramatic expansion of the artist's personal/cultural lexicon. *The American Dream* was painted over a canvas originally titled *Agadir*, a reference to a catastrophic earthquake in the Moroccan town of that name in February 1960.[14] The shifting planes of brown and black in the background of the painting create an unstable tension, while the four white tondos provide balance. It is not clear why Indiana altered the picture (he states the reason of economy), but it seems that despite the severity of the geologic event, Agadir was too far removed from the painting's audience. It was during this time that Indiana narrowed the focus of his subjects to America. The tragedy of Agadir thus became the tragedy of the American Dream, a concept that tapped into both the pleasure and the pain of America in the 1960s. The phrase spoke to the emergent sense of a "national public culture" that began in the late 1920s and intensified during the prosperity of the postwar years.[15] Because of the rootlessness of his family and the discord within it, as well as his position as a gay man in a society that reviled homosexuality, Indiana was somewhat separate from mainstream culture; nevertheless, he shared the national touchstones formed by a mass-market economy and media. This split—that of

Figure 18

Robert Indiana with *Starvosis* (on left) and "orb" paintings in his Coenties Slip studio, circa 1959.

Photograph by Rusty Morris.

being an "American" and yet an "outsider"—fueled a preoccupation with America and its contradictions. Indiana says he cannot recall where he first heard the phrase (he postulates that it was from his parents), yet the critical view of the American Dream was reinforced by Edward Albee's 1960 play of the same name, which the artist saw shortly before he began *Agadir*'s transformation. Albee explained the nature of his play *The American Dream* in the preface to its 1961 edition:

> The play is an examination of the American Scene, an attack on the substitution of artificial for real values in this society, as condemnation of complacency, cruelty, emasculation and vacuity. It is a stand against the fiction that everything in this slipping land of ours is peachy-keen.[16]

The merging of Albee's cynical Dream with the classic myth of American prosperity and promise allowed Indiana to produce a work that is as disturbing as it is eye-catching. Indiana explained the significance of the painting's central imagery in a statement written for the Museum of Modern Art in 1961:

> The TILT of all those millions of Pin Ball Machines and Juke Boxes in all those hundreds of thousands of grubby bars and roadside cafes, alternate spiritual Homes of the American; and star-studded Take All, well-established American ethic in all realms—spiritual, economic, political, social, sexual and cultural. Full Stop.[17]

This reading supports the cynicism of Albee's characterization of the Dream, as well as the growing feeling that behind its prosperity, America was spiritually bankrupt.

The American Dream (Figure 19) can also be read through the subtext of figures and symbols that Indiana assembled to express personal and cultural sentiments. The numerals in the upper left circle signify the highways in Indiana that the artist and his family often traveled. Surrounded by "danger" stripes of yellow and black, *66*, the numbers most associated with the artist's father, Earl Clark,[18] are at the bottom of the circle, diagonally across from the yellow *R* and red *I* of the artist's new initials, which appear at the top of the lower right circle. The figure/ground colors of the star, circle, and diamond at the center of the lower right circle (black, brown, black) are reversed in the upper left (brown, black, brown), and the words *the American dream* are multicolored, with *American* placed at the top. These two circular surrogates for the artist and his father are put on opposite poles, as are the words *tilt* (failure) and *take all* (success).[19] In her essay in this catalogue, Susan Elizabeth Ryan points out the cross shape that occupies the empty space between the four stars in *The American Dream*. Read as an X (the negative form of the cross), the painting functions as a Christian allegory: the Father (Earl Clark, upper left), the Son (the artist, lower right), and the Holy Spirit (the "spiritual" values the son learns from the father; upper right, lower left). This configuration combines the Dream with cultural (Judeo-Christian) and personal disillusionment.

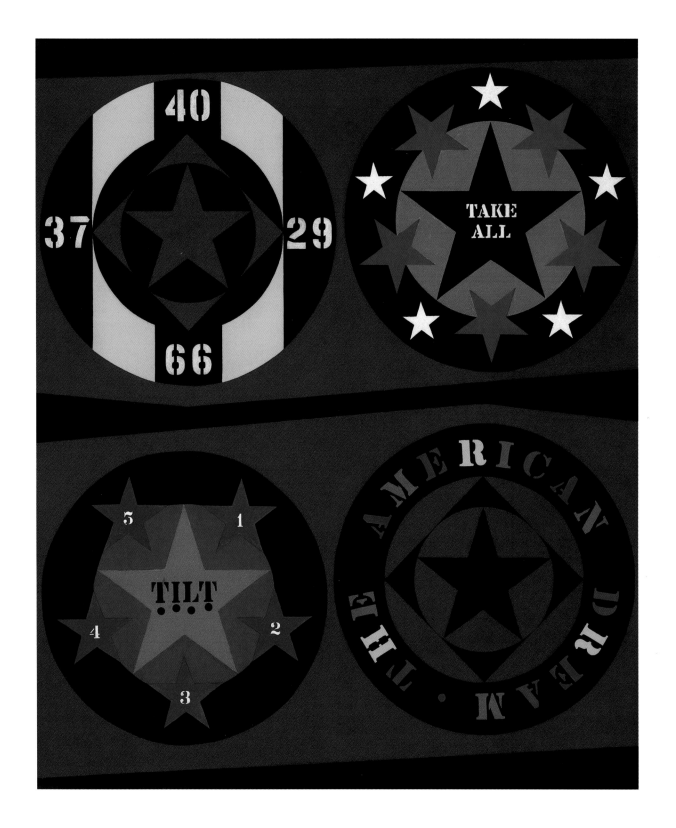

Figure 19

The American Dream I, 1961,

oil on canvas, 72 x 60 $\frac{1}{8}$ inches.

The Museum of Modern Art, New York.

Larry Aldrich Foundation Fund.

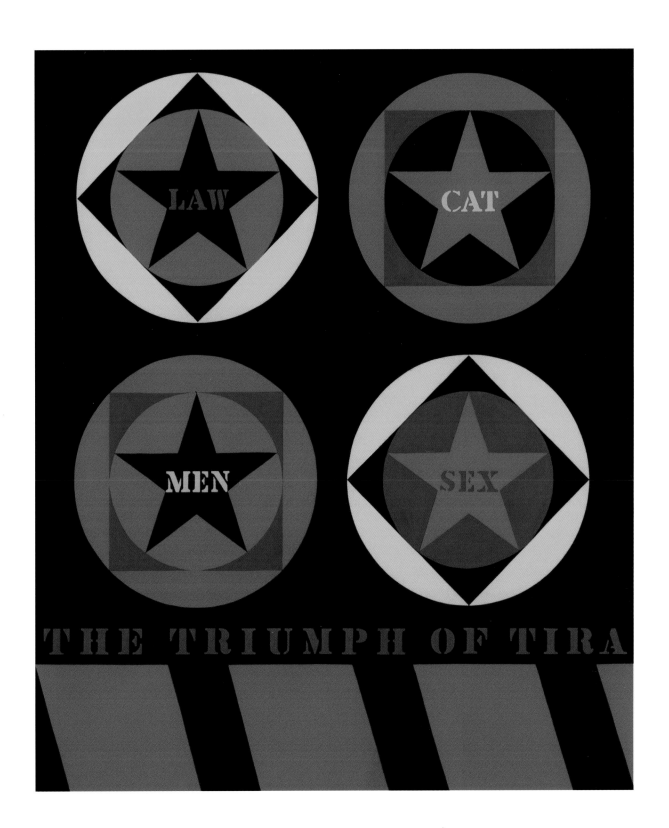

Figure 20

The Triumph of Tira, 1960–61,
oil on canvas, 72 x 60 inches.
Sheldon Memorial Art Gallery
and Sculpture Garden,
University of Nebraska-Lincoln.
Nebraska Art Association Collection,
Nelle Cochrane Woods Memorial,
1964.N-174.

The Triumph of Tira (Figure 20) shares the same format and is another view of the subject of *The American Dream*. It draws on the iconography of the American cinema, which would have been instantly legible to most viewers. The title refers directly to the 1933 Mae West movie *I'm No Angel*, which the artist recalls, "impressed me when I was a child."[20] Tira, played by West, is a small-town lion tamer who is wrongly sought for an attack on a male admirer. After she escapes from the police, she finds fame and fortune in a large New York show (where she puts her head in the lion's mouth). She eventually outwits the authorities and wins the man of her dreams. This is a female version of the American Dream and is a direct corollary to the artist's life. Like the heroine, he escaped midwestern America to a larger city, put his head in the "lion's mouth" of the art world, and emerged victorious. If interpreted as a companion to *The American Dream*, *The Triumph of Tira* can also be read as referring to the artist's mother, Carmen, whom he has described as "warm," stating that she "loved people and simply had a kind of zest and an appetite for life."[21] His feelings for her can be seen here in the black and red. These colors in Indiana's work indicate "intense and emotional subjects"; red in particular the artist considers "Carmen's color."[22] Although the brightness of the colors might appear celebratory, red, yellow, and black, as well as the angled stripes, are also "danger" signals in the artist's vocabulary, indicating the unhappiness that befell Carmen Clark, who died of cancer in 1949. *The American Dream* and *The Triumph of Tira* represented the artist's most complex symbolism to date, merging aspects of the personal and cultural Dream.

In 1962 Indiana continued the series with *The Black Diamond American Dream #2* and *The Red Diamond American Dream #3*. He also made a series of *eat/die* works, including two diptychs, one of which is *The Green Diamond Eat The Red Diamond Die* (Figure 21). *Eat* draws from the artist's lexicon of negative metaphors that refer to the American Dream, which are articulated in a statement he made in 1964: "It is pretty hard to *swallow* the whole thing about the American Dream. It started from the day the Pilgrims landed, the dream, the idea that *Americans have more to eat* than anyone else. *But I remember going to bed without enough to eat*" (my emphasis).[23] Again, in this statement, Indiana blends personal and historical information within a cultural judgment. The segment of the painting's audience who had lived through the depression, as the artist had, would naturally have found similar significance in the pairing of *eat* and *die*. *Eat/die* also refers to the artist's parents: His mother's last words to her son had been, "Did you have anything to eat?" and much later, his father died while eating breakfast.[24] These paintings also resemble the signs advertising the diners where his mother worked after his father left the family. The diamond shape and scale of *The Green Diamond Eat The Red Diamond Die* relate these paintings to the *Dream* series. As a pair, they speak to the contradictory concepts contained in the Dream: plenty and death, and conversely, hunger and salvation. *Eat/die* also clearly signals the emergence of dichotomies that become constants in Indiana's life and work.

During the early 1960s the artist was increasingly torn between turning inward, toward his personal history, and turning outward, toward his environment. Although *The American Dream* and *The Green Diamond Eat Red Diamond Die* formally reflect his growing awareness of the increasing numbers of

American signs and a sense of "road culture", they only tangentially addressed the artist's deep involvement with the sociopolitical culture of America as it was emerging in the 1960s. Indiana's concerns also extended well beyond the scope of his own small part in the world, and he addressed the way the American Dream was played out in the political and social history of the country.

American Politics

Indiana's self-designated role as an "American painter of signs"[25] clearly indicated that he considered his work to have messages for American viewers. From his appearance on the art scene, sociopolitical commentary was seen as integral to Indiana's work. At first submerged and personal, Indiana's engagement with politics would become more overt.

Indiana's earliest mature works in New York were sculptural—found-object assemblages that included wooden beams, wheels, and ornaments scavenged from demolition sites. These sculptures are conglomerates of metal and wood with evocative titles: *Sun and Moon*, *Zenith*, *Wall of China*, and *Jeanne d'Arc*. The artist's first freestanding sculpture, *French Atomic Bomb* (Figure 22), was an early work that drew directly on source material from the daily news and referred to the explosion of a plutonium bomb in 1960 by the French government.[26] He soon began to stencil words onto his sculpture, beginning with monochromatic, news-inspired works like *Cuba* (referring to the tension between the U.S. and Soviet-supported Cuba; Figure 23), and *U-2* (citing the downing of a U.S. plane by the Soviet Union).[27] While these works deal with hot political topics, the simplicity of the colors and forms is dispassionate, and they appear to express no overt opinion. However, the fact that Indiana had already defined himself as "American," coupled with the knowledge of the presumed American audience for the works, implies a negative bias on the part of the artist.

The American Reaping Company (Figure 24) taps into the artist's sense of history and his growing involvement with the communication of signs. His interest in signs was sparked by his finding commercial shipping stencils in his loft on Coenties Slip; the work itself, however, points to larger cultural issues. The artist's personal connection with the subject is a festive ball he organized while a student at the School of the Art Institute of Chicago in the abandoned mansion of Cyrus McCormick, the inventor of the reaping machine. The jagged edge at the top of the painting is reminiscent of the cutting action of the reaping machine and is juxtaposed to the hexagon, an elemental and particularly natural form.[28] *Reap* is also synonymous with death (symbolized by black triangles bisecting a white hexagon) and brings to mind the adage "For whatsoever a man soweth, that shall he also reap." The designation of this industry as "American" points to an alternative historical reading of the human cost of doing business.

In 1961 Indiana embarked on a series of paintings based on great works of American literature. *The Calumet* (Figure 25) juxtaposes bright yellow circles and red stars against orange (yellow + red) lettering and background. The central circle, pairing *the calumet* (a Native American peace pipe) with *pukwana*

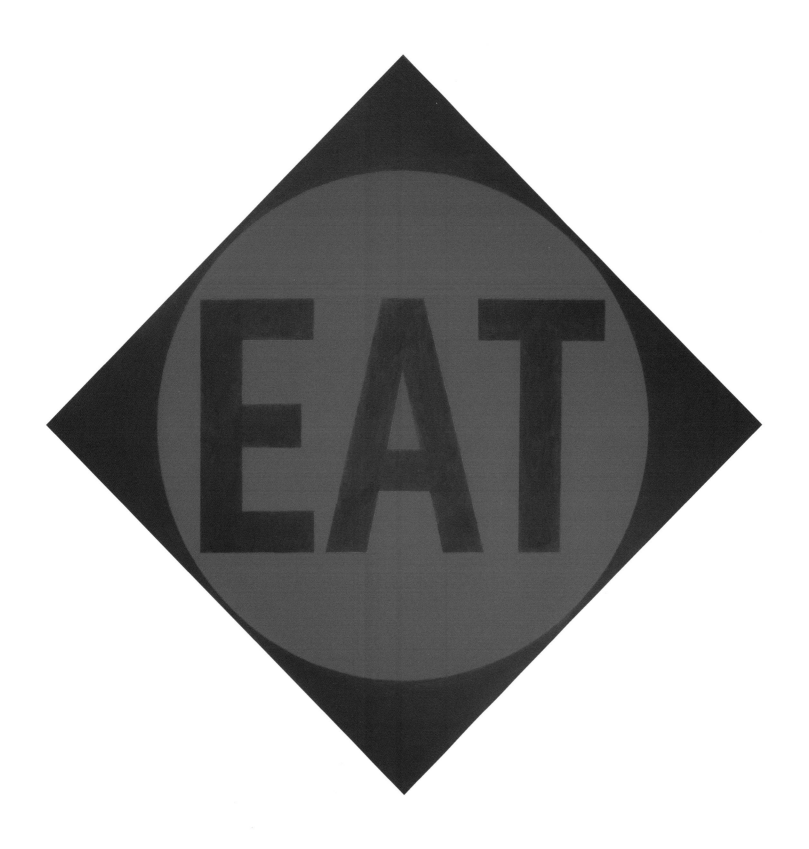

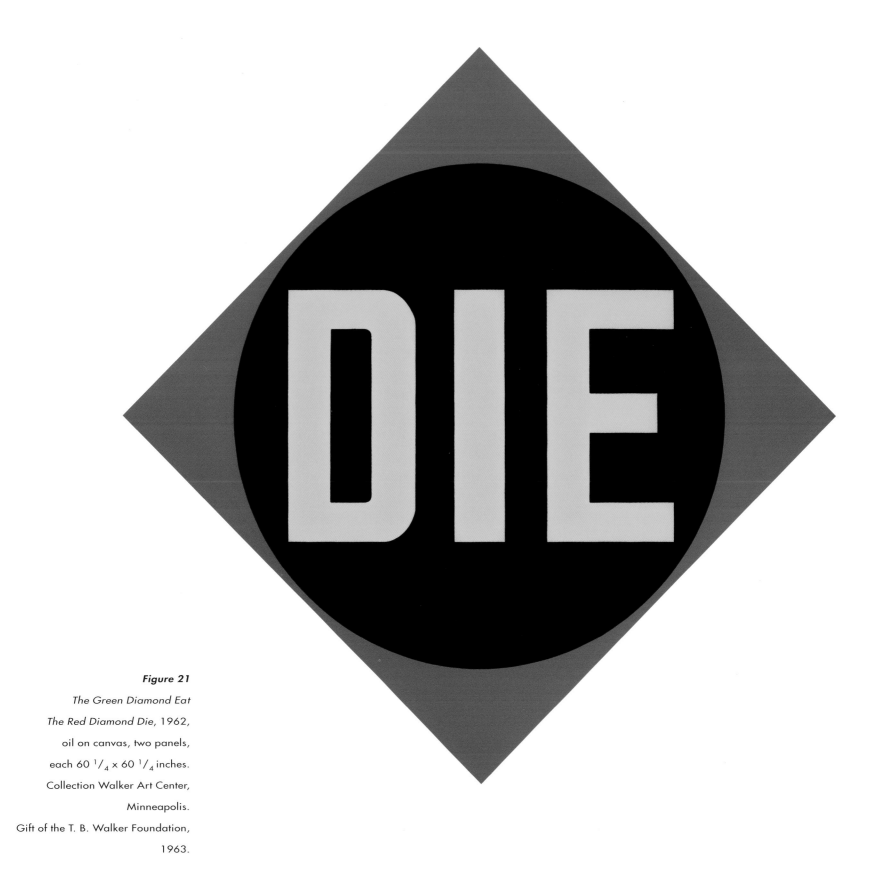

Figure 21

The Green Diamond Eat

The Red Diamond Die, 1962,

oil on canvas, two panels,

each 60 $^1/_4$ x 60 $^1/_4$ inches.

Collection Walker Art Center,

Minneapolis.

Gift of the T. B. Walker Foundation,

1963.

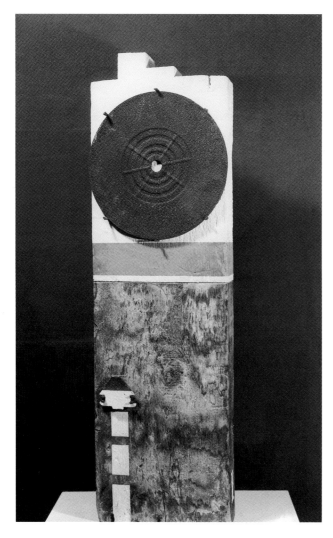

(peace), refers to the significance of the peace pipe and its role in uniting people of divergent groups. The six surrounding circles bear the names of Native American tribes, while the outer circle quotes Henry Wadsworth Longfellow's poem *Hiawatha*: "On the mountains of the prairie Gitche Manito the mighty called tribes of men together." While the source of this painting is literary, its content and forms address the relationship between the founders of the United States and Native American peoples. The placement of red (as in "red man") stars against a pervasive orange background encircled by yellow boundaries is a formal device that signifies historical events. The Native American tribe names, as well as their conception of *pukwana*, are contained and pushed to the margins of the circle by the stars, which Indiana sees as particularly "American" symbols. Stars may also be read as symbols of people, in that they have five appendages—two arms, two legs, and a head. The circle is eternal, a completely closed figure that represents continuity, yet it may also represent boundaries controlling the path of history. Although the source of *The Calumet* is literary, the painting also has political overtones.

Later in his career, Indiana took a more definitive stand on topics that had a direct bearing on the connection between social morality and political action in the contemporary United States. The most aggressive of these paintings form the *Confederacy* series, painted in 1965 at the height of the debate over civil rights in the American South. These four paintings, *Mississippi*, *Alabama* (Figure 26), *Louisiana*, and *Florida*, are damning in tone. A map of each state is decorated with a cross of stars, reminiscent of the Confederate flag. The center of the cross rests on a site of particular violence in the civil rights conflict. In two circles around each state, the artist has stenciled *just as in the anatomy of man every nation/must have its hind part*. This phrase was written by the artist himself; thus, there are no filters between the message and its meaning.

A Divorced Man Has Never Been the President (Figure 27) represents the artist's early interest in the contradictions between social values and American politics. The work has been read as a thinly veiled commentary on the political position of Nelson Rockefeller (the governor of New York and a moderate

Figure 22

French Atomic Bomb, 1959–60, polychromed wood beam and metal, 38 $^5/_8$ x 11 $^5/_8$ x 4 $^7/_8$ inches. The Museum of Modern Art, New York. Gift of Arne Ekstrom.

Republican who was favored for the presidential nomination before his 1961 divorce)[29] and a recrimination against the contradictory relationship between national morals as they are practiced in everyday life and as they are perceived in the political arena. The phrase *a divorced man has never been* appears in a white circle around a blue star (both a human and a national symbol) ringed with individual green circles bearing the letters *US*. *US* can be read as both "United States" and "us," which may signify collective judgment. This configuration signals a barrier—the unwillingness of the American public (the green circles) to accept a political leader (the blue star) who has been divorced. During the 1960s divorce became increasingly common, and Indiana's juxtaposition of white lettering (a color associated with purity) for *the president* with red lettering (indicating evil or, in Christian imagery, moral judgment)

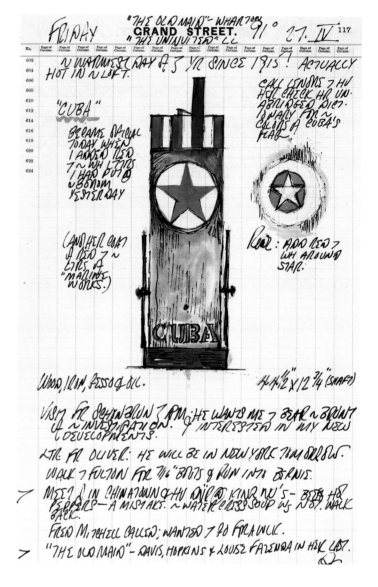

for *a divorced man has never been*, points to the hypocrisy of an increasingly permissive society that would place such a restriction on its leadership. The palette of the painting is patriotic (red, white, and blue) with the exception of the green circles; green indicates envy and thus sin, an indictment of the conservative political mores that would judge a man on his personal history rather than on his professional abilities.

Much later in his career, Indiana used a similar palette for a different purpose in *An Honest Man Has Been President: A Portrait of Jimmy Carter* (1980; Figure 28), produced as part of a portfolio in support of Carter's unsuccessful bid for a second presidential term. Here, the green field is juxtaposed to a blue-and-white star superimposed on the numeral *1*. During the 1970s, the *1* emerged for Indiana as a self-portrait, and here it signifies the artist's backing of Carter. The arrows circling the *star/1* point to continuity, and the notations *Plains, Rosalynn, Georgian,* and *76* to Carter's personal background. This composition liberally quotes from *A Divorced Man Has Never Been the President* in a hopeful manner. Although the unveiling of the portfolio at the White House was a subdued occasion (Carter had already been defeated),[30] this work indicates the depth of Indiana's engagement in the American political system.

Figure 23

Journal entry for April 27, 1962;
drawing of *Cuba*,
ink and watercolor on paper.
Collection of the artist.

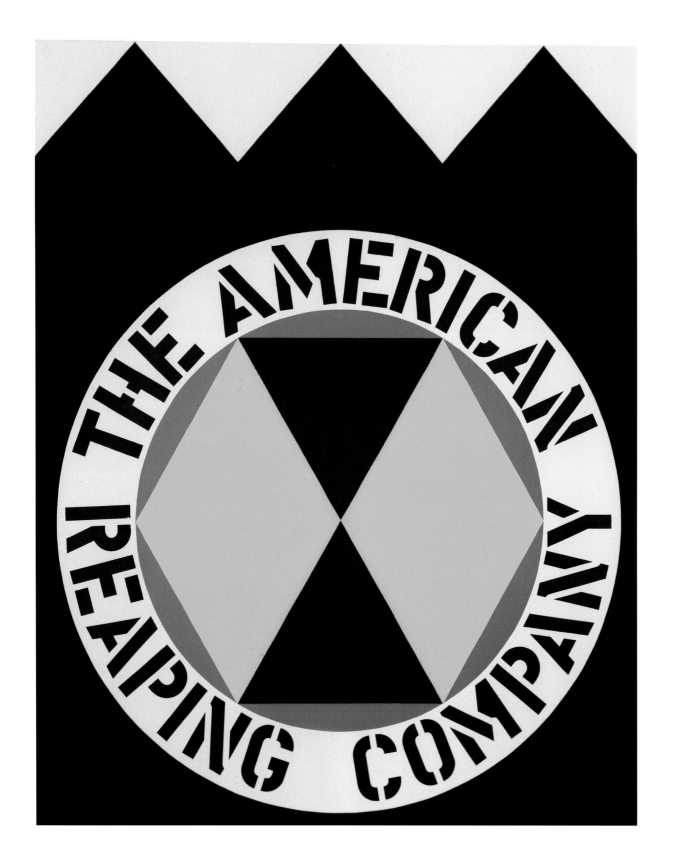

Figure 24

The American Reaping Company, 1961,

oil on canvas,

60 x 48 inches.

Herbert Lust Gallery.

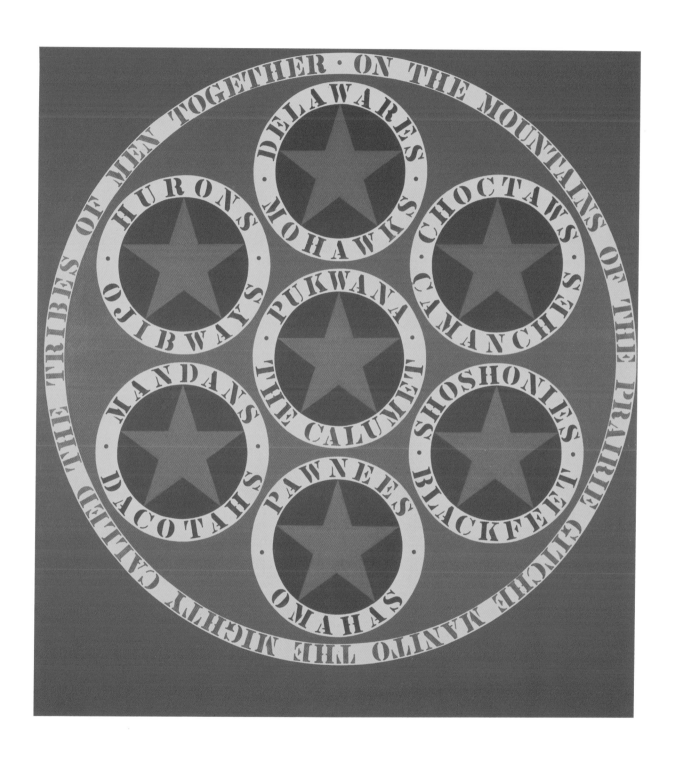

Figure 25

The Calumet, 1961,

oil on canvas, 90 x 84 inches.

Rose Art Museum,

Brandeis University,

Waltham, Massachusetts.

Gevirtz-Mnuchin Purchase Fund,

1962.

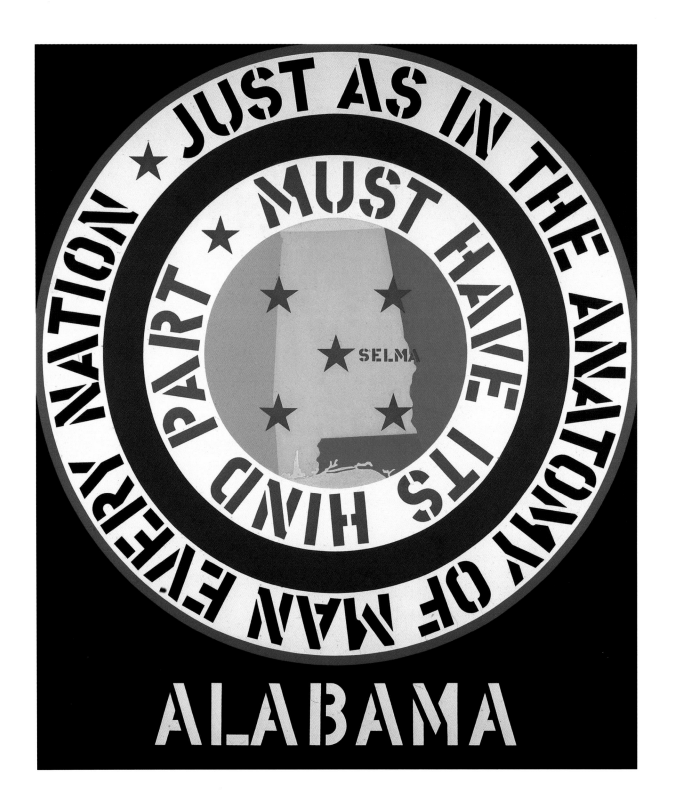

Figure 26

Alabama, 1965,

oil on canvas,

70 x 60 inches.

Miami University Art Museum,

Oxford, Ohio.

Gift of Walter and Dawn Clark Netsch,

1982.185.

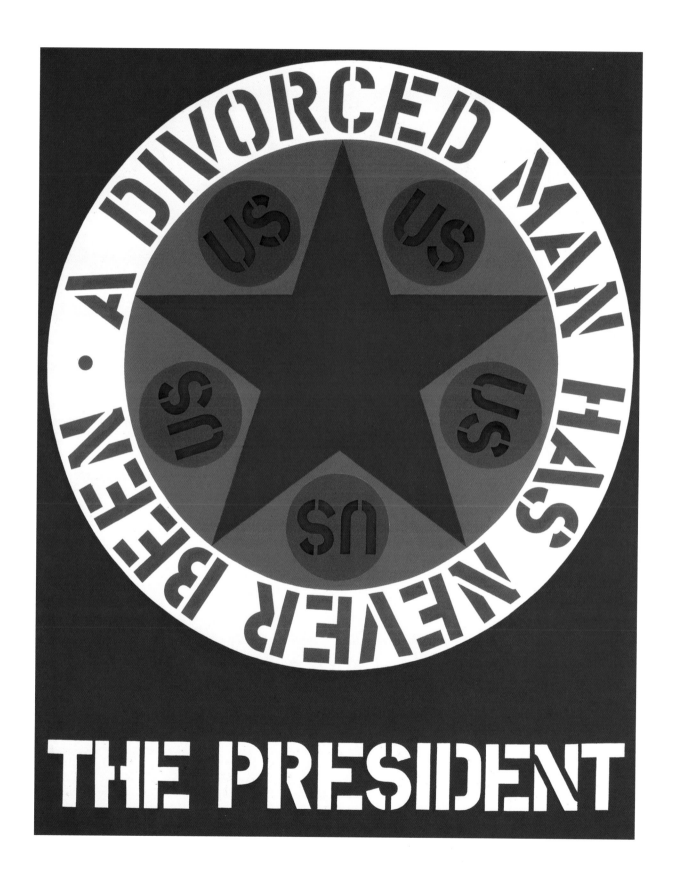

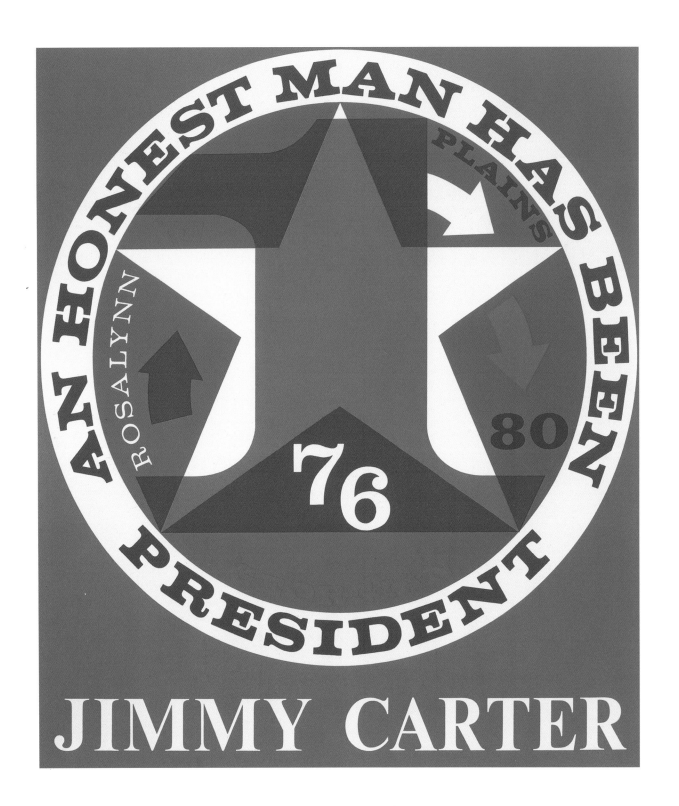

Figure 28

An Honest Man Has Been President:
A Portrait of Jimmy Carter, 1980,
silkscreen on paper, 23 $^1/_2$ x 19 $^9/_{16}$ inches.
Collection of the artist.

A Portrait of Jimmy Carter was not Indiana's first celebration of an American political figure. In the early 1960s he painted *Election* (Figure 29), which commemorates the election of John F. Kennedy as president in 1960. Besides the artist's enthusiasm for Kennedy's political platform, there were other, cultural, reasons for this celebration. The young, handsome, telegenic Kennedy was the first presidential candidate to use the medium of television effectively as a campaigning tool, a technique that has had a wide-ranging impact on American politics. Although the palette of *Election* may appear relatively somber, the brown and black stripes and legend highlight the brilliance of the primary colors of red and blue. The divided black-and-white circles in the lower half of the painting refer to the spinning wheels of the computers that counted the votes, mesmerizing the nation as viewers watched them on television.[31] *Election* was damaged when Indiana's sculpture *Zeus* fell and ripped the canvas in the lower right quadrant.[32] The painting was cut down, and the revised version, now called *Electi*, assumed a tragic tone after Kennedy was assassinated in 1963. Thereafter, the removal of the fourth section became analogous to the truncation of Kennedy's fourth year in office.

Throughout his career, Indiana often overtly supported causes he believed in, through public endorsement[33] or financial donation in the form of works of art. The first instance of this was his response to a plea from the British peace activist Bertram Russell for contributions to his antinuclear program in 1963. This event triggered the painting (and gift) of *Yield Brother* (see Figure 30), a composition that merged the Yield road sign with the symbol for peace. The painting was not purchased during the benefit auction in England, however, and was returned to the United States. As the artist noted: "Perhaps there has been too much yielding for the British; for Stand-Firm-America there is more need. That the countryside is peppered with 'Yield' signs hasn't affected the national conscience much."[34] Indiana reworked this theme in two large paintings also finished in 1963, *Yield Brother II* and *Yield Brother #3* (which he donated to the Congress on Racial Equality). Both these works are diamond-shaped and omit the peace sign, substituting a vertical line that bisects each of the four circles. The circles are ringed with stenciled letters, which entreat each member of the "typical" nuclear family (*mother, father, brother, sister*) to "yield."

This format demands a more pointed reading. The diamond shape of *Yield Brother II* (Figure 31) places *mother, father, brother,* and *sister* at opposite poles, and the way the letters are stenciled allows only one of the four to be read right side up. This causes the other "family members" to "yield"—in other words, to adjust their position in relation to the dominant figure. Read in this way, the painting represents a struggle for control. The traditional placement of the painting puts *brother* at the bottom, which corresponds to the title of the painting, but the green circle that encases the central portion functions as a wheel that can turn, subverting this orientation. Beginning in 1963, and continuing to the present, Indiana has produced smaller paintings on this theme, all of which use the legend *yield brother* in a circle (Figure 32). Many of these are personalized gifts bearing the first name of the person for whom the painting was intended. Herbert Lust, a collector and historian of Indiana's work, has suggested that the use of the word *yield* is sexual in nature.[35] Michael Plante has pointed to Constantin Brancusi's sculpture *Torso of a Young Man*

Figure 29

Electi, 1960–61,

oil on canvas,

71 $^1/_2$ × 44 $^{13}/_{16}$ inches.

Portland Museum of Art, Maine.

Gift of the artist,

1997.5.

(circa 1916), which Indiana drew in his note-book, as an early homoerotic source for the Y shape that first appeared in Indiana's *Melville Triptych* in 1962.[36] The word *yield* is also commonly used to describe sexual activity, as in yielding to one's or another's desires. While sexual ideas are present in Indiana's art, such a reading in this case is difficult to affirm. It appears, however, that the personalized paintings were made as private communications between the artist and the recipient.

While all of Indiana's political works contain a strong (if sometimes veiled) point of view, the case of the *Yield Brother* paintings demonstrates that they are also a continuing exercise in establishing a way for the artist to speak to his experiences, both public and private.

The Fourth and Fifth Dreams

Many of Indiana's political works express negative sentiments, yet they also hold out the possibility for constructive change. The forthright expression of rage in works like the *Confederacy* series directs attention to problems in America, but with an eye toward reform. While the early to mid-1960s were a time of social and political criticism for Indiana, they were also a time of tempering jaded sentiments with hope. The first three paintings in the *American Dream* series (painted between 1960 and 1962) were over-whelmingly cynical. According to the artist, the fourth painting in this series, *The Beware—Danger American Dream No. Four*, is the last "negative" Dream (Figure 33). The art historian Susan Elizabeth Ryan has noted that the appearance of the number *4* in Indiana's work signals "the American Dream number, but also an unlucky one." This sense of the Dream relates to the four arms of the cross (spiritual wholeness) and/or the nuclear family (mother, father, sister, brother), while the "danger" is attributed to superstition.[37] Indiana also gave another cautionary aspect to the number *4* in an explanatory statement written to the Hirshhorn Museum and Sculpture Garden concerning *The Beware—Danger American Dream No. Four*. "The 'Beware Danger' designation comes from the very nature of the number '4' itself, which in the scale of man's life from one to ten, indicates adolescence."[38] The first appearance of the number *4* in a painting by Indiana is in *Polygon: Square* (Figure 34), part of a series of number/shape portraits (3 to 12) he painted in 1962. In this painting, the artist stenciled *quare/quadrangel* in a circle around a diamond, all encased in a square—the circle indicates infinity and sexuality (the Jungian reading of the circle), which merges with *quare*, a homonym for "queer" and also "square" missing an "s." This lack of a letter destabilizes the wholeness of the word and thus emphasizes the precariousness of the shape. The polygons are

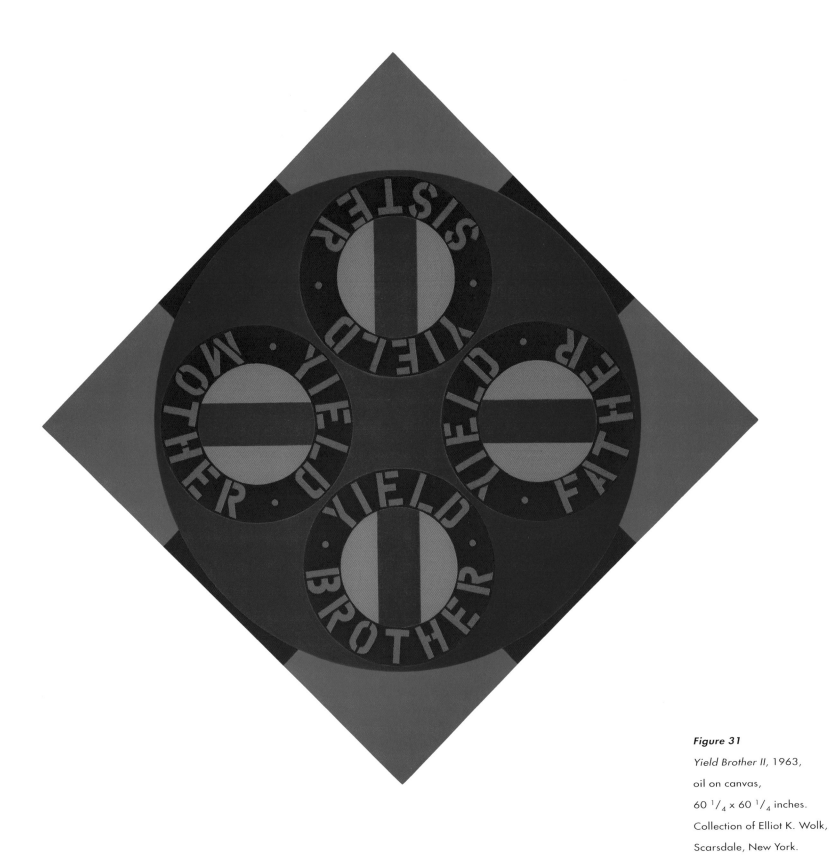

Figure 31

Yield Brother II, 1963,

oil on canvas,

60 $\frac{1}{4}$ x 60 $\frac{1}{4}$ inches.

Collection of Elliot K. Wolk,

Scarsdale, New York.

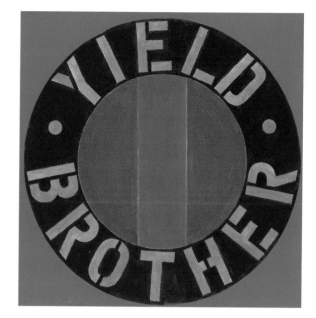

portraits of numbers that also refer to the stages of life, as the artist indicated in his statement to the Hirshhorn. As an adolescent, *4* is made volatile by awakening sexuality, especially by the recognition of its own "quare"ness. The number *4* itself—a stiff, upright figure—undergoes a transformation in subsequent works, including *The Beware—Danger American Dream No. Four.*

The Beware—Danger American Dream No. Four is not as cynical as it is cautionary. The title itself and the vibrant yellow and red letters against the black background serve as a warning. Four circles mark the corners of the diamond, three of the four divided into red and yellow sections whose junctures are marked by black stars. *Eat* is at the top, missing its companion *die*. In this form, *eat* cautions against consumption, rather than representing the cycle of inevitability that its pairing with *die* traditionally evokes. To the sides are *jack/juke* and *tilt/jilt*, similar pairs of words taken from the artist's evolving lexicon of signs from small-town, roadside culture. The painting's title, as in the second and third paintings in the *American Dream* series, is at the bottom, yet the placement of the letters signals a difference. In the first three paintings of the series (see Figure 19), *American* is centered at the top of the circle, serving as the visual weight. In *The Beware—Danger American Dream No. Four*, *dream* grounds the circle at its bottom and is thus the most noticeable part of the phrase. While this painting, like all of the *American Dream* series, is directed to American society at large, its appeal is to the individual; it is not an indictment of the culture.

Indiana's attitude toward the American Dream underwent subtle changes in 1963. In an interview with the critic Gene Swenson in *Art News*, Indiana went so far as to label the Dream "optimistic, generous, and naive."[39] He also began to see his work as "celebratory." Robert L. B. Tobin has described this change in Indiana's attitude as "the confidence of the 'Arrived.' Arrived but still seeking."[40] The year 1963 was certainly auspicious for Indiana, for the critical evaluation of his work was at its peak. His inclusion in major shows such as *Americans 1963* at the Museum of Modern Art earned him a distinct place in the New York art world of the 1960s and heralded the expansion of his audience to Europe. The change is immediately evident in the artist's "Autochronology," which designates 1963 as "the year of the Pop explosion that catches up [Indiana's] work and plants it over widespread areas of the globe."[41]

Figure 32

Yield Brother, 1964, oil on canvas, 24 x 24 inches. Herbert Lust Gallery.

The Demuth American Dream No. 5 (Figure 35) and its four companion pieces, also painted in 1963, including *The Figure Five* and *The X-5*, record the influence on Indiana of Charles Demuth. These paintings rework Demuth's *I Saw the Figure Five in Gold* (1928), Indiana's "favorite American painting in New York City's Metropolitan Museum."[42] The details that link this painting with Indiana's own experience have

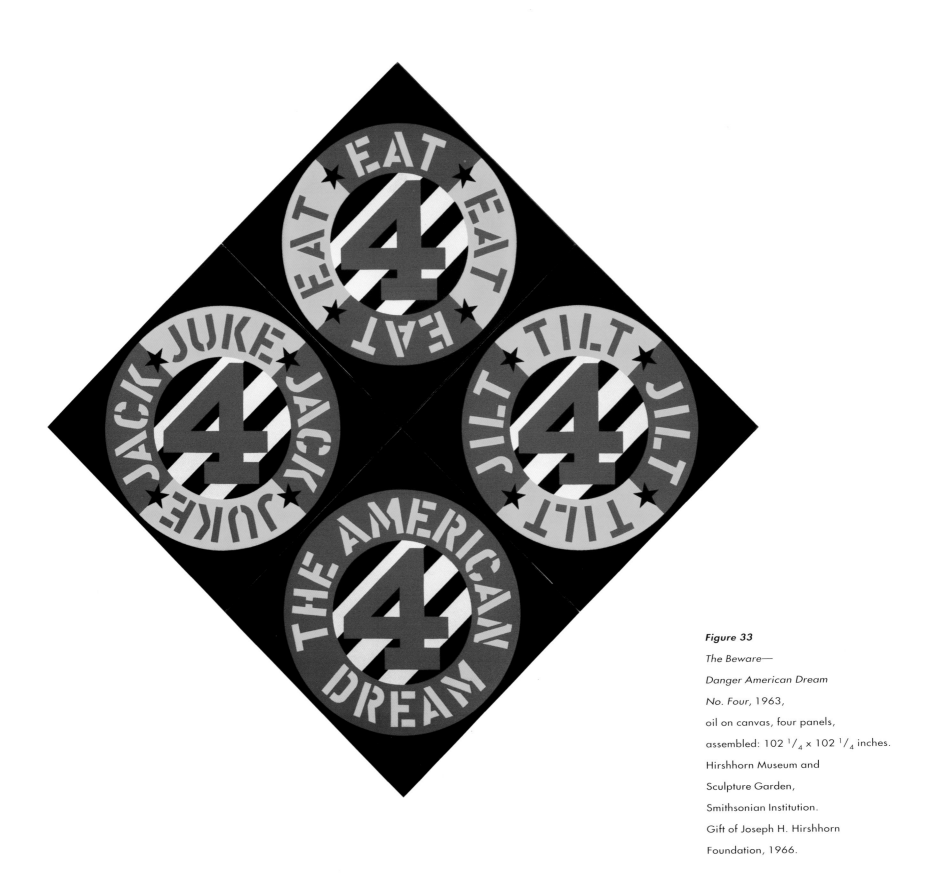

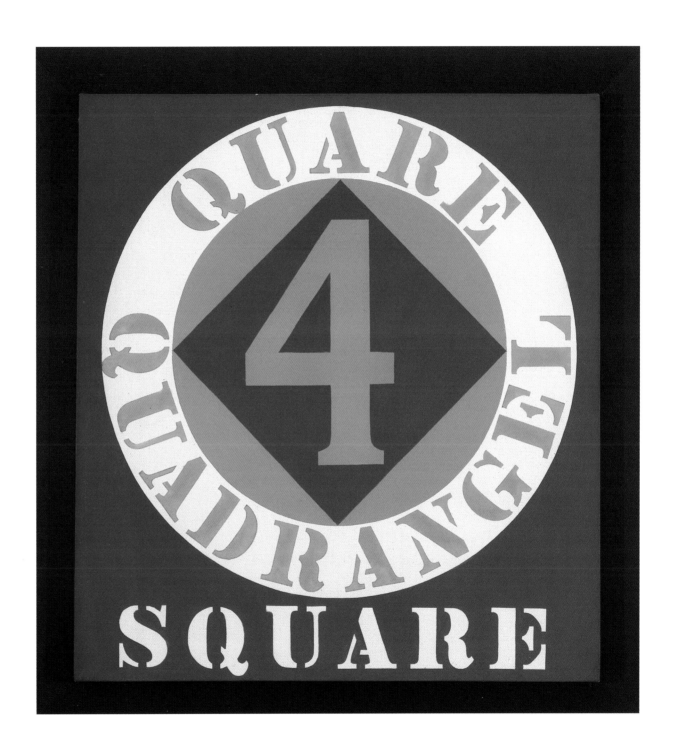

Figure 34

Polygon: Square, 1962,

oil on canvas,

24 x 24 inches.

Herbert Lust Gallery.

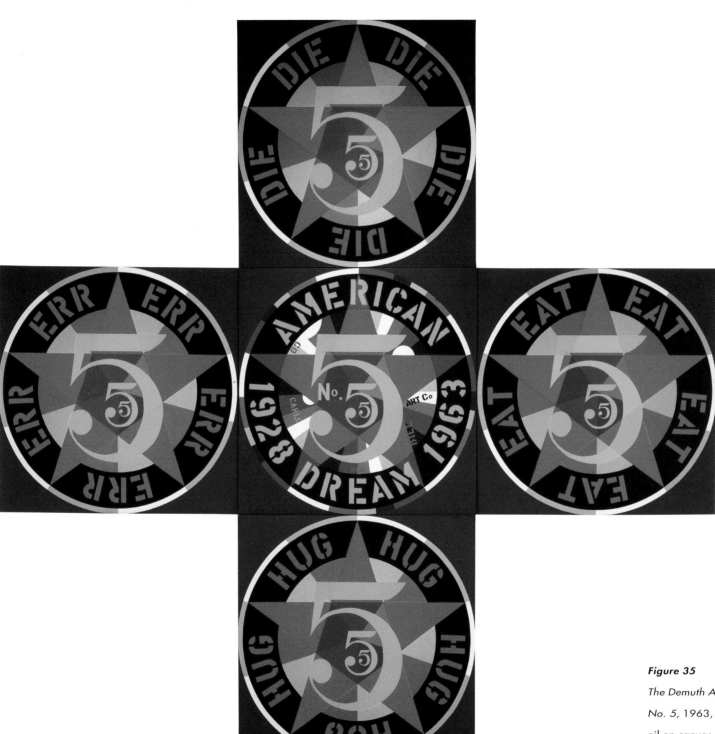

Figure 35

*The Demuth American Dream
No. 5*, 1963,
oil on canvas, five panels,
assembled: 144 x 144 inches.
Art Gallery of Ontario, Toronto.
Gift from the Women's
Committee Fund, 1964.

been well documented.[43] The color scheme and some of the forms of Indiana's painting duplicate those of Demuth's, yet the reworking includes elements that affect its reading as a Dream. This painting marks the first appearance of the words *hug* and *err*, joining *eat* and *die* as part of the lexicon of the American Dream. They add a more benign tone to the idea of the Dream. *Err*, which implies human fault, is more forgiving than *tilt*, which signals failure, or cheating. *Hug* adds a sense of human connection and prefigures the appearance of *love*. The crucifix shape of the painting also refers to the human body (with a head, legs, and arms), while inserting religious (and sacrificial) overtones. The disappearance of *the* from the legend bearing the title indicates that this is no longer the only Dream, but a particular Dream—one that specifically applies to the artistic kinship Indiana felt for Demuth. This is Indiana's first complete reworking of his own Dream in his art. Tobin's characterization of Indiana as "Arrived but still seeking" would become increasingly appropriate throughout the artist's work of the next three decades.

Reworking Oneself/Reworking the Dream

In 1963 Indiana began a double portrait of his parents, Earl and Carmen Clark (Figure 36), calling this painting "part and parcel of my American Dream."[44] The omission of *the* and insertion of *my* in this statement marks these works as the beginning of the artist's attempt to investigate and rework his own Dream rather than examine or critique the American Dream. *Mother* and *Father* (Figure 37) were not finished until 1967, although they were exhibited in 1964. The sole change in these paintings was the addition of the legends *a mother is a mother* and *a father is a father*, phrasing that recalls the writings of the American expatriate Gertrude Stein ("Rose is a rose is a rose"), who was an early hero of Indiana's, and reinforces a sense of inevitability. These works are notable both for their use of figural realism and for their overt personal content. The artist calls these paintings "a single work, a diptych in homage, and respect too, to two people conspicuously crucial to my life"—although he also notes that his parents "were immensely unimportant in their world."[45] In this work, Indiana is finally able to put his parents, and their version of the American Dream, into perspective. Earl and Carmen Clark are pictured standing in the Indiana countryside next to their prized possession, a Model-T Ford, a symbol for the restlessness of their lives. In these paintings, Indiana displays his affection for his mother (vibrant and young in her bright red cloak) and alienation from his father (painted in ghostlike gray), as well as their relationship to him—the *27* on the license plate in *Mother* represents the year of the artist's conception, and the *64* on the plate in *Father*, the year he reconciled himself with the memory of his parents and their version of the American Dream. This would be the final appearance of Earl and Carmen Clark in a painting by Robert Indiana, who declared the portraits finished in 1967, the year after completing *The Sixth American Dream*, which is

Figure 36

Earl and Carmen Clark, 1920s.

designated as his father's Dream. *Mother* and *Father* are a tribute to and an exorcism of his parents' influence, leaving Indiana the freedom to come to terms with his own place in the world.

Although Robert Clark adopted the name "Indiana" in 1958, his completion of *Mother* and *Father* finalized the transformation. Indiana's next major canvas, *The Metamorphosis of Norma Jean Mortenson* (Figure 38), reexamines the idea of personal reconstruction through the tragic example of Marilyn Monroe. In contrast to Indiana's, Monroe's transformation came from outside sources: her new name was chosen by studio executives, and her Hollywood persona was determined by the audience's interpretation of her screen roles. There are, however, similarities between the artist and the actress: both came from broken homes, both were interested in the significance of numbers (Monroe believed in numerology), and both sought new lives and identities and achieved them through high-profile careers. According to preliminary sketches, the original title of this work was *The American Woman* (the word *an* was converted to *the* early on; Figure 39). The overall composition of the painting was left basically unaltered from Indiana's original idea, yet the change refocuses the painting on Monroe herself rather than on what she meant as an American cultural icon.[46] The palette of this painting is unusual for Indiana—thin coats of pastel color replace his usual bold hues, and the work is painted on unsized linen so that the "skin" of the surface is visible—a response to both the cosmetic colors of Monroe the star and her underlying fragility as a human being. This, of course, is also in dramatic contrast to Andy Warhol's paintings of Monroe from the early sixties, which feature the garish colors of her public persona. During her lifetime, Monroe epitomized the American Dream, yet she was often criticized by her peers for what they saw as her lack of range, talent, and professionalism.

During the time he was painting *The Metamorphosis of Norma Jean Mortenson*, Indiana's work was falling out of favor in New York. Critical response to the *Love* paintings, first shown at the Stable Gallery in 1966, was never strong, and this reaction turned to vehemence as the image became popular with a mass audience. This critical rejection of his work during the late 1960s spurred him to reexamine his past, a process he began by reproducing his significant paintings from the 1960s in the *Decade* portfolio, published in 1971. This exercise would lead him to a series of paintings, the *Autoportraits*, through which he would review this important time in his life and career.

Between 1971 and 1977 Indiana completed three sets of ten paintings in the *Decade Autoportrait* series. Like the *Polygons* (1962) and *Cardinal Numbers* (1968), these paintings were meant to be shown as a

Figure 39

Preliminary drawing for

The Metamorphosis of Norma

Jean Mortenson, circa 1967.

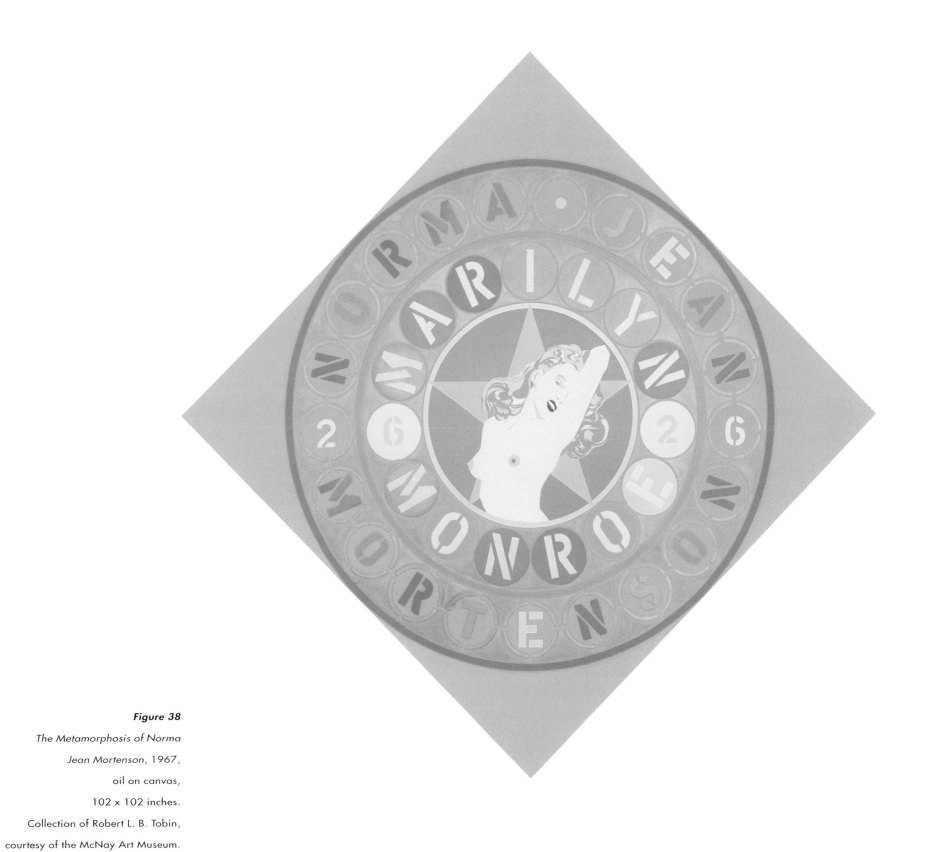

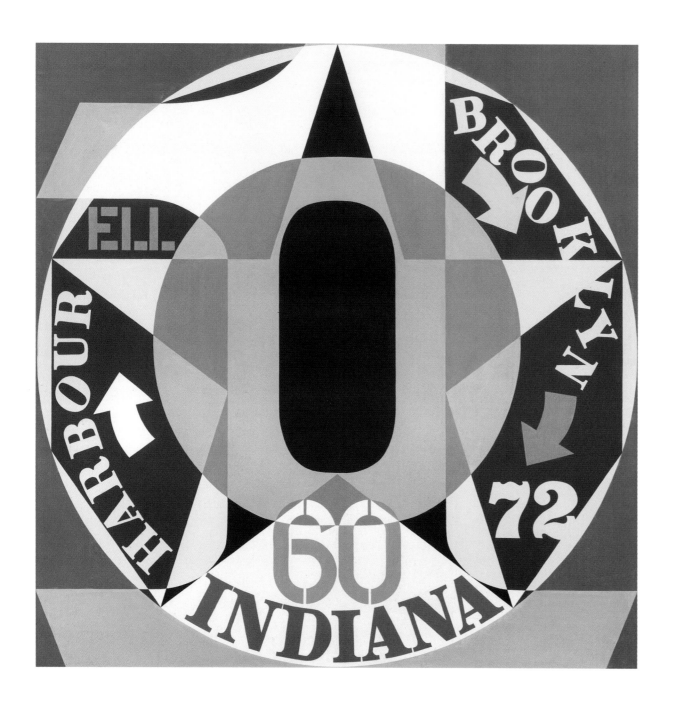

Figure 40

Decade Autoportrait 1960, 1977,

oil on canvas,

72 x 72 inches.

Private collection,

courtesy Simon Salama-Caro.

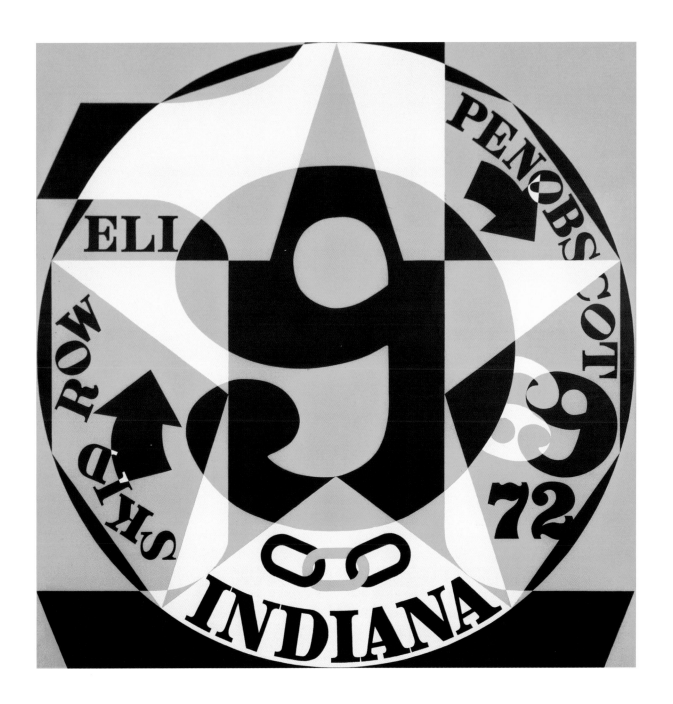

Figure 41

Decade Autoportrait 1969, 1977,

oil on canvas,

72 x 72 inches.

Collection of the artist.

series, although they stand on their own as definitive statements. In the *Autoportrait* series Indiana addresses his recent past—specifically, the years 1960 through 1969—the years of his growing fame. The *Decade Autoportrait* paintings record the status of Indiana's Dream—his search for belonging and renown as an artist. All of these paintings are square (24 x 24, 48 x 48, or 72 x 72), and on each a circle encases a decagon (the ten sides representing ten years) upon which is superimposed a star and the numeral *1* (a surrogate for the artist). The figures contained in each painting relate to significant events, places, and people that the artist encountered during the year represented by the painting. The colors also speak to the artist's experiences. *Decade Autoportrait 1960* (Figure 40), a chronicle of the year just before Indiana entered the New York art scene, is monochromatic, with the star (which can here be read as a sign for fame) barely visible. Also included is *Ell*, commemorating his friendship with Ellsworth Kelly, as well as *Brooklyn* and *harbour*, chronicling the sights visible from his studio on Coenties Slip. The final work in the series, *Decade Autoportrait 1969* (Figure 41) is black, yellow, and white, a color combination that signals unease and danger. The tumbling words *skid row* on the left of the painting refer to the home on the Bowery that he left behind in 1969. *Eli*, *Penobscot*, and the three linked rings (a symbol of the Odd Fellows) above *Indiana* refer to the artist's discovery of Vinalhaven island, where he would spend the next two decades.

In 1978 Indiana left New York, relocating to Vinalhaven, an island 15 miles off the coast of Maine. Indiana left New York for many reasons, including the fact that the building housing his studio on Spring Street (encompassing five floors where he had lived since 1965) had been sold. A crucial factor, however, was that Indiana was no longer at home in New York. During the next ten years, Indiana focused his attention on his home and largest "found-object construction," the 119-year-old Odd Fellows Lodge called the Star of Hope.[47] Indiana signaled his sense of the crisis in his artistic career in a letter written in 1979 to his friend and collector, Robert Tobin, discussing a planned suite of prints (*Decade: Autoportraits, Vinalhaven Suite*, 1980) which would track his experience of the 1970s:

> I have thought that it might be more fun to switch the geographical focus to Vinalhaven, since I have been coming here those long ten years, and the place names are much greater than The Bowery and Spring Street repeated over and over. . . . This time I'm sorry a decade has ten years. Given that it was the '70s my first inclination would be to have an all-gray suite, but common sense has to prevail![48]

As is evident from Indiana's painting style, the impulse toward order for him is powerful. During the early 1980s, carrying out repairs essential to stabilize the Star of Hope as well as his feelings of self-exile from New York necessitated a lull in Indiana's activities as a painter. The proximity of the Vinalhaven Press, however, allowed him to reexamine the art of printmaking. The Vinalhaven Press is a seasonal fine-art printmaking facility that was founded in 1984 by Patricia Nick, a longtime friend of Indiana's and a

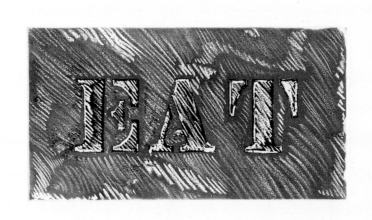

Figure 43

Mother of Exiles, 1986,
etching and aquatint on
Arches Cover paper,
47 $^1/_2$ × 31 $^1/_2$ inches.
Courtesy Vinalhaven Press.

summer resident of Vinalhaven.[49] The press reconnected Indiana with his training in intaglio printmaking, resulting in two significant works completed in 1986 which address the American Dream: *American Dream* and *Mother of Exiles*. Despite his professional troubles during the 1970s, *American Dream* (Figure 42) retains the optimism of Indiana's *Demuth American Dream No. 5*. The notion of the human hand guiding the etching needle, coupled with the stacked words *eat/die/hug/err*, emphasizes the idea of personal engagement within the Dream. Despite his hardships, Indiana retained a strong connection with the positive aspects of his Dream. The negative aspects of the cultural idea of the American Dream are also addressed in Indiana's work at the Vinalhaven Press. *Mother of Exiles* (Figure 43), published on the occasion of the 100th anniversary of the Statue of Liberty, is damning in tone. The tilted *O*, recalling Indiana's *Love*, is here juxtaposed with a bust-length image of an armless, weeping Statue of Liberty. Her "welcoming" upraised torch has been removed, indicating that immigrants are no longer welcome in the United States. Lady Liberty has been deprived of her maternal function (as *mother of exiles*) and reduced to an empty figure of impotent nationalism. This is the failure of the American Dream, the increasing unwillingness of the American people to embrace those who still believe in America as the promised land.[50] Although Indiana was able to address the full range of his thoughts about the American Dream in his prints, he did not deal with the effects of his exile in his paintings or sculpture until the early 1990s.

Susan Elizabeth Ryan notes that although soon after his move in 1978 Indiana decided that his first paintings in Maine would be an homage to Marsden Hartley, the artist delayed addressing this theme until 1990, when he began a series of works inspired by Hartley's "war motif" paintings (1914–15). Hartley painted the "war motif " series in commemoration of the death of his friend (and possible lover) Karl von Freyburg, whom he had met during a sojourn in Berlin (1913–15). These canvases were ill received when they were shown in New York in 1916, an event that prompted Hartley's further alienation from the American art scene.[51] During the time in which Indiana conceived his homage to Hartley, he found that Hartley had maintained a studio in a building that was adjacent to one that Indiana had rented for storage during the renovations of the Star of Hope. Initially, he planned to celebrate Hartley's late figurative work, which he painted while on Vinalhaven (circa 1938), but later changed his focus as he contemplated the significance of numbers and shapes in Hartley's "war motif " paintings.[52] Indiana painted 18 canvases (six rectangles, six diamonds, six tondos) on the subject between 1989 and 1994.

Through symbolic means, Hartley's paintings deal with loss, a device Indiana elaborated on. The protracted amount of time Indiana worked on the *Hartley Elegies* allowed him to become deeply involved in his subject and to depart further from the form of Hartley's original canvases. *KvF XI* (Figure 44), one of two grisaille paintings in the series, elucidates a key element in Indiana's engagement with the "war motif " paintings. The initials *KVF* and *EMH* (Hartley's given name was Edmund) are knocked to the sides of the diamond shape, bringing into full focus the central ring that bears five significant place names: *Lewiston, New York, Berlin, Ellsworth, Vinalhaven*. Lewiston, Maine, was Hartley's place of birth, and Berlin obviously refers to the "war motif " paintings. Ellsworth is not only the name of the town in Maine

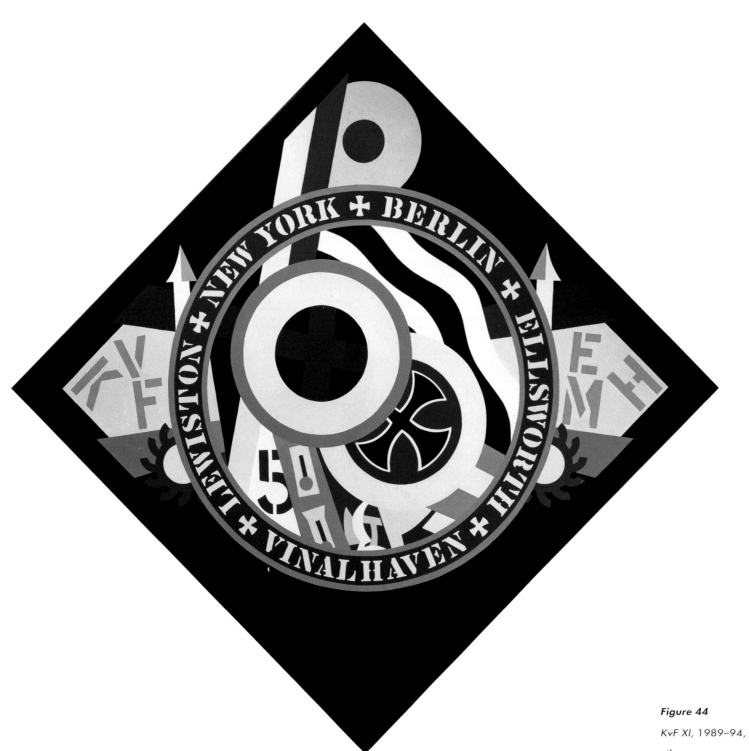

Figure 44
KvF XI, 1989–94,
oil on canvas,
85 x 85 inches.
Private collection,
courtesy Simon Salama-Caro.

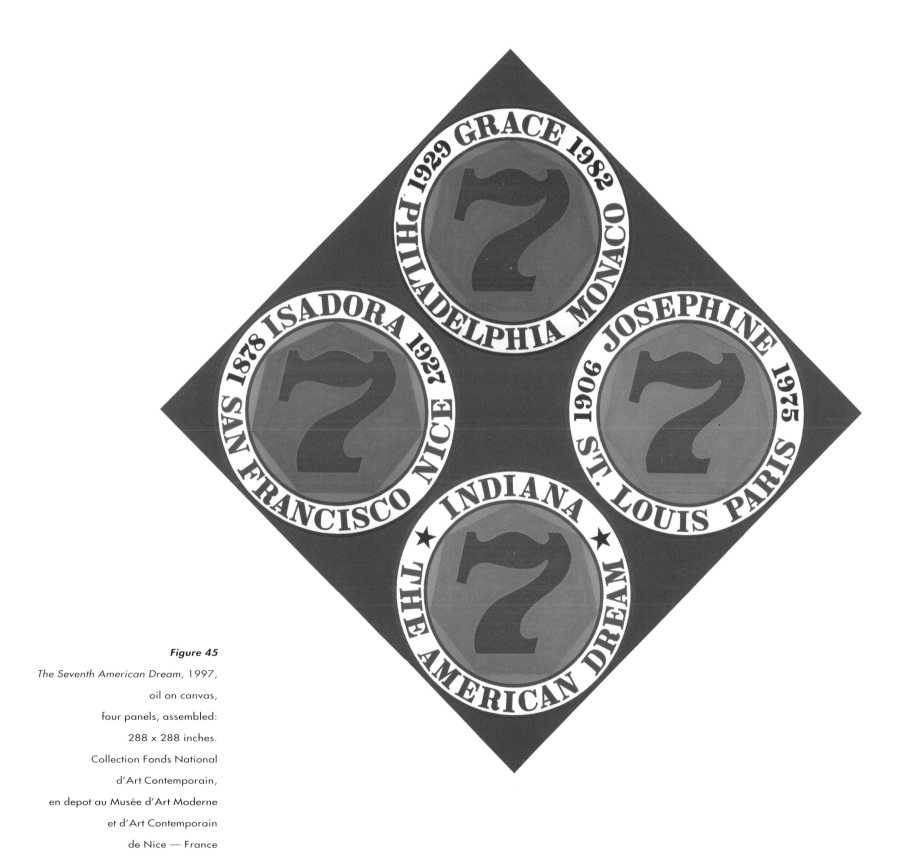

Figure 45

The Seventh American Dream, 1997,

oil on canvas,

four panels, assembled:

288 x 288 inches.

Collection Fonds National

d'Art Contemporain,

en depot au Musée d'Art Moderne

et d'Art Contemporain

de Nice — France

where Hartley died but also that of Indiana's painting mentor, Ellsworth Kelly. New York and Vinalhaven denote residences of both Indiana and Hartley. The Maine locations (Lewiston, Vinalhaven, Ellsworth) are near the bottom of the composition, while New York and Berlin are at the top. Berlin is where Hartley was happiest—a place where he felt engaged both socially and personally. Hartley was devastated by Karl von Freyburg's death, and the onslaught of World War I separated Hartley from Berlin; he spent the remainder of his life searching for a place where he could feel comfortable and be productive. Likewise, the 1960s in New York was a time of great artistic and personal growth for Indiana—his first stable home and community. Indiana has often described himself during his life in Maine as "an exile," a feeling he shared with Hartley, and which indicates Indiana still does not consider his life settled.[53] *KvF XI* is funereal in tone; in fact, despite the bright colors in other paintings in the series, the most prominent color in all of them is black. Indiana has described the *Hartley Elegies* as "a lament and a plea."[54] While the *Hartley Elegies* are a tribute to Hartley's "war motif" paintings, they also tap into the status of Indiana's Dream and his search for his place in the world.

Many of Indiana's works were initially inspired by commonplace events, and the artist transformed historical and cultural material into personal symbols. Such is the case with Indiana's most recent painting in the *American Dream* series. In 1997 Indiana contributed a large sculpture of the number 7 to commemorate the 700th anniversary of the rule of the Grimaldi family to an exhibition of outdoor sculpture in Monaco. This event, coupled with the artist's impending 70th birthday in 1998, resulted in the painting of *The Seventh American Dream* (Figure 45), a monumental diamond-shaped canvas that fully confronts Indiana's conception of himself as an exile. Built of four diamond-shaped canvases, *The Seventh American Dream* contains three circles commemorating three famous female American expatriates, including their place of birth and death: Grace Kelly (Philadelphia 1929–1982 Monaco), Isadora Duncan (San Francisco 1878–1927 Nice), and Josephine Baker (St. Louis 1906–1975 Paris). In the bottom circle the words *Indiana/the American dream*, incorporate the artist within the group.

All four of these people achieved the Dream: Kelly was a film actress who married a prince; Duncan, a dancer of international renown; Baker, an entertainer who shattered the world's conception of black women in the 1920s; and Indiana, a midwestern boy who became a famous artist (Figure 46). Kelly and Duncan died tragically in car accidents; therefore, the implied presence of the automobile is doubly significant, given Indiana's representation of his parents' Tin Lizzie as their manifestation of the American Dream. One important American woman expatriate not included is Gertrude Stein, whom the artist considered and finally deemed "inappropriate" for the composition.[55] There are several plausible explana-

Figure 46

Robert Indiana in the Star of Hope, Vinalhaven, Maine, 1988.

Photograph by Barbara M. Goodbody.

tions for Indiana's omission of Stein from *The Seventh American Dream*, the most compelling being that Stein's persona does not feed into the popular American ideal of the Dream. Her fame does not tap into the fantasy of glamour or the sense that the Dream is an achievable goal for the average American.

While *The Seventh American Dream* is a celebration, it is also a meditation on Robert Indiana's life. Grace Kelly, Isadora Duncan, Josephine Baker, and Robert Indiana all achieved the pinnacle of the American Dream, yet that attainment is by no means the sum of their lives. Kelly, Duncan, Baker, and Indiana lived out their lives in the public realm, and their lives were examined, dissected, and interpreted by a voracious public. In the end, all chose their own particular "exile" from the Dream for their own purposes: Grace Kelly for love, Isadora Duncan for artistic freedom, Josephine Baker to escape from prejudice, and Robert Indiana for all of these things, plus peace of mind.

Conclusion

Robert Indiana, in his life and his art, has come full circle. His renown as an artist was born with his first painting of the American Dream, and he continues to address the contradictory concepts of this phrase in his painting, sculpture, and graphics. Tobin's description of Indiana as "Arrived but still seeking" is still applicable. His fame has been sealed in the consciousness of the world through the spread of *Love*, yet the effect on the artist personally has been mostly negative. His current artistic quest is fueled not by the search for fame, but by a search for greater understanding from his audience and, ultimately, himself. Robert Indiana is a paragon of the Dream—a self-determined, self-constructed personality bounded by the cultural judgments that are brought to bear on him and his work. Like the Dream, Indiana and his work have been dismissed and vilified. They have also had their champions. And the question remains: Who determines the validity or failure of the Dream? Much of the personal information that is used to interpret Indiana's works is gleaned from successive updates of the artist's "Autochronology," which he readily admits contains opinions as well as facts. While there is no reason to doubt Indiana's telling of his own history, the tone of the "Autochronology" is decidedly mythic, and, as Tobin has noted, its subsequent rewritings incorporate different points of view, for both the artist and the reader.[56] This is, indeed, the resolution of the Dream—the impulse to explore and accept a life, the good and the bad—that unites Indiana's work.

Notes

1. Epigraph from Gene R. Swenson, "What Is Pop Art? Answers from Eight Painters, Part I: Jim Dine, Robert Indiana, Roy Lichtenstein, Andy Warhol," *Art News* 62, no. 7 (November 1963): 63.

2. Indiana contributed an "Autochronology" to several monographic publications on his work: University of Pennsylvania, Institute of Contemporary Art, *Robert Indiana* (Philadelphia: Institute of Contemporary Art with Falcon Press, 1968); Robert L. B. Tobin and William Katz, *Robert Indiana* (Austin: University of Texas, Austin, 1977); Salama-Caro Gallery, *Robert Indiana: Early Sculpture, 1958–1962* (London: Salama-Caro Gallery, 1991); and Musée d'Art Moderne et d'Art Contemporain, *Robert Indiana: Retrospective, 1958–1998* (Nice: Musée d'Art Moderne et d'Art Contemporain, 1998).

3. Donald B. Goodall, "Conversations with Robert Indiana," in Tobin and Katz, 36.

4. Mario Amaya, *Pop Art . . . and After* (New York: Viking Press, 1966), 80.

5. This oft-quoted statement was originally taken from Indiana's answers to a series of questions concerning *The American Dream* that were posed to the artist by the Museum of Modern Art as part of the painting's documentation after its purchase by the museum in 1961.

6. The activities of this community of artists are documented in Pace Gallery, *Indiana, Kelly, Martin, Rosenquist, Youngerman at Coenties Slip* (New York: Pace Gallery, 1993).

7. Sidra Stich, *Made in U. S. A.: An Americanization in Modern Art, the '50s & '60s* (Berkeley: University of California Press, 1987), 8.

8. Goodall, 26.

9. Robert Indiana, "The Sweet Mystery Came from These Things," in University of Pennsylania, 15.

10. *Ibid.*, 15.

11. Robert Indiana, quoted in Nicholas Calas and Elena Calas, *Icons and Images of the Sixties* (New York: E. P. Dutton, 1971), 139.

12. Indiana, "The Sweet Mystery," 15.

13. *Ibid.*, 15.

14. Indiana journals, February 2 – 3, 1959.

15. David Farber, *The Age of Great Dreams: America in the 1960s* (New York: Hill and Wang/Farrer, Straus & Giroux, 1994), 50.

16. Edward Albee, Preface to *The American Dream* (New York: Coward-McCann, 1961), 8.

17. Statement by Robert Indiana, the Museum of Modern Art curatorial files, 1961.

18. Earl Clark, the artist's father, worked for the oil company Phillips 66, whose badge, decorated in red, blue, and green, he wore on his lapel. During the depression, Earl Clark was demoted from an executive position to pumping gas. He was last seen, according to the artist, heading west on Route 66. He was born and died in June (the 6th month).

19. The artist noted in his journal that he finished these two sections (*tilt* and *take all*) on the same day, January 24, 1961.

20. Conversation between Robert Indiana and the author, March 13, 1998.

21. Goodall, 31.

22. Susan Elizabeth Ryan, *Dream-Work: Robert Indiana Prints* (Baton Rouge: Louisiana State University School of Art, 1997), n.p.

23. Indiana, quoted in Amaya, 85.

24. Earl Clark died in 1966, during the time the artist was painting *The Sixth American Dream*, which also includes the *eat/die* pairing. Although this specific personal connection with the *eat/die* was not present during the conception of the original paintings in 1962, Indiana often notes such coincidences as fatefully significant.

25. Statement by Robert Indiana, the Museum of Modern Art curatorial files, 1961.

26. Indiana journals, February 13, 1960: "'Lady Be Good' bodies found in the Sahara on the same day the French announce their detonation of a plutonium bomb. Saw the televison program a week ago on this very World War II adventure." This entry is accompanied by a newspaper clipping reporting the resolution of Morocco's King Mohamed V to contribute funds from his personal fortune to rebuild Agadir.

27. The most complete discussion of Indiana's early wood sculpture from this period is in Virginia M. Mecklenburg, *Wood Works: Constructions by Robert Indiana* (Washington, D.C.: National Museum of American Art, Smithsonian Institution, 1984). My discussion of the artist's early sculpture is indebted to this volume.

28. Conversation between Robert Indiana and the author, August 16, 1998.

29. Dorothy Gees Seckler, "Folklore of the Banal," *Art in America* 50, no. 4 (Winter 1962): 60: "In one of his paintings Indiana stenciled the legend: 'No divorced man has ever become the president.' But he prefers not to show this work so long as Rockefeller's candidacy for office is a live political issue."

30. Letter from Robert Indiana to Robert L. B. Tobin. Archives, McNay Art Museum, San Antonio.

31. Susan Elizabeth Ryan, *Figures of Speech: The Art of Robert Indiana, 1958–73*, 2 vols., Ph.D. diss., University of Michigan, 1993, 157. Quoted in Michael Plante, "Truth, Friendship, and Love: Sexuality and Tradition in Robert Indiana's Hartley Elegies," in *Dictated by Life: Marsden Hartley's German Officer Paintings and Robert Indiana's Hartley Elegies* (Minneapolis: Frederick R. Weisman Art Museum, University of Minnesota, 1995).

32. Indiana journals, April 21, 1961.

33. This included adding his name to advertisements supporting the candidacies of Robert Kennedy and Ed Koch. Indiana Archives, Star of Hope, Vinalhaven, Maine.

34. Indiana, "Yield," in University of Pennsylvania, 20.

35. Conversation between Herbert Lust and the author, July 27, 1998.

36. Plante, 75.

37. Ryan, *Dream-Work: Robert Indiana Prints*, n.p.

38. Indiana, notes on object record, Hirshhorn Museum and Sculpture Garden, Washington, D.C., April 12, 1980.

39. Swenson, "What Is Pop Art?" 27.

40. Tobin, "Robert Indiana," in Tobin and Katz, *Robert Indiana*, 17.

41. University of Pennsylvania, 54.

42. Indiana, "The Demuth American Dream No. 5," in *ibid.*, 27.

43. These include the fact that Demuth's painting is dated 1928, the year of Indiana's birth; 1928 subtracted from 1963 (the date of *The Demuth American Dream No. 5*) equals 35, signified by the three fives that appear in both paintings. Demuth died in 1935, and William Carlos Williams, the poet and physician whose poem "The Great Figure" inspired Demuth's painting, died in 1963. See Indiana, "The Figure Five," in *ibid.*, 27.

44. Indiana, "A Mother Is a Mother and a Father Is a Father," in *ibid.*, 36.

45. *Ibid.*, 36.

46. Indiana, "The Metamorphosis of Norma Jean Mortenson," in *ibid.*, 45. This text also outlines the significance of *26*, which flanks the central image: "26 the year of her birth; '62 the year of her death. At two baby Norma Jean was almost suffocated by a hysterical neighbor; at six a member of her 12 (6x2) foster families tried to rape her. In '52 (26 + 26) when she was 26, her most cherished ambition of all was realized when she starred in a dramatic role and, in the first week at the Manhattan box office, the film grossed $26,000. Death came by her hand on the sixth day of August, the eighth Month (6 + 2 for the last time)."

47. Peter Lemos, "Indiana in Maine," *Art News* 88, no. 8 (October 1989): 168.

48. Letter from Robert Indiana to Robert L. B. Tobin, August 22, 1979. Archives, McNay Art Museum.

49. Patricia Nick is a descendent of the Carver family, who settled on Vinalhaven at the turn of the century. Nick spent summers on the island as a child and met Indiana in 1978 when he moved to Vinalhaven.

50. See Aprile Gallant, "Getting Graphic: Experimentation at the Vinalhaven Press," in Aprile Gallant and David P. Becker, *In Print: Contemporary Artists at the Vinalhaven Press* (Portland: Portland Museum of Art, Maine, 1997), 32.

51. For a complete discussion of Hartley's "war motif" paintings, see Patricia McDonnell, "Marsden Hartley's War Motif Series," in *Dictated by Life*, 43–57.

52. Plante, 88.

53. Susan Elizabeth Ryan, "Elegy for an Exile: Robert Indiana's Hartley Elegies," *Art and Antiques* 8, no. 5 (May 1991): 85.

54. *Ibid.*, 109.

55. Conversation between Robert Indiana and the author, September 1998.

56. Tobin and Katz, 17.

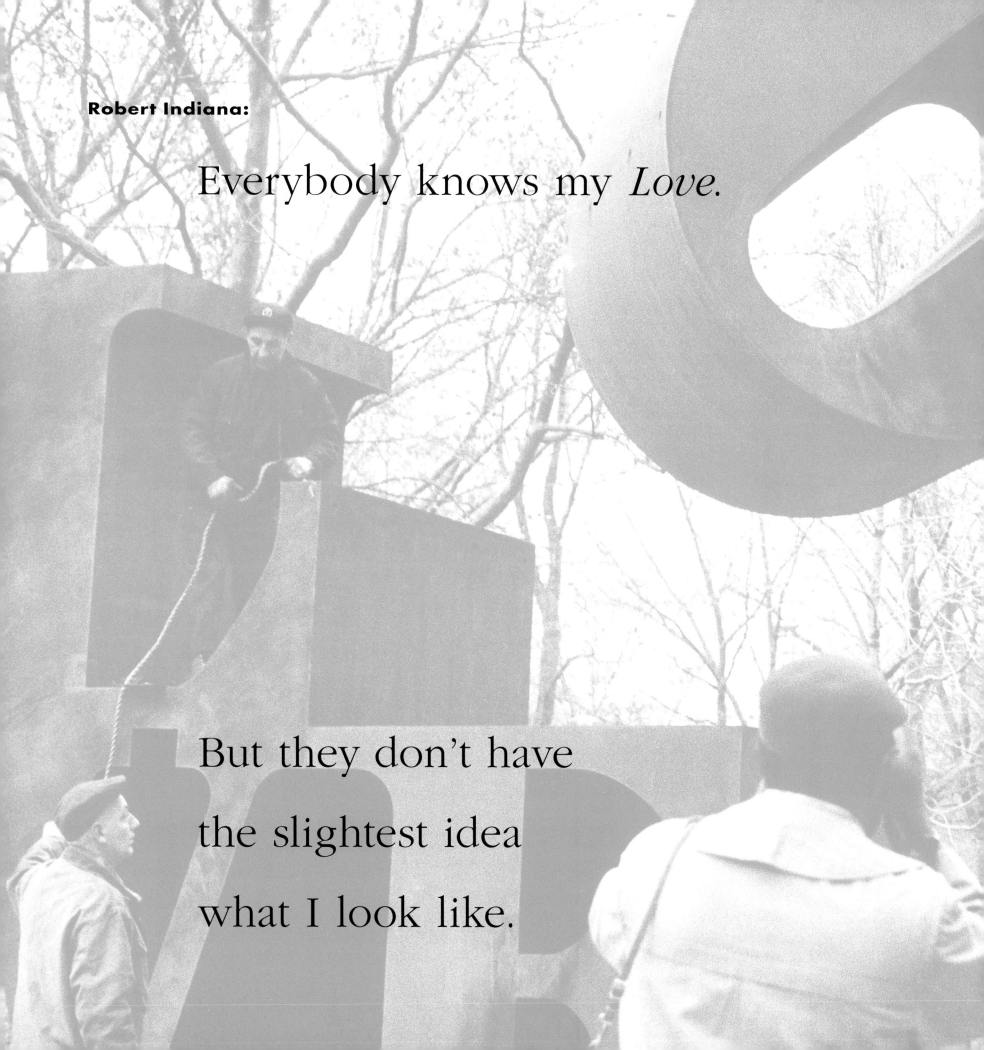

Robert Indiana:

Everybody knows my *Love.*

But they don't have

the slightest idea

what I look like.

Eternal Love

Susan Elizabeth Ryan

In a 1974 interview Robert Indiana said of his painting: "It's always been a matter of impact, the relationship of color to color and word to shape and word to complete piece—both the literal and visual aspects. I'm most concerned with the force of its impact."[1] In this comment Indiana's desire to grab hold of the viewer has led him to emphasize formal concerns, concerns he shared with his painting mentor, Ellsworth Kelly. Indiana's flat, symmetrical, hard-edge compositions—near abstractions despite their simple words—reproduce accurately and easily transfer to other media. So visually strong are they that, in 1966, the critic Aldo Pellegrini placed them "in a zone between pop and optical [Op art] painting."[2] In fact, the late Clement Greenberg, that lion of formalist criticism who rarely bothered with subject-bound styles such as Pop art—or with Pop artists, for that matter—said of Indiana's work: "[It has] more 'body' to it than the run of Pop. . . . it hit my eye more, was more 'plastic,' i.e. more 'formalist.' . . . He filled out more, worked more with the medium as against the schematicism or stunting of a lot of Pop."[3] Impact Indiana's paintings certainly possess, sometimes to an unsettling degree. Alfred H. Barr, Jr., curator of painting at the Museum of Modern Art, called *The American Dream* "spellbinding" ("I do not know why I like it so much," he said), and the critic Mario Amaya found something "deep and troubling" in the works, that the words in them "transmit a psychological and emotional jolt" and "gnaw into the subconscious."[4]

As Indiana himself points out, real impact—making the painting act forcefully on the viewer—lies exactly in the interplay between strong, even disparate, visual and verbal qualities. His own term for his work is "verbal-visual," and it goes beyond Indiana's "eye" for picture surface and precise execution, the aspects of pure formalism that he excels at and that writers like Greenberg have appreciated. Indiana also deploys dynamics that Greenberg and others seem to miss. Indiana plays on our eyes as conceptualizing receptors, activating the creative and linguistic qualities of vision. His painting is very much about the volleying back and forth of impulses between the retina and the brain, and the way this volleying navigates us in the world and constructs our self-image in response to our perceptions of others. Nowhere in his work is the seeing-reading process of identity more apparent than it is in *Love*, a painting motif and series he developed between 1964 and 1966 (Figure 47). This essay outlines that development along with its stormy social context, a context that both obscured and immortalized the unique, potently imaged, word of art.

Love was a watershed in Indiana's career, and it became a motif that he has never abandoned.[5] In format it departs from his most typical previous works like the vertical ("portrait") rectangles and the diamonds and crosses of the successive *American Dreams*. Within a difficult canvas shape, the square, the four-letter word is divided into two pairs of two letters, arranged on two levels, dividing the square into quarters. The letters fill the canvas from edge to edge. Word and image are equal; figure and ground coextensive. *Love* is partly rooted in love poems Indiana had written in the 1950s and returned to in the mid-1960s (his

Figure 48
First Love, 1991,
aquatint on Rives BFK paper,
27 x 20 inches.
Courtesy Vinalhaven Press.

practice of poetry is the "unseen" other part of his art). The act of focusing on the L-word was noted by critics like Lucy Lippard, who called Indiana an "out-and-out romantic."[6] At the same time, even more than his earlier work, the image is hard-edge and reductive. From the very first, the four-square *Love* was conceived as a painting and a series, though not in the sense of the *American Dream* series, in which each different composition is related to the others. In design and composition *Love* always remains the same, only repeated, by the artist, over and over again, varied in scale, color, material, or modular expansion and arrangement. Deceptively simple, it was originally addressed, like all Indiana's art, to both elite and popular viewing audiences, epitomizing his wish to be both a "people's painter" and a "painter's painter."[7]

His first real perception of the word as written language took place in the Christian Science services he was taken to as a child. He recalls staring at the word imprinted on the church walls. As he told Barbaralee Diamonstein,

> All Christian Science churches are very prim and pure. Most of them
> have no decoration whatsoever, no stained glass windows, no
> carvings, no paintings, and in fact, only one thing appears in a
> Christian Science church, and that's a small, very tasteful inscription,
> in gold usually, over the platform where the readers conduct the
> service. And that inscription is God is Love.[8]

Besides Christian love and brotherly love there is the erotic variety. About 1960 a newly self-named Robert Indiana referred to erotic love, in his poetry and in the sculpture *Duncan's Column*, on which are stenciled words and place names inspired by the neighborhood around Coenties Slip. Among them, "Love Pier" served as a hangout for couples.[9] About the same time (1961) the artist did the small canvas *4-Star Love* in a small, pagelike format—a painting one reads from the top down, like verse (the painting was reproduced as an aquatint, *First Love*, in 1991; Figure 48).[10] *4-Star Love* draws a poetic figure of comparison between upper and lower registers, perhaps suggesting a qualitative standard for love, as in restaurant or hotel ratings, in which four stars is highest. On the other hand, 4, at least in the context of the *American Dream* paintings, is Indiana's danger or cautionary number. *4-Star Love* also belongs to a central compositional idea that began with simple circle paintings (the artist originally called them "orbs"; Figure 49) and culminated in *The American Dream* and *The Triumph of Tira* (see Figures 19 and 20), in which a cross can be read in the negative space between the four stars/circles, anthropomorphizing and sanctifying the arrangements. So again, while Indiana's sequence of love poems and paintings admit to erotic love

Figure 49

RA, 1959,

oil on canvas.

Collection of the artist.

and may even mask specific sexual/homosexual allusions, a moralizing and cautionary tone prevails overall. *Love* is an imperative, a pronouncement of authority. We perceive it as a command.

The word did not appear again in his art until early 1964, when the fashion industrialist and art collector Larry Aldrich commissioned from Indiana a painting for a new museum of contemporary art in Ridgefield, Connecticut. Aldrich had become aware of Indiana's work when the Museum of Modern Art acquired *The American Dream*.[11] In 1963 Aldrich was instrumental in the Whitney Museum's purchase of Indiana's *X-5*, and at some point Aldrich and Indiana met. Aldrich was renovating a 1783 building called "Old Hundred" for his museum, which in 1929 had become a Christian Science church and had religious inscriptions on the walls (Figure 50). Indiana responded to Aldrich's commission with *Love Is God* (Figure 51), which reverses the dictum that Mary Baker Eddy took from Saint Paul, "God is Love," one of the inscriptions eventually lost in the renovation.[12] *Love Is God*, a diamond painting in grisaille, is unusual in Indiana's work. It contains a small central mandala, circled in white and containing the inscription in an anonymous sans-serif stenciled letter style that departs from the florid Old English of the church's version. Around the central circle, filling the space between it and the canvas edges, are 16 segments of gray shading from light gray to black, giving impressions of shadow and perspective depth and of something like reflective metal, rare effects among Indiana's paintings.[13] "Love is God" recalls to mind "God is Love," implying a word cycle like the famous poem by Gertrude Stein (an inspiration for Indiana), "Rose is a rose is a rose," written as an unending circle. Appropriately, *Love Is God* closed an autobiographical cycle for Indiana. Retrospectively viewed through the context of the Aldrich commission, a prophecy appears to be fulfilled, based in Indiana's childhood and the Christian Science services he attended.

The transition from the 1961 *4-Star Love* and the *Love Is God* diamond to the square, two-letters-over-two image took place within complex circumstances at the end of 1964. At some point after a falling out with Ellsworth Kelly, Indiana did a painting called *Fuck* (with a tilted *U*). According to his own account, when he showed it to Kelly, the latter (who never used words in his paintings) was horrified.[14] *Fuck* is a word that misreads the act of love. Likewise the painting, together with Indiana's story about it, demonstrates a witty misreading of Kelly's own carefully wrought hard-edge abstractions that amounts to a renunciation of Kelly as an artistic mentor.

That painting was never exhibited, but had it been, it might have engaged with cultural circumstances in significant ways. The word itself appeared in publicity surrounding the Berkeley Free Speech Movement (FSM), whose banner, FUCK (acronym for "Freedom under Clark Kerr," Berkeley's president), was reproduced nationwide in press coverage of the demonstrations. *Fuck* was also an operative word in the lesser-

Figure 50

Interior of the Aldrich Museum of Contemporary Art, Ridgefield, Connecticut, before renovations, circa 1963. Note the word "Love" on the upper left wall.

Photograph courtesy Larry Aldrich.

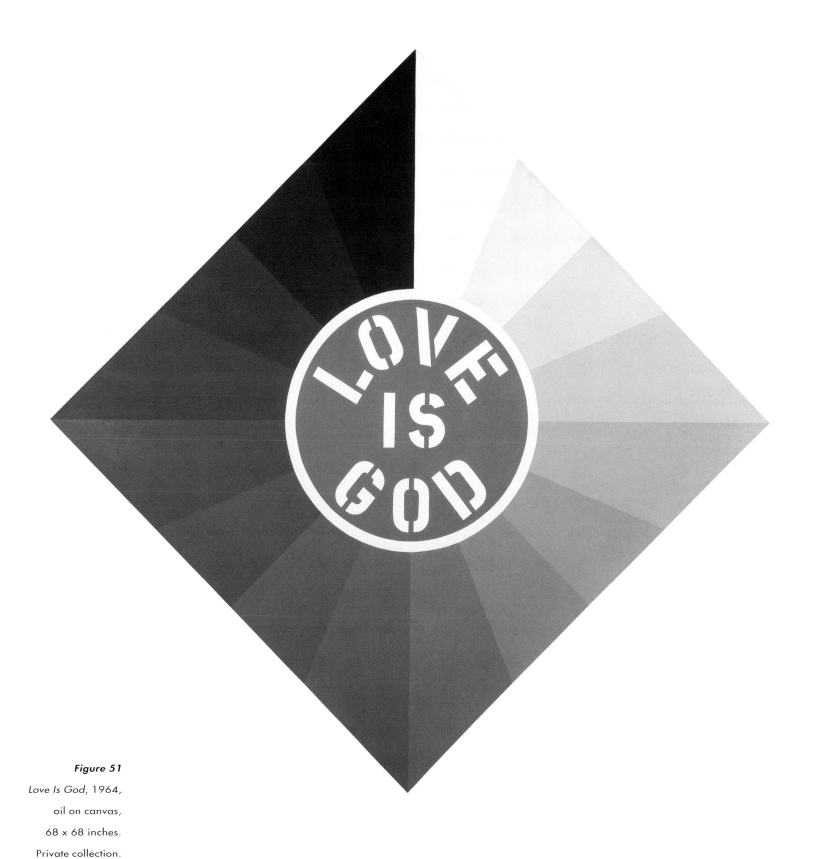

Figure 51

Love Is God, 1964,

oil on canvas,

68 x 68 inches.

Private collection.

known successor to the FSM, the so-called Filthy Speech Movement, proponents of which appeared on the Berkeley scene early in 1965.[15] Both groups targeted linguistic hypocrisies among those in power. The idea was rooted in the earlier Beat culture, demonstrated by Ed Saunders in his underground magazine *Fuck You* (1962–64) and by performers like Lenny Bruce and Taylor Mead (Mead and Saunders were acquaintances of Indiana's), whose satire exposed America's double standard regarding the F-word and other sexual pejoratives. Linguistic satire signaled the new verbal awareness of the 1960s, a time in which language as label and index of social difference was reexamined, and sometimes reinvented.[16]

By December 1964 Indiana had experimented with the composition, creating a similar *Four* (love is a "four-letter word"; Figure 52) and, finally, a *Love*. But the latter was not at first a painting—or any kind of gallery work at all. Instead it was a series of Christmas cards that Indiana sent to friends that year (Figure 53).[17] The cards were frottages made by running a pencil or conté crayon over paper with letter stencils arranged underneath, a technique that Indiana had begun using in 1962 and based on an old American Hay Company stencil he had found in his Coenties Slip building. But he had already done some single-word rubbings, including one word related to *love* from his *American Dream* quartet of three-letter verbs: *hug*. These works are contrapuntal to the hard-edge Indianas. As Rosalind Krauss wrote in *Art International*, Indiana returned to "the abstract-expressionist surface full of the shadows and highlights of the emergent image." Rather than conveying mechanicalness and anonymity, she said, *The American Eat* (a rubbing) "carries personal touch almost to the pitch of caress." [18]

This was certainly true of the 1964 *Love* rubbings. Around each letter, lines that define square sectors, the imprint of the stencils' outer edges, add complexity and almost a sense of faceted, cubist space. The adjacent letters *L O* and *V E* appear to touch almost erotically—the bottom serif of the *L* seems to stroke the lower part of the *O*, which leans toward it in response; while the *E*'s rigidly extended top serif continues into the opening of the *V*. Writers have found countless sexual forms in the negative spaces of the imaged word, from phalluses and arrows to mouths, vaginas, and breasts. But in the rubbing, the evocativeness of the graphic is engendered by the softly textured surface, which mitigates the edges and throws an irregular, seemingly fleeting highlight on each letter.

Like *4-Star Love* and orb paintings like *The American Dream*, *Love* contains a compositional cross.[19] The use of a classical, roman letter style, all capitals, is not new in his work, but its unstenciled boldface is. Closest to Stanley Morison's Times Roman of 1932, that supposedly reflected "modern journalism," it is preeminently a type*face* in Indiana's emphasis, bearing associations of presence and authority.[20] Indiana adapted the style to the visual needs of the format and negative/positive shapes of the design and emphasized, even exaggerated, the coved serifs that give the letters character.[21]

Indiana told Barbaralee Diamonstein that the tilted *O* was a "very common typographical device."[22] In some roman faces (Old Roman or Shakespeare Medieval, for example, though not Times), the inside of

Figure 52
Four, 1965,
oil on canvas,
12 x 12 inches.
Herbert Lust Gallery.

Figure 53

Love, 1964,

colored pencil on paper,

8 x 8 inches.

Spencer Museum of Art,

The University of Kansas.

Gene Swenson Collection, 70.124.a

the *O* has a backward tilt, and in any italic font the whole letter leans forward. Elsewhere he explained that he came across such examples frequently when, as a student at the University of Edinburgh, he typeset poetry.[23] Over the years he has explained the *O* as "representing" everything from a cat's eye to an erect phallus.[24] But more than anything else, it is the image's dynamic. Accentlike, it mimics the marking of intonation in speech or emphasis in the reading of poetry. By signaling the word's passage from speaker to receiver, the tilted *O* impersonates a subject and activates a command.

The Christmas card drawings were probably done in different colored pencils, exploring the motif through color variation.[25] This idea was carried over in 1965 when the artist rendered the motif in his hard-edge style. But before being formally exhibited under the Indiana name, it was, as it were, again offered to others. Late in 1964 the Museum of Modern Art (MoMA) commissioned Indiana to provide a design for one of *its* Christmas cards.[26] Indiana submitted three 12-inch, hard-edge color variations in oil on canvas. The one MoMA chose was the most intense, rendered in high-saturation, equal-value hues: red letters against a green and blue background. It became one of the most popular cards that the museum ever offered. And the card disseminated the image bearing MoMA's copyright notice. Thus, prior to the artist's definitive exhibition of his motif at the Stable Gallery in the spring of 1966 (see Figure 47), *Love* was already delivered to untold numbers of recipients via U.S. mail.

The "Love Show" at Eleanor Ward's Stable Gallery consisted of two categories of works. Most prominent were the *Love* paintings in different sizes and configurations: that is, the four-panel *Love Wall*, in which the imaged word, in different positions, created a center of four radiating *O*s (or four *V*s, as in *The Great Love* in the exhibition; Figure 54). A second room was devoted to the *Cardinal Numbers 0 – 9*. All works in the 1966 exhibition were strikingly hued in red, blue, and/or green, the equal-valued complementaries of the MoMA *Love* card and with the same vibrating saturation. Reviews of the show were few and short. Its flagrant brandishing of the word *love* may have made some critics uncomfortable. Dore Ashton called the works "stately" and "reserved" but avoided any mention of love.[27] Lucy Lippard also deemphasized the linguistic aspect: "The letter forms, often turned upside down or backward, become abstract signs forming closely packed surface patterns. Only the warm glow refers obliquely to the subject matter."[28] But for Indiana, the exhibition was just the beginning. He proceeded to expand the motif via repetition and variation. Between 1965 and the end of 1966 his painting production shot up significantly for the first time since 1962, largely due to the proliferation of *Love*s.[29]

Of course the motif appeared prominently on the Stable exhibition poster (Figure 55). In discussions with Ward and the printers, Posters Originals, the question of copyright had arisen, but apparently no one involved, including the artist at that point, was versed in the law. Then, as now, even after copyright legislation was revised in 1978, notice had to appear, along with the artist's name and date, on any work construed to be published (i.e., circulated in the public domain).[30] Printed without a properly affixed notice, the Stable posters circulated *Love* in just the manner that copyright law could not protect.

Figure 54
The Great Love, 1966,
oil on canvas, four panels,
assembled: 120 x 120 inches.
Carnegie Museum of Art, Pittsburgh.
Gift of the Women's Committee,
67.23.

Figure 55

Love exhibition poster,

Stable Gallery,

1966 (reprinted 1971),

silkscreen on paper,

32 x 24 inches.

Collection of the artist.

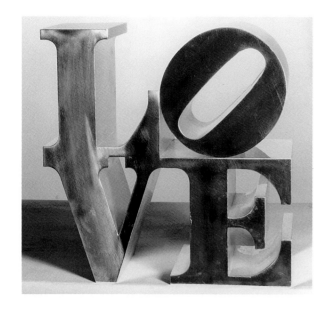

Indiana had argued against affixing notice, at least on the front, because he did not like the commercial look that such attachment gave.[31] Notice was a visual impediment, calling attention to itself within what he had taken pains to make an immediate, indivisible imaged word. But omitting notice was a telling tactical error. In retrospect one can find other indications that more specific legal protection was needed for artists at that time, when the appropriation of formalist artworks for high-priced commodities became widespread, such as when Mondrian's characteristic rectilinear motifs and Bridget Riley's optical patterns showed up on trendy attire.[32] In fact, these phenomena echoed *Vogue*'s use of Jackson Pollock paintings as a backdrop for spring dresses a decade earlier—all part of a cycle observable since the 19th century in which avant-garde art is repackaged for consumption by the culture industry.[33]

A friend of Indiana's, William Katz, recalls at the time Indiana felt that, since the role of the artist in any work of art was absolutely primary, no one could really gain by not citing the artist in a reproduction. No luster, no "aura," would transfer without the artist.[34] Katz's use of the word *aura* suggests a bond between artwork and artist, which is different from the typical meaning of the term in recent art history. There the term *aura* is usually connected with the German critical theorist Walter Benjamin, who used it in a number of writings, the best known of which is his 1936 essay, "The Work of Art in the Age of Mechanical Reproduction."[35] In it Benjamin asserts that aura is a property of the *unique* work of art and is directly related to its authenticity and authority. The presence of aura signals a strict interrelationship between the physical work and its context—its place and time. But, as Harold Bloom has shown, in other writings Benjamin gives the term additional shades of meaning based on the Gnostic and Neoplatonist idea of the astral body, of which aura is an "invisible breath or emanation" or "a sensation or shock." In his essay on Baudelaire, Benjamin has aura bind the work, not so much to a place or context, as to an author, a person, and to this sense of shock: "to perceive the aura of an object we look at means to invest it with the ability to look at us in return."[36] This aspect reminds us of Jacques Lacan's term *gaze*, which signals our fragmented condition, our central lack. Extrapolating beyond Benjamin, Bloom too connects aura with our fragmentation: aura is evidence of both individuality and its exhalation or sublime loss: "a final defense of the soul against the shock or catastrophe of multiplicity."

With *Love* we have both optical shock (in the bold and loaded word and its intense colors) *and* multiplicity—a work with no real single original, only a group of paintings, done for the MoMA card commission. At the outset *Love* underwent two mechanical reproductions: the MoMA card and the posters. The latter advertised a gallery where variations of the paintings were hung. But the situation is even more complicated. The Stable exhibition also contained one *Love* sculpture, a 12-inch-high solid aluminum piece in an

Figure 56

Love, 1967,

aluminum,

11 $^{7}/_{8}$ x 11 $^{7}/_{8}$ x 6 inches.

Hirshhorn Museum and

Sculpture Garden,

Smithsonian Institution.

Gift of Joseph H.

Hirshhorn, 1972.

edition of six (signed and numbered by the artist), commissioned by Multiples, Inc. (Figure 56).[37] Founded by Marian Goodman, Multiples was based on a new idea that translated the taste for serial art and commodity technology into concepts for art publishing—beyond editioned prints, to objects such as banners, jewelry, and domestic-scale sculpture. It was a step toward art industrialization, except that her projects were not manufactured; they were designed by artists and carried out by crafts professionals. They ranged widely in price, bridging the gap between masterpiece and merchandise. In 1966, in addition to the fairly expensive *Love* sculptures, Goodman commissioned a *Love* banner (in red-blue-and-green felt, signed and numbered) to be sold at a fraction of the sculpture's cost.

Goodman and her lawyer urged that actual copyright registration be obtained through government application. Indiana filled out and sent in the standard form, only to have it returned, rejected. The reason given was that the law did not provide protection for a single word. Indiana realized only later that he should have disputed the ruling on the grounds of creative enhancement. At the time, he was advised to patent the image as a trademark, a totally unsatisfactory solution that the artist rejected.[38] Indeed, even the suggestion that *Love* might be treated as a commercial logo boded trouble ahead.

In 1966 the word *love* was broadcast amid a new expanding youth subculture that was attracting media attention across America. The Youth Movement, or youth culture, or counterculture, or even hippyism, as it was alternatively called, had sprung from the New Left and the spirit of civil rights and the Free Speech Movement at Berkeley and was spreading among affluent, intellectual, and tuned-in students across America.[39] Soon it was not just on campuses—it outgrew institutional and generational confines. Within months of the "Love Show," the first officially named "Love-in" took place in Elysian Park in Los Angeles.[40] Newspapers here and abroad reported that 400 hippies had gathered in an "emerald glen" to "spread love." In a matter of months not only "love-in," but "love beads," "love child," "love generation," and a host of related terms appeared in what seemed like a new utopian argot. Of course it meant sex ("free love") and sexual revolution: sex as a progressive, nonpredjudicial, even transcendental activity. Making love on LSD was like making love with God, Timothy Leary told his *Playboy* interviewer in a widely read issue that appeared in September 1966. But the very media that dramatized the marginality and difference of that subculture, that offered it as entertainment and capitalized on it, simultaneously normalized and eradicated it.[41] Its enunciations, for example, held forth from haute couture: Rudi Gernreich's "Love dress" (not Indiana's motif) premiered in the summer collections for 1966, about the same time the "Love Show" was hung at the Stable.[42]

In the mid-1960s, the term used for the sort of cultural bricolage produced by the Pop artists was *camp*.[43] From the French reflexive verb *se camper*, "to position oneself" or "to posture," Pop camp resulted when mundane or vulgar objects were turned into high art through the acquisition of a "virtual context"—like invisible quotation marks or a frame, perceptible to initiated beholders who now participate in the subculture via the media. A gap is bridged. Sixties camp was specifically an *arriviste* position that momentarily

unified and neutralized the "disaffected" and centralized marginality—beats, blacks, gays, and the new youth cultures alike.[44] *Love*, appearing somewhat nostalgic in its slightly corny oversized roman lettering, the typeface of the *Times*, modeled the social gymnastics of camp. But in this role, rather than serving as an icon of unification borrowed from the art world—as a work of art made by an artist—*Love* became detached from that context and its self-referential function withered away, partly because its discourse ceased to be transgressive and rooted in difference (the act of an "owner"), and partly because (as we have seen) the legal aspects of ownership were already undermined.[45] *Love* achieved the status of a mobile or vagrant sign, its authorship elided and dispersed. Yet, in its anonymity, it asserted an uncanny influence nonetheless.

Unlike the other Pop artists, who concentrated on subjects with specific contexts, supermarket or drug-store items or aspects of domestic interiors or on cartoons—for which the context is the newspaper itself—Indiana's imaged word refers to the world of signs and, in particular, the signs of the highway and thus, allegorically, life's journey. *Love* is inherently a traveler and addresses a culture of travelers, besides being a figure of Indiana's own roving childhood and experiences of serial homes (in his own accounts, he had 21 homes by the time he was 17). The image's homelessness contributes to its hovering quality, how it seems to float free of supports and contingencies. It does not refer us to the viewing situation of art, the gallery wall, as, for example, Jasper Johns's paintings do. Philip Fisher shows us that with Johns's American flag (in *Flag* of 1955), the flag and painting are coextensive. The work asserts its existence on the museum wall and its status as art emphasized by its showy surface facture.[46] On the other hand, Cécile Whiting has shown that most Pop art functioned well in nongallery contexts such as window and super-market displays—in fact, Pop art could actually use commodity culture as its venue.[47] But Indiana's *Love* does not call forth those contexts, or any other specific ones; it was wedded only in a mobile way to the mind-set of the 1960s.

Indiana's use of mass-media graphics (typography) and explorations of images in theme-and-variation series and modular grids are practices he shared with Andy Warhol, his gallery mate at the Stable. One might even expect, since they were the only two gay artists among the core Pop group, that they would have been especially linked, perhaps sharing particular ideas about the gay content implied in the repetitive reworking of popular imagery. But no evidence suggests this. In fact, their works operate as polar opposites.

Warhol's signature on some of the silkscreen paintings produced at the Factory, as Andrew Ross reports, is like the infamous Disney industry signature that is attached to all manner of items that Disney never signed.[48] Warhol's florid early handwriting is not even entirely his own, but an imitation of his mother's, which his studio assistants later copied when they signed his name to pieces.[49] Yet even with no signature at all, Warhol's works seem indelibly stamped by an author, a personality responsible for choosing and framing them. They *need* an author and thus perfectly illustrate Michel Foucault's "author function," in

which the work projects the person of its creator.[50] In this case the author (Warhol) recontextualizes the preexisting image of a soup can and renders it as art in an enterprise related to the readymade-designating activities of Marcel Duchamp (who might be considered, in Foucault's model, the founder of this mode of art-discursivity). Warhol's authorship was not even called into question when he insisted to interviewers there was nothing behind his words.[51] His media self-promotion undermined any sense of a personal core and flew in the face of the Abstract Expressionists' position that a conceptualized inner self truly authors one's art. Warhol parodied their position: "Some company recently was interested in buying my 'aura,'" Warhol wrote (coincidentally parroting the "Benjamin term"): "They didn't want my product. They kept saying, 'We want your aura.'. . . I think 'aura' is something that only somebody else can see, and they only see as much of it as they want to. It's all in the other person's eyes."[52] Warhol's media persona may have been inauthentic, but it was efficient, and when the Campbell's soup can appeared on campy objects outside of the Warhol production, Warhol's name always silently accompanied his image.

Love functioned differently. In contradistinction to Warhol's silkscreen canvases sometimes produced by Factory drop-ins, Indiana's paintings are handcrafted and so carefully designed that the artist's signature could only go on the back, so as not to detract from the works' visual impact.[53] *Love*, as a personally distinctive formation of capitalized text, itself functions as a kind of monogram or signature—an authorship sign, where the sign is the only thing authored. But unlike Warhol's or Duchamp's framelike John Hancocks—signatures that are more context than text—Indiana's autographeme collapses the name and the work. It is an utterance from personal experience and rendered with an investiture of labor, but these are both denied, masked by the image's anonymous and hard-edge appearance and endless reproduction. This dual function of *Love* as both cathexis and repression is also reflected in the way Indiana loads his paintings (the *Love*s just like the *American Dreams*) with autobiographical content without making that content widely accessible. Perhaps he was partly inspired by Warhol's far more dramatic self-promotion— if not as a private, autobiographical, or even very dimensional personality, at least one vivid and provocative enough to ground his appropriative, campy brand of work. Indiana, on the other hand, with his sparse, mythological-sounding personal stories that appeared only in hard-to-find catalogues and interviews, abjured the flagrant and held back the private. He failed to provide a Pop persona to enframe his work, another reason for its homelessness.

Moreover, with his curious repetitive acts, he effectively gave *Love* away. He preempted his paintings with his own Christmas cards, followed by the ones he allowed MoMA to produce; then he issued the imaged word in multiple "fine art" editions. The notion of giving love away as a giving away of self is consonant with the Christian interpretation of love and the cross that lurks within the work. The image's religious association was boosted in June 1967 when John and Dominique de Menil commissioned the *Love Cross* for a projected Vatican Oecumenical Pavilion at the 1968 Hemisfair in San Antonio (Figure 57).[54] Its author signed, sealed, and delivered himself, not as owner and possessor, but as sacrificial object. Impersonating *Love*, he offered himself to Others.

Figure 57

Love Cross, 1968,
oil on canvas, five panels,
assembled: 180 x 180 inches.
The Menil Collection, Houston,
78-131 E.

Indiana's own repetition of *Love*, his self-plagiarism, paralleled the commercial pirating of the image that simultaneously took place. Prior to *Love* Indiana had never shown any interest in seeing his work disseminated beyond the museum and gallery circuit and the art press. But in the late 1960s and early 1970s this self-styled "people's painter" participated in a number of projects to reproduce *Love* in various media, projects that reached well beyond Multiples Gallery to grassroots enterprises, trying to negotiate its replication between *objet d'art* and something like an emblem of liberal classlessness. In 1967 he authorized Joan Kron and Audrey Sable of the Beautiful Box and Bag Company of Philadelphia (the City of Brotherly Love) to use the motif on 100 18-karat-gold rings, which sold for $300 each (Figure 58).[55] This was done, he said, because the rings were designed as beautiful objects. The same reasoning informed a 10-foot-square silk tapestry *Love* (1968), commissioned by the Charles E. Slatkin Gallery.[56] RCA Victor got his consent to reproduce his *Imperial Love* diptych on the album cover of the high-brow *Turangalla Symphony* (1968), Olivier Messiaen's orchestral love poem. At the same time, also in 1967, Indiana collaborated with a company called Mass Originals (owned by the collector Eugene Schwartz) to issue several thousand unsigned serigraphs at 25 dollars each—bringing *Love* within range of every wallet.[57]

Legitimate replications floated on a sea of pirated ones. As early as 1966 another Philadelphia-area company used *Love* in an unauthorized line of cheap cast-aluminum paperweights, modeled directly on the Multiples sculptures.[58] The paperweights were targeted for the new youth market and distributed to campus bookstores nationwide. Other media appropriations furnished *Love* with trivializing associations, as when the cast of *Hair*—the Broadway production that transformed counterculture into a hit musical—posed for *After Dark* magazine with one of the unsigned *Love* prints (Figure 59).

The turning point for *Love*—indexing the drift toward crisis in the culture at large—was the last years of the decade, a period Todd Gitlin calls "a cyclone in a wind tunnel."[59] One cataclysmic event followed another: the assassinations of Robert Kennedy and Martin Luther King, Jr.; the Chicago Conspiracy trial; Black Panther shoot-outs; People's Park; Kent State; the Charles Manson murders; the My Lai massacre; student revolts in Europe. Countercultural euphoria ignited in flashes of violence before burning out in a confusion of factionalism. Language hardened, and "love" typically gave way to "power." In 1968 the *New York Times* announced the death of Pop art; the same year, Warhol was shot by Valerie Solanas.[60] In 1969,

Figure 58

Robert Indiana wearing

the Love ring,

1968.

Photograph by Tana Hoban.

the year of the Altamont free festival, where a fan was killed by Hell's Angels acting as soft police at a Rolling Stones performance, Bob Cenedella, who worked at the Museum of Modern Art, produced the image *Shit* for Pandora Productions/Dadaposters.[61] *Love/Hate* was another variant that appeared about 1970, on matched items like cufflinks, or written on opposite sides of mugs (to be uttered via body language). Eventually Indiana retained copyright lawyers in New York and registered some versions of *Love*. But it was too late. Pirated productions could only be fought case by case, through lengthy litigation, a process in which the artist would not participate. In 1974, after he refused to endorse Charles Revson's Ultima II perfume campaign plan to offer a cheap version of the *Love* ring, which did hold copyright, the company proceeded anyway.

If beyond the art world, in mass culture, Indiana's identity had been severed from his image, the perception within the art world was that *Love* had made him a rich man. He had "sold out." John Canaday suggested in the *New York Times* that the artist do *Money* next.[62] Other reviewers had an inkling of what had happened. John Perreault for the *Village Voice* noted:

> Although Indiana's "love" predates the flower-power hoax, because his design came to permeate the ambiance, still present, of meaningless sentiment, it is impossible now to divorce the design . . . from the conditioned response of nostalgia for a media daydream, or justifiable contempt.[63]

The perception that Indiana had created a moneymaker persisted for more than a decade. In a 1984 article in *Studies in Visual Communication*, David Kunzle misguidedly wrote that, since introducing *Love*, Indiana has "thrived from its use in various media," and, "as late as 1972, this property, in immense enlargement, was serving . . . as proof that the market for love was bigger and richer than ever."[64] Press like this can be psychologically debilitating, and rumors long persisted that an unfriendly art world was one of the reasons Indiana moved to Maine in 1978.[65]

Starting in 1969 and culminating with his second *Love* exhibition of 1972, Indiana sought to repossess the work. John Perreault noted of the 12-foot Cor-ten steel *Love* that the artist completed in 1970, "It seems that Indiana is willfully trying to reclaim his design and this, no matter how foolhardy, is admirable" (Figure 60).[66] Indiana personally financed the work, which was made at Lippincott's, Inc., metal fabricators in North Haven, Connecticut, and he produced a documentary flier with photographs done at the plant of

Figure 59

Members of the cast of *Hair* (Paul Jabara, Suzannah Norstrand, Hiram Keller) with *Love* print, reproduced in *After Dark* (August 1966).

himself and the metalworkers "making love." From Connecticut the sculpture traveled an exhibition route to the new Indianapolis Museum of Art (which purchased it), then on to Boston, and finally to New York, before returning to Indiana in 1971. At the time, the big *Love* addressed the newly expanding field of sculpture, which was spilling out of galleries to merge with architecture, landscape, and environment.[67] *Love*'s erection in Central Park was an art event, a kind of performance that drew crowds despite a bitter November rain. A cheer went up when the titanic *O* was finally placed by a crane, completing the five-ton work.[68] In 1978 Indiana created a sequel, a 12-foot steel *Ahava*, for the State of Israel Museum.

In 1972 the United States Government approached Indiana about adapting his red-green-and-blue *Love* to the design of a postage stamp (Figure 61). Postal authorities acted on the suggestion of the Citizens Stamps Advisory Committee, 11 professionals in art, history, literature, graphics, and philately, who advised on the creation of some dozen commemorative stamps at that time issued annually.[69] The story made national news since, as a commemoration of an abstract emotion, the theme was a totally new direction for United States stamps, and besides generated good publicity for the government agency. Postal authorities explained that *Love* gave them the opportunity to respond to thousands of requests they had had over the years for stamps "appropriate" for love letters, valentines, and wedding and shower invitations. The stamp was issued on Valentine's Day, 1973, with the ceremonial place of issue the "Love City," Philadelphia. Together with its reissue in 1974, 330 million stamps were issued. It was altogether the largest commemorative up to that time (except for Christmas stamps) and long after, and it initiated generations of Love stamps, more puerile designs with flowers, hearts, or puppydogs, that continue today.

Adapting the image to the oblong commemorative format and coupling it with *US 8¢*, the *Love* stamp officially usurped Indiana's American Dream ideology—and his visual voice. The artist had proudly responded to the postal service's request that he design it, and he received a flat fee of $1,000. He has said he considers it public *editioned* art, a vast "multiple," and as such, ironically, it reechoes the first mailed-out *Love*s, the Christmas cards of 1964 and 1965. He has also pointed to the lineage of "forgotten" artists—like Gutzon Borglum and Frédéric Bartholdi—a tradition in which public works eclipse artistic identity: "Everybody knows my *Love*," he told an interviewer in 1976, "But they don't have the slightest idea what I look like. I'm practically anonymous."[70]

Fredric Jameson has described the 1960s' quality of overextension as being like "an immense and inflationary issuing of credit; . . . an extraordinary printing up of ever more devalued signifiers."[71] In the aftermath of the 1960s, *Love* was such a signifier, but not an entirely devalued one, rather one that has endured trivialization and criticism. Its strength as a survivor lies exactly in its mobility and ability to

Figure 61

Page of *Love* stamps, 1973–74.

absorb new meanings in the course of its own exploitation. This is the phenomenon that best explains *Love*'s endurance. On it rely *Love*'s descendants, strong examples of word art since the 1970s that more consciously and more critically explore the nature of subjectivity and its manipulation by language. *Love*'s voice can be found in Jenny Holzer's LED boards and Barbara Kruger's pseudo-advertisements such as *Untitled: "I am the real thing,"* or *Untitled: "You Thrive on Mistaken Identity,"* which draw their viewers into a collaborative project of

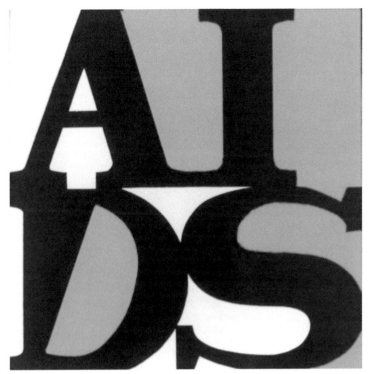

self-destruction/construction. Nancy Dwyer has demonstrated the dominating power of words in her inflated polyurethane and nylon sculptures like *Big Ego*, and Christopher Wool's stark stenciled pop song lyrics reveal to us a cultural prison with bars made of words. These works mimic, probably unwittingly, Indiana's *Love*, which attaches to them as a strong precursor. It is not at all a matter of conscious stylistic influence, but rather of an image that we cannot "unsee" once it has been seen.

Like contemporary bricolage ("the signified changes into the signifier and vice versa"[72]), *Love* often turns up as a subject employed to invoke the libidinal character of the 1960s. With the awareness of AIDS in the 1980s—a disease that itself acts like a signifier of the "sixties moment" (in the common puritanical view of the disease as just reward for that period's social ills and their legacy)—a specific group of revisionary *Love* artworks issued forth, pairing *love* (rather than *eat*) and death. Among these are Jiri Georg Dokoupils' *Love (For JK and RI)* (1986), Act Up's *Riot* (in 1989, commemorating the 20th anniversary of the Stonewall riots as well as the current epidemic), and Marlene McCarty's *Love, AIDS, Riot* (1990).[73] But the best-known appropriation of the 1980s is *AIDS* by the collaborative group General Idea (Figure 62). Representing both the fate of Indiana's *Love* and the cultural climate that precipitated it, General Idea varied the color scheme of its *AIDS* paintings and recycled the design in sundry media including an edition of stamps, silkscreened wallpaper (more reminiscent of Warhol than of Indiana), and posters distributed ("given away") in subways and on street corners of New York and San Francisco.[74]

Figure 62

General Idea, *AIDS*, 1987, acrylic on canvas, 96 x 96 inches.

Photograph courtesy Koury Wingate Gallery, New York.

Appropriations of *Love* have mounted up like ex-votos at the shrine of a good cult statue. *Love* is a big-brotherly sign offering faceless comfort to a decentered, technologized culture, in which identity is reckoned externally, through language and media. (Already in 1914 Gertrude Stein warned: "Act so that there is no use in a centre."[75]) In the 1960s individual selfhood gave way to awareness of collective identities, and an illusion died. *Love*, the verbalization of desire, became the rhetorical figure of that transition. It

attached itself to the aftermath's sense of loss and remains its relic. A few years ago, when I published a call for examples of recycled *Loves*, the overwhelming response included not just more commercial renditions, but also intimate or homemade ones—*Love* used as a theme of a wedding or patterned into a hooked rug, somehow recathected into the realm of the personal. The power of *Love* began with its visual force and its fit with the social context. But the notorious past—and present—of that imaged word is due ultimately to our attraction (and sometimes revulsion) to images that draw us into the shadows of ourselves. *Love* remains an aura or emanation of self-remembrance: an upright, speaking subject, an Apollonian imaged voice.

Notes

This essay is based on a chapter in my book, *Figures of Speech: The Art of Robert Indiana, 1958–1973*, forthcoming from Yale University Press.

1. Phyllis Tuchman, "Pop! Interviews with George Segal, Andy Warhol, Roy Lichtenstein, James Rosenquist, and Robert Indiana," *Art News* 73, no. 5 (May 1974): 29.

2. Aldo Pellegrini, *New Tendencies in Art*, trans. Robin Carson (New York: Crown Publishers, 1966), 236.

3. Clement Greenberg, postcard to author, October 2, 1991.

4. Comments by Alfred H. Barr, Jr., Director of Museum Collections; "Recent Acquisitions: Painting and Sculpture, Dec. 19–Feb. 25, 1962," press release, The Museum of Modern Art Archives; Mario Amaya, *Pop Art ...and After* (New York: Viking Press, 1966), 80.

5. More recently Indiana painted the imaged word on one side of a piece of the Berlin Wall, and the word *wall* on the other. Indiana was the only American artist invited by the ex-diplomatic analyst Cal Worthington to paint one of the segments of the Wall that Worthington brought out of Berlin (the other 113 artists are all Russian). See Paul Elmowsky, "The Plaza, the Artist, and the Wall: The Forbes Report," *Sunstorm Arts Magazine* (October 1991): 13.

6. Lucy Lippard, ed., *Pop Art* (New York: Frederick A. Praeger, 1966), 122. Many other, similar comments could be cited, as those found in, most recently, Simon Morley, "Signs of the Times: Robert Indiana in Perspective," *Art Line International Art News* 5, no. 6 (Winter 1991–92): 10.

7. Indiana, personal interview, May 5, 1992.

8. Quoted in Barbaralee Diamonstein, "Robert Indiana," *Inside New York's Art World* (New York: Rizzoli International, 1979), 151. This story is frequently repeated by the artist, as he did during a personal interview with the author, January 12, 1991.

9. Indiana, personal interview, September 1, 1992.

10. Published by the Vinalhaven Press and Todd Brassner.

11. Larry Aldrich, personal interview, November 26, 1990.

12. The phrase appears in several places but perhaps best known in 1 John 4:8. In her writings Eddy, the founder of the Christian Science movement, uses Love with a capital *L* as a synonym for God.

13. However, it also appears around the pentagon in the central mandala of *The Figure Five*. The artist recalls that at the time of *Love Is God* he was working on the *Brooklyn Bridge* and *Mother* and *Father*, paintings that required an exhaustive range of grays, a fact that partly influenced the color decisions of the one commissioned by Aldrich.

14. Indiana, personal interview, August 28, 1989. The most recent recounting of this incident, by a writer who checked with both Indiana and Kelly, is Paul Taylor, "Love Story," *Connoisseur* 221, no. 955 (August 1991): 95.

15. See W. J. Rorabaugh, *Berkeley at War: The 1960s* (New York: Oxford University Press, 1989). According to Rorabaugh, the students by this time were incensed by any incidents of verbal hypocrisy. In March a student named John Thomson sat down on the steps of the Student Union with the word *fuck* pinned to his chest. Essentially it restated FSM's "Freedom under Clark Kerr." When Thomson was arrested by university police for public obscenity, fellow students became angry, since a student, as part of a fraternity prank, had recently paraded freely on campus as "Miss Pussy Galore" (Rorabaugh 38ff.).

16. Rorabaugh, 187–189. Only the most obvious example of this is the usage change from *negro* to *black* in this period (which was a return to a 19th-early-20th-century term that had been used by whites, and turning that term on its head). On autonomy of the youth cults' generalizing neologisms, see Clifford Adelman, *Generations: A Collage on Youthcult* (New York: Praeger, 1972), chapter 4.

17. Indiana, work records, Star of Hope, Vinalhaven, Maine.

18. Rosalind Krauss, "Boston Letter," *Art International* 8, no. 1 (November 15, 1964): 42.

19. In 1972 Indiana said the 1964 *Love* was "a return, after several years of fascination with the circle (symbolic . . . of the eternal) as the dominating form in my work, to the quartered canvas." In Galerie Denise René, *Robert Indiana* (New York: Galerie Denise René, 1972).

20. Lettering and typeface handbooks have long noted the expressive associative potential of the different styles. In particular, the traditional serif styles are visually more connotative than the sans serifs, which had been in use in journalism early in the century. See discussion of typefaces in American advertising in Marc Treib, "Eye Konism (Part Three): The Word as Image," *Print* 27 (July–August 1973): 51, 75.

21. The particular variation of Roman letter style Indiana used was, as earlier in his work, inspired by the found stencils. More than anything else, it seems to correspond to New York or Times Roman that was current early in the 20th century. See, for example, Charles L. H. Wagner, *Wagner's Blue Print Text Book of Sign and Show Card Lettering* (Boston: Wagner School of Sign Arts, 1926), 63–64 and plates 32–33.

22. Diamonstein, 151.

23. Indiana, telephone interview, June 15, 1992.

24. Both repeated in Taylor, 49 and 95.

25. This is the recollection of the artist (Indiana, telephone interview, June 15, 1992).

26. Indiana (in Diamonstein, 153) says it was a gift to benefit the Junior Council and thus the museum, which owned his *Moon* and *The American Dream I.*

27. Dore Ashton, "The 'Anti-Compositional Attitude' in Sculpture: New York Commentary; Exhibition at the Stable Gallery," *Studio International* 172, no. 879 (July 1966): 46.

28. Lucy Lippard, "New York Letter," *Art International* 10, no. 6 (Summer 1966): 115.

29. Robert Indiana, work records, Star of Hope, Vinalhaven, Maine.

30. Current legislation is referred to as the Copyright Law (Title 17, United States Code); see also chapter 9, "Works Created before 1978," in William S. Strong, *The Copyright Book: A Practical Guide*, 2d ed. (Cambridge, Mass.: MIT Press, 1989).

31. Indiana, note to manuscript for Ryan, "Figures of Speech: The Art of Robert Indiana, 1958 –73" 2 vols., Ph.D.diss., University of Michigan, 1993.

32. Mondrian in the Yves St. Laurent line of 1964 and the "Go-Go" look by Mary Quant; Riley in dresses marketed by none other than Aldrich himself.

33. Susan Rubin Sulieman, *Subversive Intent: Gender, Politics, and the Avant-Garde* (Cambridge, Mass.: Harvard University Press, 1990), 198 –99; and her sources, Max Horkheimer and Theodor W. Adorno, "The Culture Industry: Enlightenment as Mass Deception," in *Dialectic of Enlightenment*, trans. John Cumming (New York: Continuum, 1982); and Thomas Crow, "Modernism and Mass Culture in the Visual Arts," in *Modern Art in the Common Culture* (New Haven, Conn.: Yale University Press, 1996). Crow states that the cycle begins with material that artists glean from subcultural groups that is first recycled as high art.

34. William Katz, personal interview, February 12, 1990; Indiana, personal interview, January 13, 1991.

35. Benjamin, "The Work of Art in the Age of Mechanical Reproduction," in *Illuminations*, ed. Hannah Arendt, trans. Harry Zohn (New York: Schocken Books, 1969).

36. Harold Bloom, *Agon: Towards a Theory of Revisionism* (New York: Oxford University Press, 1982), 230, discussing Benjamin, "On Some Motifs in Baudelaire," in *Illuminations.*

37. Each was hand-cut, polished to a mirror finish, by Tritell Gratz of Hunters Point, New York, under the supervision of Herbert Feuerlicht (Robert Indiana, work records, Star of Hope, Vinalhaven, Maine). On Goodman, see Constance W. Glenn, *The Great American Pop Art Store: Multiples of the Sixties* (Santa Monica: Smart Art Press; Long Beach: University Art Museum, California State University, 1997).

38. Indiana, personal interview, January 13, 1991, and telephone interview, June 15, 1992; the patent suggestion emerged in further discussion with Goodman and her lawyer.

39. See Todd Gitlin, *The Sixties: Years of Hope, Days of Rage* (New York: Bantam, 1987), chapter 8.

40. March 27, 1967. "Love-In," *Oxford English Dictionary*, 1989 ed.: Language Research Service, Merriam-Webster, Inc., letter to the author, October 25, 1990. It was among the earliest spin-offs from the massive "Human Be-In," also known as "A Gathering of Tribes," in San Francisco's Golden Gate Park two months before (January 1967), at which "love" rhetoric abounded (Gitlin, *The Sixties,* 208 –9).

41. Todd Gitlin, *The Whole World Is Watching: Mass Media in the Making and Unmaking of the New Left* (Berkeley: University of California Press, 1980); and Andrew Ross, *No Respect: Intellectuals and Popular Culture* (New York: Routledge, 1989), 143 –44.

42. *Newsweek*, April 25, 1966, 57.

43. See Ross, chapter 5, "Uses of Camp," and Susan Sontag, "Notes on Camp" (1964), in *Against Interpretation* (New York: Dell, 1966). *Camp* was in use in theatrical circles long before, as a term for homosexual mannerisms (pointed out to me by George Hersey).

44. Ross, 146 – 47.

45. On author as "owner," see Michel Foucault, "What Is an Author?" in *The Foucault Reader*, ed. Paul Rabinow (New York: Pantheon Books, 1984).

46. Philip Fisher, "Jasper Johns and Museum Art," in Fisher, *Making and Effacing Art: Modern American Art in a Culture of Museums* (New York: Oxford University Press, 1991).

47. Whiting, chapter 1, "Shopping for Pop," in her *A Taste for Pop: Pop Art, Gender, and Consumer Culture* (New York: Cambridge University Press, 1997).

48. Ross, 166.

49. Marco Livingston, "Do It Yourself: Notes on Warhol's Techniques," *Andy Warhol: A Retrospective* (New York: The Museum of Modern Art, 1989), 65.

50. Foucault, "What Is an Author?"

51. In Ross, 168.

52. *The Philosophy of Andy Warhol (from A to B and back Again)* (New York: Harcourt, Brace & Co., 1975), 77.

53. Although Indiana says he learned this practice from Kelly; note to author, September 2, 1992. Warhol, trained as a commercial artist, sometimes did this as well.

54. John de Menil, letter to Robert Indiana, June 26, 1967, The Menil Collection, Houston, Texas. The pavilion was to have continued the idea of the Rothko Chapel, earlier commissioned by the de Menils, in that it was conceived as a church filled with specifically commissioned contemporary art. The projected pavilion never materialized, however, and the *Love Cross* entered the Menil Collection.

55. The rings were issued in 1968 (Robert Indiana, work records, Star of Hope, Vinalhaven); Indiana, personal interview, May 5, 1992. See also "Love's Ring," *New York*, February 17, 1969.

56. Robert Indiana, work records, Star of Hope, Vinalhaven.

57. Information concerning the *Love* spin-offs and rip-offs was obtained from Indiana, personal interview, January 13, 1991.

58. Indiana recalls that a Mr. Gold, of a small company in Conshohocken, Pennsylvania, at first approached him about the paperweights, but the artist rejected the idea as grossly acquisitive and the product too poorly made. This was the premier rip-off that opened the floodgate. Robert Indiana, personal interview, January 13, 1991.

59. Gitlin, *The Sixties*, chapter 10; also see William L. O'Neill, *Coming Apart: An Informal History of America in the 1960s* (New York: Quadrangle Books, 1971), chapters 11 and 12.

60. Glenn, 28.

61. *Shit* was a folding paper image and a poster. Robert Indiana, personal interviews, January 13, 1991, and June 15, 1992; and Diamonstein, 154.

62. John Canaday, "Aesop Revised, or the Luck of the Orthopterae," *New York Times*, December 3, 1972, D21.

63. John Perreault, "Having a Word with the Painter," *Village Voice*, December 7, 1972, 34.

64. David Kunzle, "Pop Art as Consumerist Realism," *Studies in Visual Communication* 10, no. 2 (Spring 1984): 24.

65. Indiana says he moved because he had never purchased his Spring Street loft building and his landlord there decided to renovate—and he had already acquired the Odd Fellows Lodge on Vinalhaven island, which offered the space he needed (personal interview, January 13, 1991).

66. Perreault, 34.

67. See Rosalind Krauss, "Sculpture in the Expanded Field," in *The Originality of the Avant-Garde and Other Modernist Myths* (Cambridge, Mass.: MIT Press, 1985), 276–90.

68. See George Gent, "5-Ton Sculpture Says It in a Word," *New York Times*, November 30, 1971, n.p. The whole event provided the centerpiece for John Huszar's film *Robert Indiana Portrait*, released in 1973.

69. For this and information following: Rudy Maxa (Washington Post Service), "That Love Stamp Is Still Stirring up Waves," *Philadelphia Inquirer*, March 25, 1973, 8-A; and Indiana, personal interview, January 13, 1991, and telephone interview, June 15, 1992. Indiana recalls the idea was especially promoted by one particular committee member who was a graphic designer himself and an enthusiast of Indiana's work.

70. Robert Indiana, personal interview, September 1986; quotation from Jeff Goldberg, "Love," *The Unmuzzled Ox* 4, no. 2 (1976): 19. Borglum and Bartholdi are the artists of Mount Rushmore and the Statue of Liberty, respectively.

71. Jameson, "Periodizing the 60s," *The Sixties without Apology*, ed. Sohnya Sayres, Anders Stephanson, Stanley Aronowitz, and Jameson (Minneapolis: University of Minnesota Press in cooperation with *Social Text*, 1984), 208.

72. Levi-Strauss speaking of *bricolage* in *The Savage Mind*, trans. George Weidenfeld and Nicolson Ltd. (Chicago: University of Chicago Press, 1966), 21.

73. Fredric Jameson, "Postmodernism, or the Cultural Logic of Late Capitalism," *New Left Review* 146 (1984): 53–92. Dokoupils's RI and JK are Robert Indiana and Joseph Kosuth; the painting is owned by Kosuth and Cornelia Lauf, who informed me of its existence.

74. Joshua Decter, "General Idea," *Arts Magazine*, September 1988, 102.

75. It is the opening line of "Rooms" in *Tender Buttons*, her multipart prose-poem originally published in 1914. Stein, *Selected Writings of Gertrude Stein*, ed. Carl Van Vechten (New York: Vintage, 1990), 498.

Checklist of the Exhibition

All works are by Robert Indiana (given name Robert Clark), United States, born 1928. All dimensions are given in inches, height preceding width.

1. *Ginkgo*
 1958 – 60 (Figure 16)
 gesso on wood
 15 $^1/_2$ x 8 $^7/_8$
 Private collection, courtesy Simon Salama-Caro

2. *Duncan's Column*
 1960
 oil on wood
 75 $^1/_2$ x 18
 Collection of the artist

3. *Orb*
 1960
 oil and iron on wood
 45 x 19 x 13
 Private collection, courtesy Simon Salama-Caro

4. *Terre Haute*
 1960
 oil on canvas
 60 x 30
 Private collection, courtesy Simon Salama-Caro

5. *Electi*
 1960 – 61 (Figure 29)
 oil on canvas
 71 $^1/_2$ x 44 $^{13}/_{16}$
 Portland Museum of Art, Maine. Gift of the artist, 1997.5

6. *The Sweet Mystery*
 1960 – 61 (Figure 17)
 oil on canvas
 72 x 60
 Private collection, courtesy Simon Salama-Caro

7. *The Triumph of Tira*
 1960 – 61 (Figure 20)
 oil on canvas
 72 x 60
 Sheldon Memorial Art Gallery and Sculpture Garden,
 University of Nebraska-Lincoln. Nebraska Art Associa-
 tion Collection, Nelle Cochrane Woods Memorial,
 1964.N-174

8. *The American Reaping Company*
 1961 (Figure 24)
 oil on canvas
 60 x 48
 Herbert Lust Gallery

9. *The Calumet*
 1961 (Figure 25)
 oil on canvas
 90 x 84
 Rose Art Museum, Brandeis University, Waltham,
 Massachusetts. Gevirtz-Mnuchin Purchase Fund, 1962

10. *A Divorced Man Has Never Been the President*
 1961 (Figure 27)
 oil on canvas
 60 x 48
 Sheldon Memorial Art Gallery and Sculpture Garden,
 University of Nebraska-Lincoln. Gift of Philip Johnson,
 1968.U-581

11. *4-Star Love*
 1961
 oil on canvas
 12 x 12
 Portland Museum of Art, Maine. Gift of Todd R. Brassner
 in memory of Doug Rosen,
 1999.7

12. *Chief*
 1962
 oil and iron on wood
 64 $^1/_2$ x 23 $^1/_2$ x 18 $^1/_2$
 Private collection, courtesy Simon Salama-Caro

13. *The Green Diamond Eat The Red Diamond Die*
 1962 (Figure 21)
 oil on canvas
 two panels, each: 60 $^1/_4$ x 60 $^1/_4$
 Collection Walker Art Center, Minneapolis.
 Gift of the T. B. Walker Foundation, 1963

14. *#1*
1962
oil on canvas
24 x 24
Herbert Lust Gallery

15. *Polygon: Square*
1962 (Figure 34)
oil on canvas
24 x 24
Herbert Lust Gallery

16. *Star*
1962
oil, gesso, iron, and wood
76 x 18 x 13
Albright-Knox Art Gallery, Buffalo, New York.
Gift of Seymour H. Knox, 1963

17. *The Beware — Danger American Dream No. Four*
1963 (Figure 33)
oil on canvas
four panels, assembled: 102 $\frac{1}{4}$ x 102 $\frac{1}{4}$
Hirshhorn Museum and Sculpture Garden, Smithsonian
Institution. Gift of Joseph H. Hirshhorn Foundation, 1966

18. *The Demuth American Dream No. 5*
1963 (Figure 35; front cover)
oil on canvas
five panels, assembled: 144 x 144
Art Gallery of Ontario, Toronto. Gift from the Women's
Committee Fund, 1964

19. *The Figure Five*
1963
oil on canvas
60 x 50
National Museum of American Art, Smithsonian
Institution, 1984.51

20. *Small Black Diamond Polychrome Numeral
Quartet Summing 30*
1963
oil on canvas
24 x 24
Collection of Robert L. B. Tobin, courtesy of the McNay
Art Museum

21. *The X-5*
1963
oil on canvas
five panels, assembled: 108 x 108
Collection of Whitney Museum of American Art,
New York. Purchase, 64.9

22. *Yield Brother II*
1963 (Figure 31)
oil on canvas
60 $\frac{1}{4}$ x 60 $\frac{1}{4}$
Collection of Elliot K. Wolk, Scarsdale, New York

23. *Column: Eat/Hug/Die*
1964
wood and gesso
height: 78
Private collection, courtesy Simon Salama-Caro

24. *Love*
1964 (see Figure 53)
colored pencil on paper
8 x 8
Arthur C. Carr

25. *Yield Brother*
1964 (Figure 32)
oil on canvas
24 x 24
Herbert Lust Gallery

26. *Alabama*
1965 (Figure 26)
oil on canvas
70 x 60
Miami University Art Museum, Oxford, Ohio.
Gift of Walter and Dawn Clark Netsch, 1982.185

27. *Four*
1965 (Figure 52)
oil on canvas
12 x 12
Herbert Lust Gallery

28. *#5*
1966
oil on canvas
24 x 24
Herbert Lust Gallery

29. *#4*
1966
oil on canvas
12 x 12
Herbert Lust Gallery

30. *The Great Love*
1966 (Figure 54; backcover)
oil on canvas
four panels, assembled: 120 x 120
Carnegie Museum of Art, Pittsburgh.
Gift of the Women's Committee, 67.23

31. *Love*
1966 (Figure 47)
acrylic on canvas
71 $^7/_8$ x 71 $^7/_8$
Indianapolis Museum of Art. James E. Roberts Fund,
IMA67.08

32. *Love* exhibition poster, Stable Gallery
1966 (reprinted 1971) (Figure 55)
silkscreen on paper
32 x 24
Collection of the artist

33. *Model-T Ford*
1966
papier collé
26 $^1/_8$ x 20
Collection of the McNay Art Museum.
Gift of Robert L. B. Tobin, 1978.11.39

34. *Love*
1967 (Figure 56)
aluminum
11 $^7/_8$ x 11 $^7/_8$ x 6
Hirshhorn Museum and Sculpture Garden, Smithsonian
Institution. Gift of Joseph H. Hirshhorn, 1972

35. *The Metamorphosis of Norma Jean Mortenson*
1967 (Figure 38)
oil on canvas
102 x 102
Collection of Robert L. B. Tobin, courtesy of
the McNay Art Museum

36. *Mother* and *Father*
1963 – 67 (Figure 37)
oil on canvas
two panels, each: 70 x 60
Collection of the artist

37. *American Love*
1968 (Frontispiece, pages 134—35)
oil on canvas
two panels, assembled: 12 x 25
Herbert Lust Gallery

38. *Grey Love Wall*
1968
oil on canvas
four panels, assembled: 24 x 24
Herbert Lust Gallery

39. *Love Cross*
1968 (Figure 57)
oil on canvas
five panels, assembled: 180 x 180
The Menil Collection, Houston, 78—131 E

40. *Flagellant*
1963 – 69
wood, rope, iron, wire, and oil
height: 63 $^1/_2$
Collection of Robert L. B. Tobin, courtesy of
the McNay Art Museum

41. *Black and White Love*
from the *Decade* portfolio
1971
silkscreen on Schoellers Parole paper,
 artist's proof, 17/25
printed by Domberger KG, Filderstadt, Germany
published by Multiples, New York
paper: 39 x 32
image: 35 $^5/_8$ x 30
Portland Museum of Art, Maine. Gift of the artist,
1996.50.1.8A,B

42. *Yield Brother* from the *Decade* portfolio
 1971 (Figure 30)
 silkscreen on Schoellers Parole paper,
 artist's proof, 17/25
 printed by Domberger KG, Filderstadt, Germany
 published by Multiples, New York
 paper: 39 x 32
 image: 35 $^5/_8$ x 30
 Portland Museum of Art, Maine. Gift of the artist,
 1996.50.1.3A,B

43. *The Great American Love*
 1972
 oil on canvas
 four panels, assembled: 288 x 288
 Private collection, courtesy Simon Salama-Caro

44. *Jesus Saves*
 1972
 oil on canvas
 diameter: 60
 In the Collection of the Corcoran Gallery of Art.
 Gift of Lowell B. Nesbitt, in memory of his mother,
 Mildred C. Nesbitt, 1975.45

45. *Love (Red, White, Black)*
 1974
 oil on canvas
 60 x 60
 Herbert Lust Gallery

46. *Decade Autoportrait 1960*
 1977 (Figure 40)
 oil on canvas
 72 x 72
 Private collection, courtesy Simon Salama-Caro

47. *An Honest Man Has Been President:*
 A Portrait of Jimmy Carter
 1980 (Figure 28)
 silkscreen on paper, edition of 150
 printed by Alexander Heinrici, New York
 published by the Democratic National Committee,
 Washington, D.C.
 paper: 23 $^1/_2$ x 19 $^9/_{16}$
 image: 21 x 18
 Collection of the artist

48. *Decade: Autoportrait '70 (Vinalhaven)*
 from *Vinalhaven Suite*
 1980
 silkscreen on Fabriano Classico paper, edition of 125
 printed by Domberger KG, Filderstadt, Germany
 published by Multiples, New York
 paper: 26 $^3/_4$ x 25 $^3/_4$
 image: 24 x 24
 Collection of the artist

49. *Decade: Autoportrait '71 (Isle au Haut)*
 from *Vinalhaven Suite,* 1980
 silkscreen on Fabriano Classico paper, edition of 125
 printed by Domberger KG, Filderstadt, Germany
 published by Multiples, New York
 paper: 26 $^3/_4$ x 25 $^3/_4$
 image: 24 x 24
 Collection of the artist

50. *Decade: Autoportrait '72 (Penobscot)*
 from *Vinalhaven Suite*
 1980
 silkscreen on Fabriano Classico paper, edition of 125
 printed by Domberger KG, Filderstadt, Germany
 published by Multiples, New York
 paper: 26 $^3/_4$ x 25 $^3/_4$
 image: 24 x 24
 Collection of the artist

51. *Decade: Autoportrait '73 (Crockett Cove)*
 from *Vinalhaven Suite*
 1980
 silkscreen on Fabriano Classico paper, edition of 125
 printed by Domberger KG, Filderstadt, Germany
 published by Multiples, New York
 paper: 26 $^3/_4$ x 25 $^3/_4$
 image: 24 x 24
 Collection of the artist

52. *Decade: Autoportrait '74 (Hurricane)*
 from *Vinalhaven Suite*
 1980
 silkscreen on Fabriano Classico paper, edition of 125
 printed by Domberger KG, Filderstadt, Germany
 published by Multiples, New York
 paper: 26 $^3/_4$ x 25 $^3/_4$
 image: 24 x 24
 Collection of the artist

53. *Decade: Autoportrait '75 (Carver's Pond)*
 from *Vinalhaven Suite*
 1980
 silkscreen on Fabriano Classico paper, edition of 125
 printed by Domberger KG, Filderstadt, Germany
 published by Multiples, New York
 paper: 26 $^3/_4$ x 25 $^3/_4$
 image: 24 x 24
 Collection of the artist

54. *Decade: Autoportrait '76 (Coomb's Neck)*
 from *Vinalhaven Suite*
 1980
 silkscreen on Fabriano Classico paper, edition of 125
 printed by Domberger KG, Filderstadt, Germany
 published by Multiples, New York
 paper: 26 $^3/_4$ x 25 $^3/_4$
 image: 24 x 24
 Collection of the artist

55. *Decade: Autoportrait '77 (Tiptoe Mt.)*
 from *Vinalhaven Suite*
 1980
 silkscreen on Fabriano Classico paper, edition of 125
 printed by Domberger KG, Filderstadt, Germany
 published by Multiples, New York
 paper: 26 $^3/_4$ x 25 $^3/_4$
 image: 24 x 24
 Collection of the artist

56. *Decade: Autoportrait '78 (Star of Hope)*
 from *Vinalhaven Suite*
 1980
 silkscreen on Fabriano Classico paper, edition of 125
 printed by Domberger KG, Filderstadt, Germany
 published by Multiples, New York
 paper: 26 $^3/_4$ x 25 $^3/_4$
 image: 24 x 24
 Collection of the artist

57. *Decade: Autoportrait '79 (Brimstone)*
 from *Vinalhaven Suite*
 1980
 silkscreen on Fabriano Classico paper, edition of 125
 printed by Domberger KG, Filderstadt, Germany
 published by Multiples, New York
 paper: 26 $^3/_4$ x 25 $^3/_4$
 image: 24 x 24
 Collection of the artist

58. *Five*
 1984
 painted wood ceiling beam, wood dowel, wood block,
 and metal wheels
 69 $^1/_8$ x 26 $^3/_4$ x 18 $^1/_2$
 National Museum of American Art, Smithsonian Institution.
 Gift of the artist, 1984.39

59. *Gem*
 1961–84
 oil and iron on wood
 71 x 15 $^1/_4$ x 15 $^1/_2$
 Portland Museum of Art, Maine. Lent by the artist, L489

60. *American Dream*
 1986 (Figure 42)
 hard- and soft-ground etching, aquatint, drypoint, and
 stencil on Arches Cover paper
 printed by Anthony Kirk
 published by the Vinalhaven Press
 paper: 29 $^{15}/_{16}$ x 22 $^3/_8$
 image: 26 $^{15}/_{16}$ x 13
 Portland Museum of Art, Maine. Museum purchase,
 1986.238

61. *Mother of Exiles*
 1986 (Figure 43)
 hard-ground etching and aquatint on Arches Cover paper,
 edition of 15
 printed by Anthony Kirk, Orlando Condeso, and Susan
 Volker
 published by the Vinalhaven Press
 paper: 47 $^1/_2$ x 31 $^1/_2$
 image: 36 x 24
 Courtesy Vinalhaven Press

62. *KvF I* from *The Hartley Elegies: The Berlin Series*
 August 1990
 silkscreen on Saunders watercolor paper
 printed by Bob Blanton, Istvan Kosbor, Tom Little, and
 Bill Wygonik, Brand X Editions, Ltd., New York
 published by Park Granada Editions, Woodland Hills,
 California
 paper: 80 x 55
 image: 76 $^1/_4$ x 53 $^3/_8$
 Portland Museum of Art, Maine. Lent anonymously,
 L491

63. *Eat*
 1991
 oil on bronze
 60 x 15 $^1/_2$ x 17
 Collection of the artist, courtesy Simon Salama-Caro

64. *First Love*
 1991 (Figure 48)
 aquatint on Rives BFK paper
 edition of 66
 printed by James Davies Cambronne
 co-published by Vinalhaven Press and Todd Brassner
 paper: 27 x 20
 image: 12 x 11
 Courtesy Vinalhaven Press

65. *American Dream*
 1992
 gesso, oil, and metal on wood
 84 x 35 $^1/_2$ x 17
 Courtesy Simon Salama-Caro

66. *KvF XI*
 1989 – 94 (Figure 44)
 oil on canvas
 85 x 85
 Private collection, courtesy Simon Salama-Caro

67. *Wherefore the Punctuation of the Heart*
 from *The Book of Love*
 1996
 silkscreen and embossing on A.N.W. Crestwood
 Museum Edition paper, artist's proof, 7/15
 printed by Freeman Barks at American Image Editions,
 New York
 Portland Museum of Art, Maine. Gift of the artist,
 1997.19.14A–C

68. *Love*
 1966 – 98
 painted aluminum, artist's proof, 1/4
 36 x 36 x 18
 Private collection, courtesy Simon Salama Caro

69. *The X-7*
 1998
 oil on canvas
 five panels, each 60 x 60
 Private collection, courtesy Simon Salama-Caro

Annotated Bibliography

Compiled by Elizabeth A. Barry with contributions by Susan Elizabeth Ryan

1959

"Studio Workshop Begins 'Construction' Classes." *Scarsdale Inquirer*, November 27, 1959, 5.

1960

Alloway, Lawrence. "Notes on Abstract Art and the Mass Media." *Art News and Review* 12, no. 3 (February 1960): 3–12.

Canaday, John. "Art: A Wild but Curious, End-of-Season Treat." *New York Times*, June 7, 1960, 32.

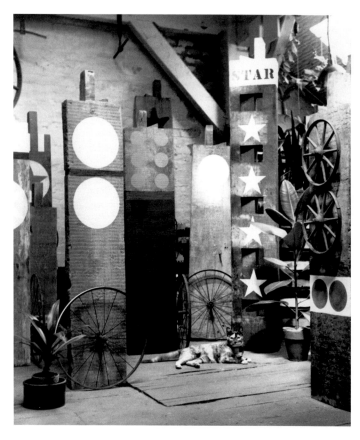

Assemblages in Indiana's studio,
Coenties Slip, New York, 1960.

——. "The Blind Artist: In a Crucial Time He Plays Games." *New York Times*, October 2, 1960, II-21.

Martha Jackson Gallery. *New Forms—New Media*. New York: Martha Jackson Gallery, 1960. Catalogue for the exhibition held June 1960. Foreword by Martha Jackson. Essays by Lawrence Alloway and Allan Kaprow.

Morse, John D. "He Returns to Dada." *Art in America* 48, no. 3 (1960): 77.

"Painting in Progress." *Scarsdale Inquirer*, January 22, 1960, 12.

Porter, Fairfield. "Art." *Nation*, October 15, 1960, page unknown.

1961

David Anderson Gallery. *Indiana/Forakis*. New York: David Anderson Gallery, 1961. Catalogue for the exhibition held April 1961.

The Museum of Modern Art. *The Art of Assemblage*. New York: The Museum of Modern Art, 1961. Catalogue for the exhibition held at the Museum of Modern Art, New York, October 2–November 12, 1961; Dallas Museum for Contemporary Arts, January 9–February 11, 1962; San Francisco Museum of Art, March 5–April 15, 1962. Foreword by William C. Seitz.

"New Pictures from the Museum of Modern Art's New Show." *New York Times*, December 24, 1961, X-14.

Swenson, Gene R. "Reviews and Previews: Peter Forakis and Robert Indiana; Exhibition at Anderson Gallery." *Art News* 60, no. 3 (May 1961): 20.

——. "Reviews and Previews: Stephen Durkee, Robert Indiana, and Richard Smith; Exhibition at Dance Studio Gallery." *Art News* 60, no. 4 (Summer 1961): 16.

Tillim, Sidney. "American Dream." *Arts Magazine* 35, no. 5 (February 1961): 34–35.

1962

Alloway, Lawrence. "Pop Art since 1949." *Listener* 67, no. 1761 (December 27, 1962): 1085.

Barr, Alfred H., Jr. *Recent Acquisitions: Painting and Sculpture*. New York:

The Museum of Modern Art, 1962. Catalogue for the exhibition held December 19, 1961–February 26, 1962.

Dwan Gallery. *My Country 'Tis of Thee*. Los Angeles: Dwan Gallery, 1962. Catalogue for the exhibition held November 18–December 15, 1962. Introduction by Gerald Nordland.

Frackman, Noel. "Indiana, Natkin Display Avant-Garde Paintings." *Scarsdale Inquirer*, March 29, 1962, page unknown.

Fried, Michael. "New York Letter." *Art International* 6, no. 9 (November 1962): 53–56.

Genauer, Emily. "One for the Road Signs." *New York Herald Tribune*, October 21, 1962, IV-1, 7.

—. "New Realists Put Everyday Objects in Different Context." *New York Herald Tribune*, Paris edition, October 24, 1962, 5.

Jacobs, Rachael. "L'Idéologie de la peinture américaine." *Aujourd'hui* 7, no. 37 (1962): 6–19.

Kozloff, Max. "New York Letter." *Art International* 6, no. 2 (March 1962): 57–65.

—. " 'Pop' Culture, Metaphysical Disgust, and the New Vulgarians." *Art International* 6, no. 2 (March 1962): 34–36.

O'Doherty, Brian. "Art: Avant-Garde Revolt." *New York Times*, October 31, 1962, 41.

Seckler, Dorothy Gees. "Folklore of the Banal." *Art in America* 50, no. 4 (Winter 1962): 57–61.

Seldis, Henry J. "New Realism Comes in Humor, Cynicism." *Los Angeles Times*, December 2, 1962, 2.

Shepard, Richard F. "Painter Finishing Art Center Work." *New York Times*, March 8, 1964, 85.

Sidney Janis Gallery. *The New Realists: An Exhibition of Factual Paintings and Sculpture from France, England, Italy, Sweden, and the United States by the Artists*. New York: Sidney Janis Gallery, 1962. Catalogue for the exhibition held October 31–December 1, 1962. Introduction by John Ashbery. Essays by Sidney Janis and Pierre Restany.

Stable Gallery. *Robert Indiana*. New York: Stable Gallery, 1962. Catalogue for the exhibition held October 16–November 3, 1962.

Swenson, G. R. "The New American 'Sign Painters.' " *Art News* 61, no. 5 (September 1962): 44–47, 60–62.

—. "Reviews and Previews: Robert Indiana; Exhibition at Stable Gallery." *Art News* 61, no. 6 (October 1962): 14. Preview of exhibition.

Tillim, Sidney. "Month in Review." *Arts Magazine* 36, no. 5 (February 1962): 34–37. Overview of New York exhibitions.

—. "In the Galleries: The New Realists." *Arts Magazine* 37, no. 3 (December 1962): 43–4.

—. "In the Galleries: Robert Indiana." *Arts Magazine* 37, no. 3 (December 1962): 49. Review of exhibition at Stable Gallery.

van der Marck, Jan. "Robert Indiana." *The Museum of Modern Art Bulletin* 29, no. 2–3 (1962): 60.

1963

Albright-Knox Art Gallery. *Mixed Media and Pop Art*. Buffalo: Albright-Knox Art Gallery, 1963. Catalogue for the exhibition held November 19–December 15, 1963. Foreword by Gordon M. Smith.

Alloway, Lawrence. "Notes on Five New York Painters." *Buffalo Fine Arts Academy and Albright-Knox Art Gallery, Gallery Notes* 26, no. 2 (Fall 1963): 13–21.

"*Americans 1963* at the Museum of Modern Art, New York." *Art International* 7, no. 6 (June 25, 1963): 71–75.

The Art Institute of Chicago. *66th American Annual Exhibition*. Chicago: The Art Institute of Chicago, 1963. Catalogue for the exhibition held January 11–February 10, 1963. Foreword by A. James Speyer.

Ashton, Dore. "*Americans 1963* at the Museum of Modern Art." *Arts and Architecture* 80 (July 1963): 5. Review of exhibition.

Baro, Gene. "A Gathering of Americans." *Arts Magazine* 37, no. 10 (September 1963): 28–33. Review of *Americans 1963* at the Museum of Modern Art, New York.

Blade, Tim. "New Walker Show: Portrays 'American Environment.' " *Minnesota Daily*, October 23, 1963, 4–5.

Coplans, John. "*Pop Art U.S.A.*" *Artforum* 2, no. 4 (October 1963): 27–30. Review of Oakland Art Museum exhibition.

Genauer, Emily. "Battleground of Contemporary Art: Gallery Selects '101 Best' Paintings." *New York Herald Tribune*, September 8, 1963, IV-1, 7.

—. "The Art Critic up on Changes." *New York Herald Tribune*, May 12, 1963, 41, 47.

Hess, Thomas B. "Phony Crisis in American Art." *Art News* 62, no. 4 (Summer 1963): 24–28, 59–60.

MacAgy, Douglas. "Vox Pop." *Buffalo Fine Arts Academy and Albright-Knox Art Gallery, Gallery Notes* 26, no. 2 (Fall 1963): 5–12.

Magloff, Joanna. "Direction—American Painting, San Francisco Museum of Art." *Artforum* 2, no. 5 (November 1963): 43–44.

Messer, Thomas A. "Art for Everyday Living: Coins by Sculptors." *Art in America* 51, no. 2 (April 1963): 32–38.

Monte, James. "*Americans 1963*, San Francisco Museum of Art." *Artforum* 3, no. 1 (September 1963): 43–44.

The Museum of Modern Art. *Americans 1963*. New York: The Museum of Modern Art, 1963. Catalogue for the exhibition held May 22–August 18, 1963. Edited by Dorothy C. Miller.

Nordland, Gerald. "Pop Goes the West." *Arts Magazine* 37, no. 5 (February 1963): 60–62.

Oakland Art Museum. *Pop Art U.S.A.* Oakland, Calif.: Oakland Art Museum, 1963. Catalogue for the exhibition held September 7–29, 1963. Essay by John Coplans.

"Le *Pop Art*." *Aujourd'hui* 8 (October 1963): 195.

"Pop Art—Cult of the Commonplace." *Time*, May 3, 1963, 69–72.

"Pop Art Diskussion." *Das Kunstwerk* 17, no. 10 (April 1964): 2–33.

Indiana and Agnes Martin at the exhibition *Americans 1963*,
The Museum of Modern Art, New York, 1963.

Photograph by William Kennedy.

Poses Institute of Fine Arts, Brandeis University. *New Directions in American Painting.* Waltham, Mass.: Brandeis University, 1963. Catalogue for the exhibition held at Munson-Williams-Proctor Institute, Utica, New York, December 1963–January 1964; Isaac Delgado Museum of Art, New Orleans, February 7–March 8, 1964; Atlanta Art Association, Georgia, March 18–April 22, 1964; The J. B. Speed Art Museum, Louisville, Kentucky, May 7–June 7, 1964; Art Museum of Indiana University, Bloomington, June 22–September 20, 1964; Washington University, St. Louis, Missouri, October 5–30, 1964; The Detroit Institute of Arts, November 10–December 6, 1964. Essay by Sam Hunter.

Richardson, John. *The Dunn International: An Exhibition of Contemporary Painting.* Fredericton, New Brunswick: Arts Council; London: Westerham Press, 1963. Catalogue for the exhibition sponsored by the Sir James Dunn Foundation and held at Beaverbrook Art Gallery, Fredericton, New Brunswick, September 7–October 6,

1963; Tate Gallery, London, November 14–December 22, 1963. Foreword by M. Beaverbrook.

Selz, Peter. "Pop Goes the Artist." *Partisan Review* 30, no. 2 (Summer 1963): 313–16.

Selz, Peter, et al. "A Symposium on Pop Art." *Arts Magazine* 37, no. 7 (April 1963): 36–45. Contributions by Dore Ashton, Henry Geldzahler, Hilton Kramer, Stanley Kunitz, and Leo Steinberg.

Sherman, John K. "Metal Sculpture, 'Pop' Art Compete." *Minneapolis Sunday Tribune,* October 27, 1963, 13.

"Sold Out Art." *Life,* September 1963, 125–29.

Swenson, Gene R. "What Is Pop Art? Answers from Eight Painters, Part I: Jim Dine, Robert Indiana, Roy Lichtenstein, Andy Warhol." *Art News* 62, no. 7 (November 1963): 24–27, 59–64.

Walker Art Center. *Richard Stankiewicz, Robert Indiana: An Exhibition of Recent Sculptures and Paintings.* Minneapolis: Walker Art Center, 1963. Catalogue for the exhibition held at Walker Art Center, Minneapolis, October 22–November 24, 1963; Institute of Contemporary Art, Boston, December 14, 1963–January 26, 1964. Preface by Jan van der Marck with statements by the artists.

Washington Gallery of Modern Art. *Formalists.* Washington, D.C.: Washington Gallery of Modern Art, 1963. Catalogue for the exhibition held June 6–July 7, 1963. Foreword by Adelyn D. Breeskin.

Whitney Museum of American Art. *1963 Annual Exhibition: Contemporary American Painting.* New York: Whitney Museum of American Art, 1963. Catalogue for the exhibition held December 11, 1963–February 2, 1964.

1964

"Accessions of American and Canadian Museums: Indiana's *X-5* at the Whitney Museum of American Art." *Art Quarterly* 27, no. 3 (April–June 1964): 376, 391.

"Art." *Time,* February 21, 1964, 68.

"Biography of a Poster." *Program for Inaugural Performances.* New York: State Theater, Lincoln Center, April 1964, 2.

Brattinga, Pieter. "Robert Indiana, Grafik im Bild." *Gebrauchsgraphik* 35, no. 4 (April 1964): 52–56. With English, French and Spanish texts.

Canaday, John. "Pop Art Sells on and on—Why?" *New York Times Magazine,* May 31, 1964, 7, 48, 52–53.

Carlson, Walter. "Pavilion at Fair to Show Fine Art." *New York Times,* May 13, 1964, 35.

Davison Art Center, Wesleyan University. *The New Art.* Middletown, Conn.: Wesleyan University, 1964. Catalogue for the exhibition held March 1–22, 1964. Contribution by Lawrence Alloway.

"Eight-Foot Painting by Indiana, Original for Posters, on Exhibit, Philharmonic Hall Plaza." *New York Times,* April 14, 1964, 2.

Fundacao Calouste Gulbenkian. *Painting and Sculpture of a Decade, 54–64.*

London: Fundacao Calouste Gulbenkian with Shenval Press, 1964. Catalogue for the exhibition organized with the assistance of the Arts Council of Great Britain and the Association française d'Action artistique and held at Tate Gallery, London, April 22–June 28, 1964. Contributions by Alison Smithson and Peter Smithson.

Johnson, Philip. "Young Artists at the Fair and at Lincoln Center." *Art in America* 52, no. 4 (August 1964): 114–15.

Judd, Donald. "In the Galleries: Robert Indiana; Exhibition at Stable Gallery." *Arts Magazine* 38, no. 10 (September 1964): 61.

Kelly, Edward T. "Neo-Dada: A Critique of Pop Art." *Art Journal* 23, no. 3 (Spring 1964): 192–201.

Krauss, Rosalind. "Boston Letter." *Art International* 8, no. 1 (February 15, 1964): 32–4.

—. "Boston Letter." *Art International* 8, no. 9 (November 1964): 42–43.

"Lincoln Center Shows an Original." *New York Times*, April 14, 1964, 34.

Lord, J. Barry. "Pop Art in Canada." *Artforum* 2, no. 9 (March 1964): 28–31.

McDarrah, Fred. "Commanding Painter." *Time* 83, no. 21 (May 22, 1964): 72.

"More Art for Lincoln Center." *Musical America* 84, no. 5 (May 1964): page unknown.

Hofmann, Werner, and Otto A. Graf. *Pop, etc.* Vienna: Museum des 20. Jahrhunderts, 1964. Catalogue for the exhibition held September 19–October 31, 1964.

Oeri, G. "Object of Art." *Quadrum*, no. 16 (1964): 17.

Piene, Otto. *Group Zero*. Philadelphia: University of Pennsylvania, 1964. Catalogue for the exhibition held at the Institute of Contemporary Art, University of Pennsylvania, Philadelphia, October 30–December 11, 1964.

Rhode Island School of Design Museum of Art. *Paintings and Constructions of the 1960s Selected from the Richard Brown Baker Collection*. Providence: Rhode Island School of Design Museum of Art, 1964. Catalogue for the exhibition held October 2–25, 1964. Foreword by Hugh J. Gourley III. Introduction by Richard Brown Baker.

"Robert Indiana Designs Promotional Poster (Lincoln Center, New York State Theater): Interview." *New York Times*, March 8, 1964, 2, 5.

Rose Art Museum. *Recent American Drawings*. Waltham, Mass.: Brandeis University, 1964. Catalogue for the exhibition held at Rose Art Museum, Brandeis University, Waltham, Massachusetts, April 19–May 17, 1964. Foreword by Sam Hunter. Introduction by Thomas H. Garver.

Shepard, Richard F. "Painter Finishing Art Center Work." *New York Times*, March 8, 1964, 83–84.

Solomon, Alan R. "The New American Art." *Art International* 8, no. 2 (March 20, 1964): 50–55.

Swenson, Gene R. "Reviews and Previews: Robert Indiana at Stable Gallery." *Art News* 63, no. 4 (Summer 1964): 13.

University of British Columbia. *Art Becomes Reality*. Vancouver: University of British Columbia, 1964. Catalogue for the Festival of Contemporary Arts exhibition held January 29–February 8, 1964. Introduc-

tion by Alvin Balkind.

Wagner, Geoffrey. "Has Pop Art Reached Bottom?" *Connoisseur* 156, no. 630 (August 1964): 255–56.

Whitney Museum of American Art. *Permanent Collection, 1963–64*. New York: Whitney Museum of American Art, 1964. Catalogue for the exhibition held in 1964.

Wijsenbeek, L. J. F., et al. *Nieuwe Realisten*. The Hague: Haags l'Aja Gemeente Museum, 1964. Catalogue for the exhibition held June 24–August 30, 1964. Contributions by Jasia Reichardt, Pierre Restany, and W. A. L. Beeren.

Willard, Charlotte. "Dealers Eye-View: Leading Gallery Directors Give Their Views on Trends in American Art." *Art in America* 52, no. 2 (April 1964): 120–34.

1965

"Art: Pop." *Time*, May 28, 1965, 80.

Atkinson, Tracy. *Pop Art and the American Tradition*. Milwaukee: Milwaukee Art Center, 1965. Catalogue for the exhibition held April 9, May 9, 1965.

Belz, Carl. "Pop Art, New Humanism, and Death." *Kulcher* 5, no. 17 (Spring 1965): 18–37.

Calas, Nicholas. "Why Not Pop Art?" *Art and Literature*, no. 4 (Spring 1965): 178–84.

The Corcoran Gallery of Art. *The Twenty-ninth Biennial Exhibition of Contemporary American Painting*. Washington, D.C.: The Corcoran Gallery of Art, 1965. Catalogue for the exhibition held February 26–April 18, 1965. Introduction by Hermann Warner Williams, Jr.

Dienst, Rolf-Gunter. *Pop Art: Eine critische Information*. Wiesbaden: Rudolph Bechtold und Co., 1965.

Galeria Colibri. *L'Avant Garde*. San Juan: Galeria Colibri with Centro Tipografico de Puerto Rico, 1965. Catalogue for the exhibition held December 1965. Contribution by Luigi Marrozzini. Essay by Ernesto Ruiz de la Matz.

Hayes, Bartlett H. *Drawings of the Masters: American Drawings*. New York: Shorewood Publishers, 1965.

Katz, William. "Robert Indiana: Making Worlds of Small Things." *New Baltimore Morning Herald*, May 9, 1965, 12.

Krannert Art Museum and College of Fine and Applied Arts. *Contemporary American Painting and Sculpture, 1965*. Urbana-Champaign: University of Illinois, 1965. Catalogue for the exhibition held March 7–April 11, 1965. Introduction by Allen S. Weller.

Lyon, Ninette. "Robert Indiana, Andy Warhol, a Second Fame: Good Food." *Vogue* 145, no. 5 (March 1, 1965): 184–86.

"Neue Abstraktion: Robert Indiana." *Das Kunstwerk* 18, no. 10–12 (April–June 1965): 113.

"Painting by Robert Indiana Stolen from Show at Feigen Gallery, May, Turns up in Bin at Stable Gallery." *New York Times*, October 31, 1965, 6.

Richard Feigen Gallery, New York. "Letters to the Editor: Painting Stolen." *Arts Magazine* 39, no. 6 (March 1965): 8.

Rosenblum, Robert. "Pop Art and Non-Pop Art." *Art and Literature*, no. 5 (Summer 1965): 80–93.

Rublowsky, John. *Pop Art*. New York: Basic Books, 1965.

Sandler, Irving. "The New Cool-Art." *Art in America* 53, no. 3 (February 1965): 96–101.

Sheldon Memorial Art Gallery. *NAA 75th Annual*. Lincoln: Sheldon Memorial Art Gallery, University of Nebraska, 1965. Catalogue for the exhibition held April 4–May 2, 1965.

University of Michigan Museum of Art. *One Hundred Contemporary American Drawings*. Ann Arbor: University of Michigan, 1965. Catalogue for the exhibition held February 24–March 28, 1965. Foreword by Albert Mullen. Introduction by Dore Ashton.

Indiana in front of *Eat*, New York World's Fair, 1964.
Photograph by William Katz.

Varian, Elayne H. *Art in Process: The Visual Development of a Painting*. New York: Finch College Museum of Art, 1965. Catalogue for the exhibition held at Finch College Museum of Art, Contemporary Study Wing, New York, opened February 25, 1956.

White House Festival of the Arts. Washington, D.C.: The White House, 1965. Program brochure.

Whitney Museum of American Art. *A Decade of American Drawings, 1955–1965: 8th Exhibition*. New York: Whitney Museum of American Art, 1965. Catalogue for the exhibition held April 28–June 6, 1965. Foreword by Donald M. Blinken.

—. *1965 Annual Exhibition of Contemporary American Painting*. New York: Whitney Museum of American Art, 1965. Catalogue for the exhibition held December 8, 1965–January 30, 1966.

Wilson, William. "Come and See, Rolf Nelson Gallery, L.A., Group." *Artforum* 4, no. 2 (October 1965): 13.

Worcester Art Museum. *The New American Realism*. Worcester, Mass.: Worcester Art Museum, 1965. Catalogue for the exhibition held February 18–April 4, 1965. Preface by Daniel Catton Rich. Introduction by Martin Carey.

1966

Amaya, Mario. *Pop Art . . . and After*. New York: Viking Press, 1966.

—. "The New Super Realism." *Sculpture International* 1, no. 1 (January 1966): 19–27.

Antin, David. "Pop—Ein Paar klärende Bemerkungen." *Das Kunstwerk* 19, no. 10–12 (April–June 1966): 8–11.

Art Association of Indianapolis, John Herron Art Institute. *Painting and Sculpture Today*. Indianapolis: Herron Museum of Art, 1966. Catalogue for the exhibition held in 1966.

Ashton, Dore. "The 'Anti-Compositional Attitude' in Sculpture: New York Commentary; Exhibition at the Stable Gallery." *Studio International* 172, no. 879 (July 1966): 46.

Bannard, Darby. "Present-Day Art and Ready-Made Styles in Which the Formal Contribution of Pop Art Is Found to Be Negligible." *Artforum* 5, no. 4 (December 1966): 30–35.

Beranek, Barbara. "Mystery Artist Backs Pop Art." *Indianapolis News*, January 13, 1966, page unknown.

Bianchini Gallery. *Master Drawings: Pissarro to Lichtenstein*. New York: Bianchini Gallery, 1966. Catalogue for the exhibition held at Bianchini Gallery, New York, January 15–February 5, 1966; Contemporary Arts Center, Cincinnati, February 7–26, 1966. Essay by William Albers Leonard.

Cladders, Johannes. *Robert Indiana, Number Paintings*. Krefeld, Germany: Museum Haus Lange Krefeld, 1966. Catalogue for the exhibition held June 11–July 24, 1966.

Dayton's Gallery 12. *Robert Indiana*. Minneapolis: Dayton's Gallery 12, 1966. Catalogue for the exhibition held September 27–October 22, 1966. Introduction by Jan van der Marck. Essay by G. R. Swenson.

Frankenstein, Alfred. "American Art and American Moods." *Art in America* 54, no. 2 (March–April 1966): 76–87.

Galerie Schmela. *Robert Indiana*. Düsseldorf: Galerie Schmela, 1966. Catalogue for the exhibition held March 4–31, 1966.

Goodrich, Lloyd. *Three Centuries of American Art*. New York: Frederick A. Praeger, 1966.

Gowans, Alan. *The Restless Art: A History of Painters and Painting, 1760–1960*. New York: J. B. Lippincott, 1966.

"Hoosier-Born Robert Indiana Will Open Special Campus Art Show." *Ball State News* 46, no. 32 (October 5, 1966): 1.

The Howard and Jean Lipman Foundation and the Whitney Museum of American Art. *Contemporary American Sculpture: Selection 1*. New York: Whitney Museum of American Art, 1966. Catalogue for

Indiana hanging *Exploding Numbers* in his studio,
Spring Street, New York, 1966.

the exhibition held April 5–May 15, 1966. Foreword by John I. H. Baur.

Institute of Contemporary Art. *Art Turned On*. Boston: Institute of Contemporary Art, 1966. Catalogue for the exhibition held December 10, 1965–January 30, 1966.

Katz, William. "A Mother Is a Mother: Production of Virgil Thomson–Gertrude Stein's *The Mother of Us All* with an Original Visual Presentation by Robert Indiana." *Arts Magazine* 41, no. 3 (December 1966–January 1967): 46–48.

Kunsthalle Bern. *Formen der Farbe*. Bern: Kunsthalle, 1967. Catalogue for the exhibition held April 14–May 21, 1967.

Lippard, Lucy. "New York Letter." *Art International* 10, no. 6 (Summer 1966): 108–15.

—, ed. *Pop Art*. New York: Frederick A. Praeger; Toronto: Oxford University Press, 1966. Contributions by Lawrence Alloway, Nicolas Calas, and Nancy Marmer.

McConagha, Al. "Robert Indiana Exhibit to Open." *Minneapolis Sunday Tribune*, September 25, 1966, page unknown.

National Collection of Fine Arts. *Hard-Edge Trend*. Washington, D.C.: National Collection of Fine Arts, 1966. Catalogue for the exhibition held July 13–September 18, 1966.

Palais des Beaux-Arts. *Pop Art, New Realism, etc.* Brussels: Palais des Beaux-Arts, 1966. Catalogue for the exhibition held in 1966.

Parnell, Ita. "Hooked on the American Dream." *Manchester (England) Guardian Weekly*, September 22, 1966, 14.

Pellegrini, Aldo. *New Tendencies in Art*. Translated by Robin Carson. New York: Crown Publishers, 1966.

Pennsylvania Academy of the Fine Arts. *161st Annual Exhibition of American Painting and Sculpture*. Philadelphia: Pennsylvania Academy of the Fine Arts, 1966. Catalogue for the exhibition held January 21–March 6, 1966.

Reaney, James. "The Role of Inscription in Painting." *Canadian Art*, no. 109 (October 1966): 43–45.

Richardson, John Adkins. "Dada, Camp, and the Mode called Pop." *Journal of Aesthetics and Art Criticism* 24, no. 4 (Summer 1966): 549–58.

Rosenberg, Harold. "Virtuosos of Boredom." *Vogue*, September 1966, 296–97, 328.

Rosenblum, Robert. "Pop and Non-Pop: An Essay in Distinction." *Canadian Art*, no. 100 (January 1966): 50–54.

Skowhegan School of Painting and Sculpture with Lennox Hill Hospital. *Annual Art Exhibit and Sale*. Skowhegan, Maine: Skowhegan School of Painting and Sculpture, 1966. Catalogue for the exhibition held November 2–13, 1966. Foreword by Lloyd Goodrich.

Sommer, Ed. "Bericht aus Deutschland: Review of Galerie Schmela, Düsseldorf Exhibition." *Art International* 10, no. 5 (May 20, 1966): 47–51.

Stedelijk van Abbemuseum. *Kunst Licht Kunst*. Eindhoven: Stedelijk van Abbemuseum, 1966. Catalogue for the exhibition held September 25–December 4, 1966.

Swenson, Gene R. "The Horizons of Robert Indiana." *Art News* 65, no. 3 (May 1966): 48–49, 60–62.

Taylor, Angela. "The Kloss Style: Modern Art and Jigsaw Puzzles." *New York Times*, March 30, 1966, C-40. Discusses impact of Indiana's work on the fashion designer John Kloss.

Washington Gallery of Modern Art. *The Permanent Collection*. Washington, D.C.: Washington Gallery of Modern Art, 1966. Introduction by Gerald Nordland.

Whitney Museum of American Art. *1966 Annual Exhibition of Contemporary Sculpture and Prints*. New York: Whitney Museum of American Art, 1966. Catalogue for the exhibition held December 16, 1966–February 5, 1967.

"Word & Image." *Print* 20, no. 1 January–February 1966): 18–19.

Württembergischer Kunstverein. *"Robert Indiana: Number Paintings at Studio 7*. Stuttgart: Württembergischer Kunstverein, 1966. Catalogue for the exhibition held August 5–28, 1966.

Zinsser, William K. *Pop Goes America*. New York: Harper & Row, 1966.

1967

Alloway, Lawrence. "Hi-Way Culture: Man at the Wheel." *Arts Magazine* 41, no. 4 (February 1967): 28–33+.

Art in America, eds. *The Artist in America*. New York: W. W. Norton, 1967. Foreword by Russell Lynes. Introduction by Lloyd Goodrich.

Breitenbach, Edgar, and Margaret Cogswell. *The American Poster*. New York: October House, 1967. Catalogue for the exhibition prepared by the American Federation of the Arts and held at the National Collection of Fine Arts, Smithsonian Institution, Washington, D.C.;

Yale University Art Gallery, New Haven, Connecticut; and The University of Texas Art Museum, Austin, July 1967–69. Contributions by Caroline H. Backlund and Frank R. Cawl, Jr.

Carnegie Institute, Museum of Art. *Pittsburgh International Exhibition of Contemporary Painting and Sculpture.* Pittsburgh: Carnegie Institute, Museum of Art, 1967. Catalogue for the exhibition held October 27, 1967–January 7, 1968. Foreword by Gustave von Groschwitz.

Doherty, Paul M. "Pop Poster May Put Lure in Tourism Trap." *Indianapolis Star* 65, no. 61 (August 5, 1967): page unknown.

Expo '67. *American Painting Now: The Memorial Album of the First Category Universal and International Exhibition Held in Montreal.* Montreal: Thomas Nelson & Sons with Expo '67, 1967. Catalogue for the exhibition held April 27–October 29, 1967. Preface by Pierre Dupuy. Essays by Claude Beaulieu, Pierre de Bellefeuille, Guy Dozois, Edouard Fiset, James Gladstone, Maryvonne Kendergi, Jean-Louis de Lorimier, and Robert F. Shaw. Text in English and French.

Gold, Barbara. "Art Notes: Contemporary Painting Exhibition." *Baltimore Sun*, December 31, 1967, page unknown.

Hunter, Sam. *The 180 Beacon Collection of Contemporary Art.* Boston: 180 Corporation, 1967.

Institute of Contemporary Art. *American Paintings Now.* Boston: Institute of Contemporary Art, 1967. Catalogue for the exhibition held December 15, 1967–January 10, 1968.

Kaprow, Allan. "Pop Art: Past, Present and Future." *Malahat Review,* July 1967, 54–76.

Krannert Art Museum and College of Fine and Applied Arts. *Contemporary American Painting and Sculpture, 1967.* Urbana-Champaign: University of Illinois, 1967. Catalogue for the exhibition held March 5–April 9, 1967. Introduction by Allen S. Weller.

Kulturmann, Udo. *The New Sculpture: Environments and Assemblages.* Tübingen, Germany: Praeger, 1967.

"Modern Pop Art Show Ribs Serious Painters." *Indianapolis Star,* January 8, 1967, page unknown.

"Mother of Us All." *Opera News,* March 25, 1967, 32.

Museum of Modern Art, São Paulo. *São Paulo, Environment USA: 1957–1967.* São Paulo, Brazil: Museum of Modern Art, 1968. Catalogue for the exhibition held September 22, 1967–January 10, 1968. Essays by Lloyd Goodrich and William C. Seitz with statements by the artists.

National Collection of Fine Arts. *São Paulo 9.* Washington, D.C.: Smithsonian Institution Press, 1967. Catalogue of two exhibitions selected by William Seitz: *Edward Hopper* and *Environment U.S.A.: 1957–1967* held for the 9th biennial of the Museum of Modern Art, São Paulo, Brazil, September 22, 1967–January 8, 1968. Essays by Lloyd Goodrich and William Seitz.

New School for Social Research. *Protest and Hope: An Exhibition of Contemporary American Art.* New York: New School for Social Research, 1967. Catalogue for the exhibition held at Wollman Hall, October 24–December 2, 1967. Foreword by Paul Mocsanyi.

"On Exhibition: A Selection from Current and Forthcoming Exhibitions." *Studio International* 174, no. 891 (July 1967): 56–61.

Piene, Nan R. "Light Art." *Art in America* 55, no. 3 (May–June 1967): 25–47.

Sandberg, John. "Some Traditional Aspects of Pop Art." *Art Journal* 26, no. 3 (Spring 1967): 228–33, 245.

Townsend, Benjamin. "Albright-Knox-Buffalo: Work in Progress." *Art News* 65, no. 9 (January 1967): 66–70.

University of St. Thomas Art Department. *Mixed Masters.* Houston: University of St. Thomas, 1967. Catalogue for the exhibition held May–September 1967. Introduction by Kurt von Meier.

Whitney Museum of American Art. *1967 Annual Exhibition of Contemporary American Painting.* New York: Whitney Museum of American Art, 1967. Catalogue for the exhibition held December 13, 1967–January 4, 1968.

1968

"Accessions of American and Canadian Museums," *Art Quarterly* 31, no. 2 (Summer 1968): 205–27.

Aldrich Museum of Contemporary Art. *Selections from the Collection of Hanford Yang.* Ridgefield, Conn.: Aldrich Museum of Contemporary Art, 1968. Catalogue for the exhibition held September 29–December 22, 1968. Preface by Dorothy Mayhall. Introduction by Larry Aldrich.

Allison, Jane. "At Home with Robert Indiana: Hoosier in Manhattan." *Indianapolis News,* November 2, 1968, 9.

Ashton, Dore. "New York Commentary." *Studio International* 175, no. 897 (February 1968): 92–94.

Bongard, Willi von. "Plakate, Kunst und Kohl: Die Bundesrepublik wird von einer Poster-Seuche heimgesucht." *Kunstmarkt,* May 17, 1968, page unknown.

Bruner, Louise. "Robert Indiana's Pop Art Displayed Here." *Blader,* November 10, 1968, page unknown.

Charles E. Slatkin Galleries. *American Tapestries.* New York: Charles E. Slatkin Galleries, 1968. Introduction by Mildred Constantine. Notes by Irma B. Jaffe.

Creeley, Robert. *5 Numbers: A Sequence for Robert Indiana, January 16, 1968.* New York: Poets Press, 1968. Contribution by William Katz.

Denver, Joseph X. "Robert Indiana Exhibit Is a 'Love-In.'" *Bulletin,* April 17, 1968, page unknown.

Dienst, Rolf-Gunter. *Positionen Malerische Malerei—Plastische Plastik.* Cologne: M. DuMont Schauberg, 1968.

Donohoe, Victoria. "A Progress Report on Robert Indiana." *Philadelphia Inquirer,* April 21, 1968, VII-6.

Galerie-Verein München. *Sammlung 1968*. Munich: F. Dahlem, 1968. Catalogue for the exhibition held under the auspices of Galerie-Verein München at the Neue Pinakothek in the Haus der Kunst, Munich, June 14–August 9, 1968. Contributions by Karl Stroher, Six Friedrich, and Franz Dahlem.

Glauber, Richard. *Violence! In Recent American Art*. Chicago: Museum of Contemporary Art, 1968. Catalogue for the exhibition held November 8, 1968–January 12, 1969.

Honisch, Dieter, ed. *Robert Indiana and Robert Creeley: Numbers*. Stuttgart: Edition Domberger; Düsseldorf: Die Galerie Schmela, 1968; distributed by Pace Editions, New York, 1968. A limited-edition book containing 10 silkscreens and 10 number poems. Translation of poems into German by Klaus Reichert.

Kunsthalle Museum Fridericianum. *Documenta 4: Internationale Ausstellung*. Kassel, Germany: Kunsthalle Museum Fridericianum, 1968. Catalogue for the exhibition held June 27–October 6, 1968.

Metken, G. "Documenta." *Deutsche Bauzeitung* 102 (October 1968): 790.

Metzger, Othmar. "Vervielfältigte Kunst." *Das Werk* 55, no. 5 (May 1968): 313–19.

Miller, Ann Abbinati. "Indiana Puts Bite in Signs of the Times." *Philadelphia Sunday Bulletin*, April 14, 1968, page unknown.

Moore College of Art. *American Drawing 1968*. Philadelphia: Moore College of Art, 1968. Catalogue for the exhibition held January 13–February 16, 1968. Introduction by Harold Jacobs.

The Museum of Modern Art, New York. *Word & Image*. New York: The Museum of Modern Art, 1968. Catalogue for the exhibition held in early 1968. Edited by Mildred Constantine. Contributions by Mildred Constantine and Alan M. Fern.

National Institute of Arts and Letters. *An Exhibition of Contemporary Painting and Sculpture*. New York: National Institute of Arts and Letters, 1968. Catalogue for the exhibition held in 1968.

Ohff, Heinz. *Pop und die Folgen!* Düsseldorf: Droste Verlag, 1968.

Restany, Pierre. "Kassell." *Domus* 467 (October 1968): 41.

Sello, Gottfried von. "Schau von Kaussel." *Die Zeit*, July 5, 1968, 9.

Siegel, Jean. "Documenta IV, Homage to the Americans?" *Arts Magazine* 43, no. 1 (September–October 1968): 37–41.

Sweeney, James Johnson. *Signals in the Sixties*. Honolulu: Honolulu Academy of Arts, 1968. Catalogue for the exhibition held October 5–November 10, 1968. Foreword by James W. Foster, Jr.

University of Pennsylvania, Institute of Contemporary Art. *Robert Indiana*. Philadelphia: Institute of Contemporary Art with Falcon Press, 1968. Catalogue for the exhibition held at Institute of Contemporary Art, University of Pennsylvania, Philadelphia, April 17–May 27, 1968; Marion Koogler McNay Art Institute, San Antonio, Texas, July 1–August 15, 1968; John Herron Art Institute, Indianapolis, September 1–29, 1968. Introduction by John W. McCoubrey with statements by the artist.

Weller, Allen S. *The Joys and Sorrows of Recent American Art*. Urbana-Champaign: University of Illinois Press, 1968. The *De Young Lectures in Higher Education* at Illinois State University, 1966.

Wolfran, Gretchen. "Robert Indiana: Signs of the Time." *Indianapolis Star Magazine*, September 8, 1968, 38–41.

1969

Arts Council of Great Britain. *Pop Art Redefined*. London: Arts Council of Great Britain, 1969.

Belt, Byron. "Bowery Artists Exude Talent, Excitement." *Long Island Press*, March 30, 1969, 32.

Colby College Museum of Art. *The Prints and Posters of Robert Indiana, 1961–69: New England Tour*. Waterville: Colby College Museum of Art; New York: privately published, 1969. Catalogue for the exhibition held at Colby College Museum of Art, Waterville, Maine, December 1, 1969–January 3, 1970; The Currier Gallery of Art, Manchester, New Hampshire, January 10–February 8, 1970; Hood Museum of Art, Dartmouth College, Hanover, New Hampshire, February 2–March 13, 1970; Bowdoin College Museum of Art, Brunswick, Maine, March 19–April 12, 1970; Rose Art Museum, Brandeis University, Waltham, Massachusetts, April 19–May 10, 1970. Introduction by Raymond Alasko. Essay by William Katz. Poem by Michael Patrick O'Conner with commentary by the artist.

Denvir, Bernard. "London Letter." *Art International* 13, no. 7 (September 1969): 66–69.

Deutscher Gesellschaft für Bildende Künste E.V. und der Nationalgalerie der Staatlichen Museen Preussischer Kulturbesitz in der Neuen Nationalgalerie. *Sammlung 1968: Karl Ströher*. Berlin: Nationalgalerie der Staatlichen Museen Preussischer Kulturbesitz; Munich: Klein & Volbert, 1969. Catalogue for the exhibition held at Kulturbesitz in der Neuen Nationalgalerie, Berlin, March 1–April 14, 1969; Städtische Kunsthalle, Düsseldorf, April 25–June 17, 1969; Kunsthalle, Bern, July 12–August 17 and August 23–September 28, 1969. Essays by Thordis Moller.

Fine Arts Academy of Finland. *Ars 69 Helsinki*. Helsinki: Fine Arts Academy of Finland, 1969. Catalogue for the exhibition held in 1969.

Gablik, Suzi. "Protagonists of Pop: Five Interviews." *Studio International* 178, no. 913 (July–August 1969): 9–16. Features interviews with Richard Bellamy, Leo Castelli, Robert Fraser, Hubert Peeters, and Robert C. Scull.

Gablik, Suzi, and John Russell. *Pop Art Redefined*. New York: Frederick A. Praeger; London: Thames & Hudson, 1969.

Hakanson, Joy. "He Paints in Words." *Detroit News Magazine*, March 9, 1969, 52–53.

The Howard and Jean Lipman Foundation and the Whitney Museum of American Art. *Contemporary American Sculpture: Selection 2*.

New York: Whitney Museum of American Art, 1969. Catalogue for the exhibition held April 15–May 5, 1969. Foreword by John I. H. Baur.

The Jewish Museum. *Superlimited: Books, Boxes, and Things.* New York: The Jewish Museum, 1969. Catalogue for the exhibition held April 16–June 29, 1969. Introduction by Susan Tumarkin Goodman.

Leering-van Moorsel, Wies. *The Van Abbe Museum in Eindhoven: Painting in the Twentieth Century.* Munich: Knorr & Hirth Verlag, 1969. Translation from the Dutch by Ian F. Finlay.

Moreau Art Gallery, Saint Mary's College, Notre Dame University. *Sign, Signal, Symbol.* Notre Dame, Ind.: Notre Dame University, 1969. Catalogue for the exhibition held November 7–December 23, 1969, in conjunction with the symposium "Language, Symbol, Reality." Essay by R. P. Penkoff.

"Pop Art Comes from a Loft on Coenties Slip." *San Francisco Sunday Examiner and Chronicle,* October 19, 1969, page unknown.

Russell, John. "Pop Reappraised." *Art in America* 57, no. 5 (July 1969): 78–89.

Saint Mary's College, University of Notre Dame. *Robert Indiana: Graphics.* Notre Dame, Ind.: Notre Dame University, 1969. Catalogue for the exhibition *Dynamics of Creativity* held June 12–July 6, 1969. Introduction by Richard-Raymond Alasko. Poem by Michael Patrick O'Conner with statements by the artist.

Wallraf-Richartz Museum. *Kunst der Sechziger Jahre: Sammlung Ludwig im Wallraf-Richartz Museum.* Cologne: Wallraf-Richartz Museum; distributed in New York by Wittenborn and Co., 1969. Catalogue for the exhibition held in 1969. Contributions by Horst Keller and Gert von der Osten.

Whitney Museum of American Art. *70 Years of American Art: Contemporary American Prints and Drawings from the Collection.* New York: Whitney Museum of American Art, 1969. Catalogue for the exhibition held July 3–September 15, 1969.

1970

The Aldrich Museum of Contemporary Art. *Aldrich Fund Acquisitions for the Museum of Modern Art, 1959 through 1969.* Ridgefield, Conn.: The Aldrich Museum of Contemporary Art, 1970. Catalogue for the exhibition held September 27, 1970–January 3, 1971.

Ashton, Dore. *L'Art vivant aux États-Unis.* Saint-Paul-de-Vence: Fondation Marguerite et Aimé Maeght, 1970. Catalogue for the exhibition held July 16–September 30, 1970.

Compton, Michael. *Pop Art: Movements of Modern Art.* New York: Hamlyn, 1970.

Contemporary Arts Center. *Monumental American Art.* Cincinnati: Contemporary Arts Center, 1970. Catalogue for the exhibition in 1970.

Davis, Douglas. "The Nth Dimension." *Newsweek,* June 16, 1970.

Dempsey, Michael, ed. *The Year's Art 1969–70: Europe and the U.S.A.* New

York: G. P. Putnam's Sons, 1970. Introduction by William Gaunt.

Finch College Museum of Art. *N Dimensional Space.* New York: Finch College Museum of Art, 1970. Catalogue for the exhibition held at Finch College Museum of Art, New York, April 22–June 15, 1970; The Art Gallery, State University of New York at Albany; Everson Museum of Art, Syracuse, New York; Memorial Art Gallery of the University of Rochester, New York. Prepared by Ted McBurnett. Introduction by Elayne H. Varian.

Indiana working on the 12-foot *Love* at Lippincott, Inc., North Haven, Connecticut, 1970.

Photograph by Tom Rummler.

Hunter, Sam, ed. *American Art since 1960.* Princeton: Princeton University Press, 1970. Catalogue for an exhibition prepared by the graduate students of the Department of Art and Archaeology and held at the Art Museum, Princeton University, May 6–27, 1970. Essays by John Hand, Michael D. Levin, and Peter P. Morrin.

Kostelanetz, Richard, ed. *Imaged Words and Worded Images.* New York: Outerbridge and Dienstfrey, 1970.

—. "Words and Images Artfully Intertwined." *Art International* 14, no. 7 (September 1970): 44–56.

Lipman, Jean. "Money for Money's Sake." *Art in America* 58, no. 1 (January–February 1970): 76–83.

Mayfair Gallery. *Pop! '70.* London: Mayfair Gallery, 1970. Catalogue for the exhibition held November 26, 1969–January 16, 1970. Introduction by Ira D. Gale.

"Mini-Multiple 6." *Art Gallery* 14, no. 1 (October 1970): 16.

Pace Gallery. *Pace Editions.* New York: Pace Gallery, 1970. Catalogue for the exhibition held in the spring of 1970.

Reiser, Walter. *Begegnung: Maler und Bildhauer der Gegenwart.* Stuttgart: Belser Verlag, 1970. Introduction by Dietrich Mahlow.

Roos, Frank J., Jr. *An Illustrated Handbook of Art History.* London: Macmillan, 1970.

"Sehet sein grinsendes Gesicht." *Der Spiegel*, April 6, 1970, 208.

Sverbeyeff, Elizabeth, and Sue Nirenberg. "Six in the Arts and How They Live: Robert Indiana." *House Beautiful* 112, no. 2 (February 1970): 52–55, 166.

Tuchman, Phyllis. "American Art in Germany: The History of a Phenomenon." *Artforum* 9, no. 3 (November 1970): 58–69.

University of Pennsylvania, Institute of Contemporary Art. *The Highway: An Exhibition.* Philadelphia: Institute of Contemporary Art, University of Pennsylvania, 1970. Catalogue for the exhibition held at Institute of Contemporary Art, University of Pennsylvania, Philadelphia, January 14–February 25, 1970; Institute for the Arts, Rice University, Houston, March 12–May 18, 1970; The Akron Art Institute, Ohio, June 5–July 26, 1970. Contribution by John W. McCoubrey.

White, David Manning, ed. *Pop Culture in America.* Chicago: Quadrangle Books, 1970.

1971

Le Cadre de Europalia '71. *Stedelijk '60–'70: Palais des Beaux-Arts, Bruxelles.* Amsterdam: Stedelijk Museum, 1971. A catalogue of two exhibitions held at Stedelijk Museum, Amsterdam: Netherlandish art, September 22–October 17, 1971, and non-Netherlandish art October 20–November 22, 1971. Introduction by E. de Wilde. Essay by Dolf Welling. Translated by Paul Lebeer.

Calas, Nicolas, and Elena Calas. *Icons and Images of the Sixties.* New York: E. P. Dutton, 1971.

Chapin, Louis. "Robert Indiana." *Christian Science Monitor*, May 25, 1971, 8.

Domingo, Willis. "Robert Indiana at Multiples Gallery, N.Y.; Exhibit." *Arts Magazine* 45, no. 8 (Summer 1971): 54.

Farnham, Emily. *Charles Demuth: Behind a Laughing Mask.* Norman: University of Oklahoma Press, 1971.

Field, Richard S. *Silkscreen: History of a Medium.* Philadelphia: Philadelphia Museum of Art, 1971. Catalogue for the exhibition held December 17, 1971–February 27, 1972.

Galerie de Gestlo, Bremen. "Weltberühmt: Robert Indiana." *Graphik: Werbung und Formgebung*, May 5, 1971, 39–41.

Gent, George. "5-Ton Sculpture Says It in a Word." *New York Times*, November 30, 1971, page unknown.

Gidal, Peter. *Andy Warhol Films and Paintings.* New York: Studio Vista/ Dutton, 1971.

Hope, Henry R. "Public Art Museum Notes: Indianapolis Museum of Art," *Art Journal* 31, no. 2 (Winter 1971–72): 200. A write-up on Indiana's *Love* sculpture.

Indianapolis Museum of Art. *Seven Outdoors.* Indianapolis: Indianapolis Museum of Art, 1971. Catalogue for the exhibition held in 1971.

Institute of Contemporary Art. *Monumental Sculptures for Public Space.* Boston: Institute of Contemporary Art, 1971. Catalogue for the exhibition held October 2–November 14, 1971.

Kahmen, Volker. *Erotik in der Kunst.* Cologne: Verlag Ernst Wasmuth, 1971.

Krannert Art Museum. *American Paintings and Sculpture: 1948–1969.* Urbana-Champaign: University of Illinois, 1971. Catalogue for the exhibition held March 7–April 11, 1971.

Museo de Tertulia. *Primera bienal americana de Artes graficas.* Cali, Colombia: Museo de Tertulia, 1971. Catalogue for the exhibition held in 1971.

The Museum of Modern Art. *The Artist as Adversary: Works from the Museum Collections.* New York: The Museum of Modern Art, 1971. Catalogue for the exhibition held July 1–September 27, 1971. Introduction by Betsy Jones with statements by the artists.

Niss, Robert S. "Wall Prints to Be on Exhibit when Symphony Opens Tuesday." *Portland (Maine) Press Herald*, October 25, 1971, 4.

"One Way of Saying It." *Saturday Evening Post* 243 (Summer 1971): 71.

Plagens, P. "Robert Indiana at Multiples Gallery, Los Angeles; Exhibit." *Artforum* 10, no. 2 (October 1971): 90.

Robert Indiana: Druckgraphik und Plakate, 1961–1971 (The Prints and Posters, 1961–1971). Stuttgart and New York: Edition Domberger, 1971. Introduction by William Katz. Commentary by Robert Indiana. Text in English and German.

Russell, John. "A Passion for the New: Larry Aldrich." In Jean Lipman, ed., *The Collector in America.* New York: Viking Press, 1971.

Seldis, Henry J., and William Wilson. "Art Walk: A Critical Guide to the Galleries." *Los Angeles Times*, May 7, 1971, page unknown.

Thomas, Karin. *Bis Heute: Stilgeschichte der bildenden Kunst im 20. Jahrhundert.* Cologne: Verlag M. DuMont Schauberg, 1971.

Thomas, Robert. "Graphics: DM Gallery." *Art & Artists* 6, no. 3 (June 1971): 28. Review of exhibition at the DM Gallery, London.

University of Iowa Museum of Art. *Living with Art: Selected Loans from the Collection of Mr. and Mrs. Walter A. Netsch.* Iowa City: University of Iowa Museum of Art, 1971. Catalogue for the exhibition held September 15–October 21, 1971. Foreword by Ulfert Wilke. Introduction by Walter A. Netsch.

University of Kansas Museum of Art. "Gene Swenson: Retrospective for a Critic." *Register of the Museum of Art.* Lawrence: University of Kansas, 1971.

Wilmerding, John. *American Art.* Middlesex, England: Penguin Books, 1971.

1972

Barker, Myrtie. "LOVE Sets One Thinking." *Indianapolis News*, February 14, 1972, 15.

Canaday, John. "Aesop Revised, or the Luck of the Orthopterae." *New York Times*, December 3, 1972, D-21.

"La Chronique des Arts: Robert Indiana à de Carlsruhe; Exposition." *Gazette des Beaux-Arts* 79 (March 1972): supplement.

Dopheide-Klose, Gerda, et al., eds. *Art around 1970*. Aachen, Germany: Neue Galerie der Stadt Aachen, 1972. Catalogue of the exhibition held in June 1972. Contributing editors Wolfgang Becker and Astrid Brock. Interview with Peter Ludwig.

Galerie Denise René. *Robert Indiana*. New York: Galerie Denise René, 1972. Introduction by Sam Hunter. Catalogue for the exhibition held November 22–December 30, 1972.

Garmel, Marion Simon. "Indiana Has LOVE Affair with State." *News/Blue Streak (Indianapolis)*, February 14, 1972, 1.

Genauer, Emily. "Will *Art* Replace the *Love* Symbol?" *Arts*, December 8, 1972, 11A.

High Museum of Art. *The Modern Image*. Atlanta: High Museum of Art, 1972. Catalogue for the exhibition held April 15–June 11, 1972

Indianapolis Museum of Art. *Painting and Sculpture Today, 1972*. Indianapolis: Contemporary Art Society and the Indianapolis Museum of Art, 1972. Catalogue for the exhibition held April 26–June 4,

Indiana and Louise Nevelson on her first visit to Vinalhaven, Maine, 1972.

1972. Introduction by Richard L. Warrum. Foreword by Carl J. Weinhardt, Jr.

Mondale, Joan Adams. *Politics in Art*. Minneapolis: Lerner Publications, 1972.

Perrault, John. "Having a Word with the Painter." *Village Voice*, December 7, 1972, 34.

Peters, H. A. "Buchstabe und Zahl." *Museen in Köln* 11, no. 5 (May 1972): 1046–48.

"Robert Indiana: Neue 'Autoportraits' und Skulpturen." *Aufbau*, December 8, 1972, 20.

Westecker, Dieter, et al. *Documenta-Dokumente, 1955–1968*. Kassel, Germany: Georg Wenderoth Verlag, 1972. Contributions by Carl Eberth, Werner Lengemann, Erich Müller.

Wills, F. H. "Printed Graphics and Exhibition Posters by Robert Indiana, USA." *Novum Gebrauchsgraphik* 43, no. 26 (December 12, 1972): 2–9.

1973

Adams, Marion, and Craig Beardsley. "Love—Robert Indiana Style." *Indianapolis* 10, no. 3 (March 1973): 24–27.

Burnett, Clyde. "*Love* Artist Indiana Has No Doubts as to Direction." *Atlanta Journal*, October 25, 1973, B-22.

Crimp, Douglas. "New York Letter: Robert Indiana at Denise René Gallery, N.Y.; Exhibit." *Art International* 17, no. 2 (February 1973): 47.

"Dos artistas Pop, Galerías Denise René y Sidney Janis, Nueva York; exposiciónes." *Goya*, no. 112 (January 1973): 239.

Dyckes, William. "Reviews: Robert Indiana at Denise René Gallery, N.Y.; Exhibit." *Arts Magazine* 47, no. 4 (February 1973): 76.

Forman, Nessa. "Stamp of Quality by Postal Service." *Philadelphia Sunday Bulletin*, January 7, 1973, page unknown.

Glueck, Grace. "I'd Rather Put the Dogs in the Basement." *New York Times*, March 18, 1973, page unknown.

Henry, Gerrit. "Reviews and Previews: Robert Indiana at Denise René Gallery, N.Y.; Exhibit." *Art News* 72, no. 1 (January 1973): 19.

Hoffman, Klaus. *Kunst-im-Kopf: Aspekte der Realkunst*. Cologne: Verlag M. DuMont Schauberg, 1972.

Horn, Robert Sydnell. "En rencontrant *Love*." *XXᵉ Siècle* 35, no. 41 (December 1973): 112–16.

Koch, Stephen. *Stargazer: Andy Warhol's World and His Films*. New York: Praeger, 1973.

Kunstmuseum der Stadt Düsseldorf. *Zero Raum*. Düsseldorf: Kunstmuseum der Stadt Düsseldorf, 1973. Catalogue for the exhibition held June 8–August 23, 1973. Contribution by Gerhard Storck. Foreword by Wend von Kalnein.

Lincoln, Joseph L. "Special Exhibit Marks *Love* Issue's Release." *Philadelphia Sunday Bulletin*, January 7, 1973, 81.

Marandel, J. Patrice. *Small Works: Selections from the Richard Brown Baker*

Collection of Contemporary Art. Providence: Rhode Island School of Design Museum of Art, 1973. Catalogue of the exhibition held April 5–May 6, 1973. Preface by Stephen E. Ostrow.

Marchesseau, Daniel. "Amérique 73: Indiana le puriste." *Jardin des Arts,* no. 217 (March–April 1973): 4–5.

Masheck, Joseph. "Exhibition Reviews: Robert Indiana; Denise René Gallery, N.Y.; Exhibit." *Artforum* 11, no. 6 (February 1973): 79–80.

Maxa, Rudy. "That Love Stamp Is Still Stirring up Waves." *Philadelphia Inquirer,* March 25, 1973, 8-A.

New York Cultural Center. *Robert Indiana: Decade.* New York: New York Cultural Center, 1973. Catalogue for the exhibition held January 12–February 11, 1973.

"Popular Artist." *Morning Sentinel (Maine),* 17 September 1973, 6.

Raynor, Vivien. "The Man Who Invented Love." *Art News* 72, no. 2 (February 1973): 58–62.

Russell, John. "Persistent Pop." *New York Times,* July 21, 1974, section 6, 6, 25, 27, 30, 32–34.

Smith, Griffin. "High above Factory Area, N.Y. Artists Live and Work." *Miami Herald,* June 24, 1973, 1G, 6G.

"Ten Sculptors: A Photo Portfolio." *Archives of American Art Journal* 13, no. 4 (1973): 9–13.

Thomson, Virgil. *Edges; a Portrait of Robert Indiana, for Piano.* New York: G. Schirmer, 1973. Sheet music.

Tilley, Kathy. "LOVE Artist." *Atlanta Constitution,* November 1, 1973, H-9.

Towers, Samuel A. "It's Love, Love, Love." *New York Times,* January 14, 1973, page unknown.

van der Marck, Jan. *American Art Third Quarter Century.* Seattle: Seattle Art Museum, 1973. Catalogue for the exhibition held August 22–October 14, 1973.

Wallraf-Richartz Museum. *Katalog der Bildwerke und Objekte, Neuzugänge seit 1965 im Wallraf-Richartz Museum mit Toilen der Sammlung Ludwig.* Cologne: Wallraf-Richartz Museum, 1973. Catalogue for the exhibition held in 1973. With contributions by Rainer Budde, Johann Karl Schmidt, and Evelyn Weiss.

William Marsh Rice University, Institute for the Arts. *Gray Is the Color: An Exhibition of Grisaille Painting, XIIIth–XXth Centuries.* Houston: William Marsh Rice University, Institute for the Arts, 1973. Catalogue for the exhibition held October 19, 1973–January 19, 1974. Foreword by Dominique de Menil. Introduction by J. Patrice Marandel.

1974

Alloway, Lawrence. *American Pop Art.* New York: Collier Books in association with the Whitney Museum of American Art, 1974. Catalogue for the exhibition held April 6–June 16, 1974.

Aquila, Emily H. *Pop Art and After.* Williamstown, Mass.: Williams College Museum of Art, 1974. Catalogue for the exhibition held January 1974.

Baldwin, Carl R. "On the Nature of Pop." *Artforum* 12, no. 10 (June 1974): 34–38.

Barron, Stephanie. "Giving Art History the Slip." *Art in America* 62, no. 2 (March–April 1974): 80–84.

Dallas Museum of Fine Arts and Southern Methodist University. *Poets of the Cities New York and San Francisco, 1950–1965.* New York: E. P. Dutton, 1974. Catalogue for the exhibition held at Dallas Museum of Fine Arts and Pollock Galleries, Southern Methodist University, November 20–December 29, 1974; San Francisco Museum of Art, January 31–March 23, 1975; Wadsworth Atheneum, Hartford, April 23–June 1, 1975. Contributions by Robert Creeley, Lana Davis, John Clellon Holmes, and Robert M. Murdock.

Diamonstein, Barbaralee. "Caro, de Kooning, Indiana, Lichtenstein, Motherwell, and Nevelson on Picasso's Influence." *Art News* 73, no. 4 (April 1974): 44–46.

"Group Portrait with Accountant." *Esquire,* November 1974, 124–25.

Hirshhorn Museum and Sculpture Garden, Smithsonian Institution. *An Introduction to the Hirshhorn Museum and Sculpture Garden.* New York: Harry N. Abrams, 1974. Introduction by Abram Lerner.

—. *Opening Exhibition.* Washington, D.C.: Hirshhorn Museum and Sculpture Garden, Smithsonian Institution, 1974. Catalogue for the exhibition held in 1974.

Indianapolis Museum of Art. *Painting and Sculpture Today, 1974.* Indianapolis: Contemporary Art Society and Indianapolis Museum of Art, 1974. Catalogue for the exhibition held at the Indianapolis Museum of Art, May 22–July 14, 1974, and Taft Museum, Cincinnati, September 12–October 26, 1974. Introduction by Richard L. Warrum.

Laffel, Jeff. "Robert Indiana Portrait." *Film News* 31, no. 5 (December 1974): 14, 30.

Mogelon, Alex, and Norman Laliberté. *Art in Boxes.* New York: Van Nostrand Reinhold, 1974.

Ritter, Walter. "Marine Art: A Document, a Mixture of Centuries." *South Street Reporter (New York),* 8, no. 1 (Spring 1974): 9.

Sidney Janis Gallery. *25 Years of Janis, Part 2: From Pollock to Pop, Op and Sharp-Focus Realism.* New York: Sidney Janis Gallery, 1974. Catalogue of the exhibition held March 13–April 13, 1974.

A Special Place. Test Version: A Visual Artist. St. Louis: Cemrel, 1974. *The Aesthetic Education Program* series accompanied by *A Teacher's Manual.*

Tuchman, Phyllis. "Pop! Interviews with George Segal, Andy Warhol, Roy Lichtenstein, James Rosenquist, and Robert Indiana." *Art News* 73, no. 5 (May 1974): 24–29.

Virginia Museum of Fine Arts. *Twelve American Painters.* Richmond: Virginia Museum of Fine Arts, 1974. Catalogue for the exhibition held September 30–October 27, 1974.

Whitney Museum of American Art. *Nine Artists: Coenties Slip*. New York: Whitney Museum of American Art, 1974. Catalogue for the exhibition held January 10–February 14, 1974.

Wilson, Simon. *Pop*. London: Thames and Hudson, 1974.

1975

Alloway, Lawrence. *Topics in American Art since 1945*. New York: W. W. Norton, 1975.

American Express Co. Card Division. *Robert Indiana "The American Love."* Great Neck, N.Y.: American Express Co. Card Division, 1975. Brochure advertising *Love* prints.

Atwell, Tom. "U.S. Art Is Retrogressing, Claims Indiana." *Portland (Maine) Press Herald* , April 18, 1975, 17.

Carroll, Margaret. "Light, Air, and Lots of Color: Art Flair in an Innovative Abode." *Chicago Tribune*, June 12, 1975, page unknown. Includes photograph of Indiana works in the collection of Walter and Dawn Netsch.

"Downstairs at the Museum: Robert Indiana." *Pennsylvania Gazette* 73, no. 6 (April 1975): 31, 35.

Galerie Denise René. *Robert Indiana, Selected Prints*. New York: Galerie Denise René, 1975. Catalogue for the exhibition held December 12, 1975–January 10, 1976.

Katz, William. "Robert Indiana." *Currânt* 1, no. 5 (December 1975–January 1976): 48–53.

Legg, Alicia. *American Art since 1945 from the Collection of the Museum of Modern Art*. New York: The Museum of Modern Art, 1975. Catalogue for the exhibition held at Worcester Art Museum, Massachusetts, October 20–November 30, 1975; The Toledo Museum of Art, Ohio, January 10–February 22, 1976; Denver Art Museum, March 22–May 2, 1976; Fine Arts Gallery of San Diego, California, May 31–July 11, 1976; Dallas Museum of Fine Arts, August 19–October 3, 1976; Joslyn Art Museum, Omaha, Nebraska, October 25–December 5, 1976; Greenville County Museum, South Carolina, January 8–February 20, 1977; Virginia Museum of Fine Arts, Richmond, March 14–April 17, 1977. Foreword by Richard E. Oldenburg.

Loring, John. "American Portrait." *Arts Magazine* 50, no. 3 (November 1975): 58–59.

National Collection of Fine Arts, Smithsonian Institution. *Images of an Era: The American Poster, 1945–75*. Washington, D.C.: Smithsonian Institution, National Collection of Fine Arts, 1975. Catalogue for the exhibition held at Corcoran Gallery of Art, Washington, D.C., November 21, 1975–January 4, 1976; Contemporary Art Museum, Houston, February 2–March 19, 1976; Museum of Science and Industry, Chicago, April 1–May 2, 1976; New York University, Grey Art Gallery and Study Center, May 22–June 30, 1976.

Newall, Robert H. "Artist Reflects on Lucky Break." *Bangor Daily News*, April 19–20, 1975, page unknown.

Portland Art Museum. *Masterworks in Wood: The Twentieth Century*. Portland, Oreg.: Portland Art Museum, 1975. Catalogue for the exhibition held September 17–October 19, 1975. Foreword by Francis J. Newton. Introduction by Jan van der Marck.

Prather, Jean. "Indiana Reveals City 'Ties.'" *Republic (Columbus)*, October 24, 1975, A1, A5, B6.

Risher, Patricia. "The Juror: One Man's Opinion—Columbus Work Representative of U.S." *Columbia Dispatch*, April 27, 1975, 16.

Robinson, Franklin Westcott, and Jan van der Marck. *Works on Paper, Nineteenth & Twentieth Century Drawings and Watercolours from the Dartmouth College Collection*. Hanover, N.H.: Dartmouth College, 1975. Catalogue for the exhibition held May 30–September 21, 1975.

Slade, Roy. *34th Biennial of Contemporary American Painting*. Washington, D.C.: Corcoran Gallery of Art, 1975. Catalogue for the exhibition held February 22–April 6, 1975. Contribution by Linda Simmons.

Indiana working on a costume for the opera *The Mother of Us All*, Santa Fe, New Mexico, 1976.

Sustendal, Diane. "*LOVE* Artist Indiana Exits as Famed Pour in for Bowl." *New Orleans Times-Picayune*, January 16, 1975, 6–8.

Yale University Art Gallery. *Richard Brown Baker Collects: A Selection of Contemporary Art from the Richard Brown Baker Collection*. New Haven, Conn.: Yale University Art Gallery, 1975. Catalogue for the exhibition held April 24–June 22, 1975. Introduction by Theodore E. Stebbins, Jr. Essays by Susan P. Casteras, John R. Klein, Carol Ockman, Margaret S. Nesbit, Leo H. Rubinfien, Mark Savitt, Kenneth E. Silver, and the artists.

1976

André, Michael. "New York Reviews: Robert Indiana at Denise René Gallery, N.Y.; Exhibit." *Art News* 75, no. 2 (February 1976): 108.

Art Galleries, California State University. *Beyond the Artist's Hand: Explorations of Change*. Long Beach: California State University, 1976. Catalogue for the exhibition held September 13–October 10, 1976. Essay by Suzanne Paulson. Contributions by J. Butterfield and F. K. Fall.

Baro, Gene. *30 Years of American Printmaking, Including the 20th National Print Exhibition*. Brooklyn: The Brooklyn Museum, 1976. Catalogue for the exhibition held November 20, 1976–January 30, 1977.

Castleman, Riva. *Prints of the 20th Century: A History*. New York: The Museum of Modern Art, 1976.

Columbia University, Department of Art History and Archaeology. *Modern Portraits: The Self and Others*. New York: Columbia University Art Department and Wildenstein's, 1976. Catalogue for the exhibition held October 20–November 28, 1976. Edited and with introduction by J. Kirk T. Varnedoe. Preface by Alfred Frazer.

Da Vinci, Mona. "Indiana Dreams Come True." *Soho Weekly News*, May 13, 1976, 18.

Dienst, R. G. "Buchstabierte Bilder." *Kunstwerk* 29, no. 2 (March 1976): 3–32.

Downs, Joan. "An American Momma." *Time*, August 23, 1976, 37.

Eakins, Patricia. "Meeting the 'Mother of Us All.'" *East Side Express*, May 20, 1976, 8.

Fleming, Shirley. "Music Notes: Thomson's Opera, Indiana's Painting at Santa Fe." *New York Times*, July 18, 1976, page unknown.

Frank, Peter. "New York Reviews: Robert Indiana at Galerie Denise René, N.Y.; Exhibit." *Art News* 75, no. 7 (September 1976): 123.

Frankenstein, Alfred. "Review." *San Francisco Chronicle*, August 29, 1976, 27.

Genauer, Emily. "Art and the Artist." *New York Post*, October 30, 1976, page unknown.

Goldberg, Jeff. "Love." *The Unmuzzled Ox* 4, no. 2 (1976): 17–22. Interviews with Alice Cooper, Rodney Dangerfield, Robert Indiana, Marshall McLuhan, Lou Reed, et al.

Grunwald, Beverly. "Getting around Robert Indiana: His LOVE Goes On and On." *Women's Wear Daily*, February 12, 1976, 20.

Institute of Contemporary Art. *A Selection of American Art: The Skowhegan School, 1946–1976*. Boston: Institute of Contemporary Art, 1976. Catalogue for the exhibition held at Institute of Contemporary Art, Boston, June 16–September 5, 1976; Colby College Museum of Art, Waterville, Maine, October 1–30, 1976. Essays by Allen Ellenzweig, Lloyd Goodrich, and Bernarda B. Shahn.

Maine State Museum. *76 Maine Artists*. Augusta: Maine State Museum, 1976. Catalogue for the exhibition held July–August 1976.

Maitland, Leslie. "Factory Brings Sculptors' Massive Dreams to Fruition." *New York Times*, November 24, 1976, C35, 55.

Merkling, Frank. "Yankee Doodle Opera." *Opera News*, July 1976, 9–14.

New Gallery of Contemporary Art. *American Pop Art and the Culture of the Sixties*. Cleveland: New Gallery of Contemporary Art, 1976. Catalogue for the exhibition held January 10–February 21, 1976. Essays by Carol Nathanson and Nina Sundell.

Peterson, William, and Bob Tomlinson. "Robert Indiana." *Artspace* 1, no. 1 (Fall 1976): 4–9. Interview with the artist.

Schleswig-Holsteinisches Landesmuseum, Schloß Gottorf, Schleswig. *Illustrations zu Melvilles "Moby Dick."* Schloß Gottorf: Schleswig-Holsteinisches Landesmuseum, 1976. Catalogue for the exhibition held June 18–September 19, 1976. Foreword by Joachim Kruse. Essays by Jens Peter Becker, Leland R. Phelps, et al.

School of the Art Institute of Chicago. *Visions, Painting and Sculpture: Distinguished Alumni 1945 to the Present*. Chicago: The Art Institute of Chicago, 1976. Catalogue for the exhibition held October 7–December 10, 1976. Foreword by Donald J. Irving. Preface by Dennis Adrian.

Stern, Ellen. "Wallflowers: Best Bets, Recommendations of Events, Places, and Phenomena of Particular Interest This Week." *New York* 9, no. 12 (March 22, 1976): 63.

Tannenbaum, Judith. "Arts Reviews: Robert Indiana at Denise René Gallery, NY; Exhibit." *Arts Magazine* 51, no. 1 (September 1976): 22–24.

Taylor, Joshua Charles. *America as Art*. Washington, D.C.: National Collection of Fine Arts, Smithsonian Institution, 1976. Catalogue for the exhibition held April 30–November 7, 1976.

Thomson, Virgil. "The Mother of Us All." *Santa Fe Opera*, July 7–August 28, 1976, 45–47. Twentieth-season program.

1977

Cossitt, F. P. "The Chrysler Shows Works of Indiana." *(Norfolk) Virginia Pilot*, December 2, 1977, B1, B4.

Dillenberger, Jane, and John Dillenberger. *Perceptions of the Spirit in Twentieth-Century American Art*. Indianapolis: Indianapolis Museum of Art, 1977. Catalogue for the exhibition held at Indianapolis Museum of Art, Indiana, September 20–November

27, 1977; University Art Museum, University of California, Berkeley, December 20, 1977–February 12, 1978; Marion Koogler McNay Art Institute, San Antonio, Texas, March 5–April 16, 1978; Columbus Gallery of Fine Art, Ohio, May 10–June 19, 1978. Foreword by Robert A. Yassin and Claude Welch.

Glueck, Grace. "The 20th Century Artists Most Admired by Other Artists." *Art News* 76, no. 9 (November 1977): 87.

Jones, Mary Lou. "Robert Indiana and the Big M." *Midwest Art* 4, no. 4 (November 1977): 1, 16.

Kardon, Janet, and Don McDonagh. *Artists' Sets and Costumes: Recent Collaborations between Painters and Sculptors and Dance, Opera, and Theatre.* Philadelphia: Philadelphia College of Art, 1977. Catalogue for the exhibition held at Philadelphia College of Art, October 31–December 17, 1977; Sarah Lawrence College, Bronxville, New York, January 24–February 19, 1978.

Kennedy Galleries. *Artists Salute Skowhegan.* New York: Kennedy Galleries, 1977. Catalogue for the exhibition held December 8–21, 1977. Preface by Louise Nevelson.

Kloss, Gerald. "At Last: The Floor Is Yours." *Milwaukee Journal,* September 27, 1977, 1, 4.

Morison, Samuel Eliot, et al. *A Concise History of the American Republic.* New York: Oxford University Press, 1977. Contributions by Henry Steele Commager and William E. Leuchtenburg.

Rich, Alan. "Several Operas." *New York Magazine,* June 20, 1977, 20.

"Robert Indiana: What's Behind His Words." *Art and Man* 8, no. 3 (December 1977–January 1978): 18.

Société des Expositions du Palais des Beaux-Arts. *American Art in Belgium.* Brussels: Palais des Beaux-Arts de Bruxelles, 1977. Catalogue for the exhibition held May 25–August 28, 1977. Contributions by K. J. Geirlandt and G. Rogue.

Tobin, Robert L. B., and William Katz. *Robert Indiana.* Austin: University of Texas, 1977. Catalogue for the exhibition held at University of Texas Art Museum, Austin, September 25–November 6, 1977; Chrysler Museum, Norfolk, Virginia, December 1, 1977–January 15, 1978; Indianapolis Museum of Art, Indiana, February 21–April 2, 1978; Neuberger Museum, State Univerisity of New York, Purchase, April 23–May 21, 1978; Art Center, South Bend, Indiana, June 2–July 16, 1978. Introduction by Donald B. Goodall. "Autochronology" by the artist.

"The 'Vasari' Diary: 'We Had This Nice Big Rectangle, So Why Not Put a Painting on It?'" *Art News* 76, no. 10 (December 1977): 24.

1978

Hine, Thomas. "*LOVE* or *DIE*, His Art He'll Ply." *Philadelphia Inquirer,* May 16, 1978, C-1.

Lipman, Jean, and Richard Marshall. *Art about Art.* New York: E. P. Dutton in association with the Whitney Museum of American Art, 1978. Catalogue for the exhibition at the Whitney Museum of American Art, New York, July 19–September 24, 1978; North Carolina Museum of Art, Raleigh, October 15–November 26, 1978; Frederick S. Wight Art Gallery, University of California, Los Angeles, December 17, 1978–February 11, 1979; Portland Art Museum, Oregon, March 6–April 15, 1979. Introduction by Leo Steinberg.

Loring, John. "Architectural Digest Visits: Robert Indiana." *Architectural Digest* 35, no. 9 (November 1978): 112–21.

Maxwell, Marnie. "Robert Indiana: Sign Painter-Artist." *New Republican,* March 9, 1978, 3.

"Robert Indiana Exhibit Opens." *South Bend Tribune,* June 10, 1978, page unknown.

Rosen, Randy. *Prints: The Facts and Fun of Collecting.* New York: E. P. Dutton, 1978.

Russell, John. "Gallery Review: De-Complication Is the Aim." *New York Times,* May 14, 1978, D-27.

Wallace, Andrew. "Confessions of Sculptor who Created *LOVE.*" *Philadelphia Inquirer,* November 8, 1978, B-2.

1979

Diamonstein, Barbaralee. "Robert Indiana." *Inside New York's Art World.* New York: Rizzoli International, 1979.

University of Texas Art Museum. *25 Anõs Despues.* Austin: University of Texas, 1979. Catalogue for the exhibition held in 1979. Introduction by John Stringer. Text by William Goodall, Robert Indiana, William Katz, and Robert L. B. Tobin.

"The 'Vasari' Diary: Indiana's Latest *LOVE.*" *Art News* 78, no. 1 (January 1979): 8–14.

1980

Betti, Claudia, and Teel Sale. *Drawing: A Contemporary Approach.* New York: Holt, Rinehart and Winston, 1980. 2d ed., 1986.

Castleman, Riva. *Printed Art: A View of Two Decades.* New York: The Museum of Modern Art, 1980. Catalogue for the exhibition held in 1980.

Eisenberg, Sondra Ward. *The 900–910 Art Collection.* Chicago: Uptown Service Corp., Richard Stein, 1980. Catalogue of the art collection displayed in the 900–910 Lake Shore Drive building, Chicago.

Kayser, Alex. *Artists' Portraits by Alex Kayser.* New York: Harry N. Abrams, 1980.

"Künstler Kochen." *Du,* no. 9 (1980): 13.

Reichman, Leah Carol. "Robert Indiana and the Psychological Aspects of His Art." M.A. thesis, Hunter College, Department of Art, The City

University of New York, 1980.

Trasko, Mary. "The Most American Painter: Robert Indiana." *Indiana Alumni Magazine* 42, no. 9 (July 1980): 6–11.

University of Pennsylvania, Institute of Contemporary Art. *Urban Encounters: Art, Architecture, Audience*. Philadelphia: University of Pennsylvania, 1980. Catalogue for the exhibition held March 19–August 30, 1980. Contributions by Lawrence Alloway, Nancy Foote, Janet Kardon, and Ian L. McHarg.

Warhol, Andy, and Pat Hackett. *POPism: The Warhol '60s*. New York and London: Harcourt Brace Jovanovich, 1980.

1981

Beem, Edgar Allen. "Robert Indiana's Island Countdown." *Maine Times*, May 22, 1981, 24.

"Creator of *LOVE* Has a Dream Come True." *Simon Developments* 9, no. 2 (Summer 1981): 12–13.

Cummings, Paul. *Twentieth-Century Drawings: Selections from the Whitney Museum of American Art*. New York: Dover, 1981.

Dückers, Alexander, and Angela Schönberger. *Druckgraphik: Wandlungen eines Mediums seit 1945*. Berlin: Nationalgalerie, Kupferstichkabinett, 1981. Catalogue for the exhibition held at the Staatliche Museen Preussischer Kulturbesitz, Nationalgalerie, Berlin, June 17–August 16, 1981.

"Enamored of Indiana." *Columbus Republic*, December 3, 1981, A-4.

Farah, Joseph C. "Back Home Again with Indiana." *Arts Insight* 3, no. 6 (December 1981): page unknown.

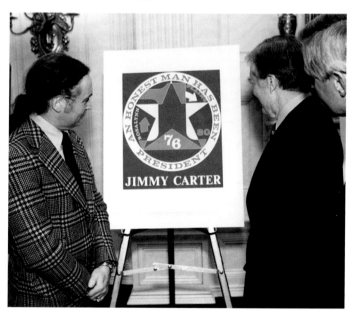

Indiana with President Jimmy Carter and Vice-President Walter Mondale viewing *An Honest Man Has Been President: Portrait of Jimmy Carter*, Washington, D.C., 1980.

Fry, Donn. "City Changed, Numbers Same for Robert Indiana." *Indianapolis Star Magazine*, November 13, 1981, 48.

Isaacson, Philip. "Indiana's Maine Decade." *Maine Sunday Telegram*, May 24, 1981, D-6.

McCormick, Patrick. "*LOVE*: Vinalhaven's Resident Artist Painted His Way to Fame with a 4-Letter Word." *Morning Sentinel (Maine)*, July 24, 1981, page unknown.

Mearn, Emmett. "Vinalhaven Is Home for Famous Artist." *Bangor Daily News*, August 5, 1981, page unknown.

Minnesota Museum of Art. *West '81 Art and the Law*. St. Paul: Minnesota Museum of Art, 1981. Catalogue for the exhibition held June 12–July 12, 1981. Foreword by James V. Toscano. Essay by G. L. Cafesjian.

Newall, Robert H. "Robert Indiana Chats about Life and Painting." *Bangor Daily News*, June 6–7, 1981, 8.

"Robert Indiana: Doctor of Fine Arts." *Colby Alumnus* (Summer 1981): 9, 26.

Scherschel, Greg. "Indiana's Painting Has Special Meanings." *Columbus Republic*, November 9, 1981, A-1.

Scott, Billie. "Simon Interview: Robert Indiana." *Simon Developments* 9, no. 2 (Summer 1981): 12–13.

"Student Award Aided L-O-V-E Artist Indiana." *McAllen Texas Monitor*, July 23, 1981, page unknown.

Swift, Mary. "Robert Indiana." *Washington Review* 7, no. 4 (December 1981–January 1982): 24–25. Interview with the artist.

Thayer, Edna. "A Visit with Robert Indiana, the Painter of Signs: Robert Indiana Visits His Old 'Hometown.'" Five-part series. *Columbus Republic*, June 22–26, 1981, A-1.

Vogt, Paul. *Contemporary Painting*. Translated from German by Robert Erich Wolf. New York: Harry N. Abrams, 1981.

1982

Ashton, Dore. *American Art since 1945*. New York: Oxford University Press, 1982.

Beem, Edgar Allen. "Robert Indiana at Home in Penobscot Bay." *Downeast*, August 1982, 74–79, 138.

Cavinder, Fred D. "Robert Indiana by the Numbers." *Indianapolis Star Magazine*, January 17, 1982, 8–10, 24–26.

"Indiana: New Roots in Maine." *Camden Herald*, September 30, 1982, 9.

Isaacson, Philip. "From Rockland with Love." *Maine Sunday Telegram*, September 5, 1982, 24A.

Johnson, Ellen H., ed. *American Artists on Art, 1940–1980*. New York: Harper & Row, 1982.

Patten, Bill. "Indiana: The American Sign Painter." *Camden Herald*, September 23, 1982, 9.

Quinn, Jim. "Mall It Over, 4t Wayne: Is It Art 4 Art's Sake?" *Indianapolis News Sentinel*, April 23, 1982, 1.

William A. Farnsworth Library and Art Museum. *Indiana's Indianas: A 20-Year Retrospective of Paintings and Sculpture from the Collection of Robert Indiana*. Rockland: William A. Farnsworth Library and Art Museum, 1982. Catalogue for the exhibition held at William A. Farnsworth Library and Art Museum, Rockland, Maine, July 16–September 26, 1982; Colby College Museum of Art, Waterville, Maine, October 17–December 12, 1982. Preface by Marius B. Péladeau. Introduction by Martin Dibner.

Williamson, Cynthia. "Back Home, from Indiana." *Hamptons Newspaper Magazine*, August 5, 1982, 4–5.

1983

Miami University Art Museum. *Living with Art, Two: The Collection of Walter and Dawn Clark Netsch*. Oxford, Ohio: Miami University Art Museum, 1983. Catalogue for the exhibition held September 10–December 16, 1983.

The Museum of Modern Art. *This Modern American Poster*. New York: The Museum of Modern Art, 1983. Catalogue for the exhibition held at National Museum of Modern Art, Kyoto, and National Museum of Modern Art, Tokyo, in 1983.

Indiana with his dogs, Casso and Cleon, in front of his sculpture studio, Vinalhaven, Maine, 1984.

1984

Fleming, L. "Robert Indiana." *Art News* 83, no. 8 (October 1984): 160–61. Review of exhibition at National Museum of American Art, Washington, D.C.

Gerdts, William H., and Peter Frank. *Indiana Influence: The Golden Age of Indiana Landscape Painting; Indiana's Modern Legacy*. Fort Wayne: Fort Wayne Museum of Art; New York: Independent Curators, Inc., 1984. Catalogue for the exhibition held April 18–June 24, 1984. Foreword by Valerie V. Braybrooke. Contribution by Susan Sollins.

Hunter, Sam. *Masters of the Sixties: From New Realism to Pop Art*. New York: Marisa del Re Gallery, 1984. Catalogue for the exhibition held November–December 1984.

Kuhns, Lydon. "Sculpture by the Numbers." *National Mall Monitor* (January–February 1984): page unknown.

Kunzle, David. "Pop Art as Consumerist Realism." *Studies in Visual Communication* 10, no. 2 (Spring 1984): 16–33.

Mecklenburg, Virginia M. *Wood Works: Constructions by Robert Indiana*. Washington, D.C.: National Museum of American Art, Smithsonian Institution, 1984. Catalogue for the exhibition held at National Museum of American Art, Smithsonian Institution, Washington, D.C., May 1–September 3, 1984; Portland Museum of Art, Maine, October 2–28, 1984.

Nelson, Derek. "Robert Indiana in Portland." *Greater Portland* 29, no. 4 (Winter 1984): 12–17.

Sayres, Sohnya, et al., eds. *The Sixties without Apology*. Minneapolis: University of Minnesota Press in cooperation with *Social Text*, 1984. Contributing editors Anders Stephanson, Stanley Aronowitz, and Fredric Jameson.

1985

Castleman, Riva. *American Impressions: Prints since Pollock*. New York: Alfred A. Knopf, 1985.

Geldzahler, Henry. *Pop Art, 1955–70*. Sidney: International Cultural Corporation of Australia, 1985. Catalogue for the exhibition organized under the auspices of the International Council of the Museum of Modern Art, New York, and sponsored by United Technologies Corporation. Exhibition held at Art Gallery of New South Wales, February 27–April 14, 1985; Queensland Art Gallery, May 1–June 2, 1985; National Gallery of Victoria, June 26–August 11, 1985. Contribution by Edmund Capon.

Lack, Peter. "Plakate." *Zeitschrift für Ästhetik und Allgemeine Kunstwissenschaft* 30, no. 2 (1985): 262–74.

Ratcliff, Carter. "Art: Painted Alphabets; The Visual Life of Words and Letters." *Architectural Digest* 42, no. 11 (November 1985): 172–7.

Smith College Museum of Art. *Dorothy C. Miller: With an Eye to American Art.* Northampton, Mass.: Smith College Museum of Art, 1985. Catalogue for the exhibition held April 19–June 16, 1985. Foreword by Charles Chetham. Contributions by Betsy B. Jones and Robert Rosenblum.

Kloss, William. *Treasures from the National Museum of American Art.* Washington, D.C.: National Museum of American Art, Smithsonian Institution, 1985. Catalogue for the exhibition organized by National Museum of American Art and held at Seattle Art Museum, Washington, February 20–April 13, 1986; The Minneapolis Institute of Arts, May 17–July 13, 1986; The Cleveland Museum of Art, Ohio, August 13–October 5, 1986; Amon Carter Museum, Fort Worth, Texas, November 7, 1986–January 4, 1987; The High Museum of Art, Atlanta, Georgia, February 3–March 29, 1987; and National Museum of American Art, Smithsonian Institution, Washington, D.C., May 8–June 7, 1987. Foreword by Charles C. Eldredge.

1986

Brown University Department of Art. *Definitive Statements: American Art, 1964–66: An Exhibition.* Providence: Brown University, 1986. Catalogue for the exhibition held at David Winton Bell Gallery, List Art Center, Brown University, Providence, Rhode Island, March 1–30, 1986; Parrish Art Museum, Southampton, New York, May 3–June 21, 1986. Preface by Kermit S. Champa. Essays by Christopher Campbell, Ima Ebong, Megan Fox, Mitchell F. Merling, Michael Plante, and Jennifer Wells.

Gustafson, Donna. "Food and Death: *Vanitas* in Pop Art." *Arts Magazine* 60, no. 6 (February 1986): 90–93.

Hunter, Sam. *Masters of the Great Divide: Modernism, Mass Culture, Postmodernism.* Bloomington: Indiana University Press, 1986.

Péladeau, Marius B. "*LOVE* on a Maine Island: Robert Indiana's Struggle to Turn a Quirky Odd Fellows Lodge into His Year-Round Home on Vinalhaven." *Historic Preservation* 38, no. 1 (February 1986): 12–16.

Ryan, Susan Elizabeth. "An Artist Is an Artist." *Artists in Maine* 1, no. 2 (Fall–Winter 1986): 30–35.

—. "Vinalhaven Suite: Pulling a Proof." *Artists in Maine* 1, no. 2 (Fall–Winter 1986): 18–24.

1987

Alloway, Lawrence, with Marco Livingstone and Brain Trust, Inc. *Pop Art: U.S.A.—U.K.: American and British Art of the '60s in the '80s.* Funabashi: The Mainichi Newspapers. 1987. Catalogue for the exhibition held at Odakyu Grand Gallery, Tokyo, July 24–August 18, 1987; Daimaru Museum, Osaka, September 9–28, 1987; The Funabashi Seibu Museum of Art, Funabashi, October 30–November 17, 1987; Sogo Museum of Art, Yokohama, November 19–December 13, 1987. Essay by Masataka Ogawa.

Mahsun, Carol Anne Runyon. *Pop Art and the Critics.* From the series *Studies in Fine Arts: Criticism.* Ann Arbor, Mich.: UMI Research Press, 1987. Revision of author's Ph.D. thesis from University of Chicago (1981) originally presented under the title *A Review of the Critical Reactions to Pop Art in the United States.*

Stich, Sidra. *Made in U.S.A.: An Americanization in Modern Art, the '50s and '60s.* Berkeley: University of California Press, 1987. Catalogue for the exhibition held at University Art Museum, University of California, Berkeley, April 4–June 21, 1987; Nelson-Atkins Museum of Art, Kansas City, Missouri, July 25–September 6, 1987; Virginia Museum of Fine Arts, Richmond, October 7–December 7, 1987.

1988

Alloway, Lawrence, et al. *Modern Dreams: The Rise and Fall and Rise of Pop.* New York: Institute for Contemporary Art; Cambridge, Mass.: MIT Press, 1988. Catalogue for a series of exhibitions held at Clocktower Gallery, October 22, 1987–June 12, 1988.

Connelly, Michael. "*LOVE* Sculpture Is Being Moved." *Indianapolis News,* November 11, 1988, page unknown.

Corr, John. "*LOVE* Sculpture Taken from Plaza for Refurbishing." *Philadelphia Inquirer,* March 31, 1988, 3F.

Geske, Norman A., and Karen O'Janovy. *The American Painting Collection of the Sheldon Memorial Art Gallery.* Lincoln: University of Nebraska Press, 1988. Preface by George W. Neubert.

Larson, Kay. "Signs of the Times: Work of R. Solomon." *New York* 21 (June 6, 1988): 80+.

Lubowsky, Susan. *Precisionist Perspectives: Prints and Drawings.* New York: Whitney Museum of American Art at Philip Morris, 1988. Catalogue for the exhibition held March 2–April 28, 1988.

McEvilley, Thomas, et al., eds. "Age." *Artforum* 26, no. 6 (February 1988): 1–3, 73–84, 129–39. Contributing editors Lucas Samaras and Ingrid Sischy.

Sandler, Irving. *American Art of the 1960s.* New York: Harper & Row, 1988.

Sullivan, Charles, ed. *America in Poetry.* New York: Harry N. Abrams, 1988.

Williams, Reba, and Dave Williams. *American Screenprints.* New York: National Academy of Design, 1988. Catalogue for the exhibition held in Federal Reserve Board Building, May 17–September 2, 1988.

Wye, Deborah. *Committed to Print: Social and Political Themes in Recent American Printed Art.* New York: The Museum of Modern Art, 1988. Catalogue for the exhibition held January 31–April 19, 1988.

1989

Beem, Edgar Allen. "From Pop to Now in Prints." *Maine Times*, November 24, 1989, II-6.

Calvesi, Maurizio. *Pop Art*. Florence: Giunti, 1989. Contribution by Alberto Boatto.

Feinstein, Roni. *The Junk Aesthetic: Assemblage of the 1950s and Early 1960s*. New York: Whitney Museum of American Art, 1989. Catalogue for the exhibition held at Whitney Museum of American Art, Fairfield County, April 17–June 14; Whitney Museum of American Art at Equitable Center, June 30–August 23, 1989.

Galerie Natalie Seroussi. *Robert Indiana*. Paris: Galerie Natalie Seroussi, 1989. Catalogue for the exhibition held September 28–November 25, 1989. Essay by Herbert Lust.

Harrison, Helen. "Art for the Millions, or Art for the Market?" In *Remembering the Future: The New York State World's Fair from 1939 to 1964*. New York: Queens Museum and Rizzoli International Publications, 1989.

Lemos, Peter. "Indiana in Maine." *Art News* 88, no. 8 (October 1989): 166–69.

Mahsun, Carol Anne. *Pop Art: The Critical Dialogue*. From the series *Studies in the Fine Arts: Criticism*. Ann Arbor, Mich.: UMI Research Press, 1989.

Maine Coast Artists. *The Vinalhaven Press: The First Five Years, Selected Prints, 1984–1989*. Rockport: Maine Coast Artists, 1989. Catalogue for exhibition held at Maine Coast Artists Gallery, Rockport, Maine, August 24–September 23, 1989; Museum of Art, Olin Arts Center, Bates College, Lewiston, Maine, October 5–November 26, 1989. Introduction by Bruce Brown.

Russell, John. "Robert Indiana: Virginia Lust Gallery; Exhibit." *New York Times*, March 3, 1989, C32.

Susan Sheehan Gallery. *American Prints from the Sixties*. New York: Susan Sheehan Gallery, 1989. Catalogue for the exhibition held November–December 1989.

Stanley, N. J. "Robert Indiana at 60: 21 Hoosier Homes and Other Symbols." *Arts Indiana* 11, no. 1 (February 1989): 10–11.

Steir, Pat. "The Word Unspoken." *Artforum* 28, no. 4 (December 1989): 125–27.

Yarrow, Andrew L. "'Day without Art' to Mourn Losses from AIDS." *New York Times*, November 20, 1989, C15–16.

1990

Beem, Edgar Allen. *Maine Art Now*. Gardiner, Maine: The Dog Ear Press, 1990.

—. "In Praise of Indiana's *Hartleys*." *Maine Times*, December 7, 1990, page unknown.

Des Moines Art Center. *American Pop: The Work of Art in the Post-Industrial Age*. Des Moines: Des Moines Art Center, 1990. Catalogue for the exhibition held at Des Moines Art Center, Iowa, July 14– November 4, 1990.

James Goodman Gallery. *Pop on Paper*. New York: James Goodman Gallery, 1990. Catalogue for the exhibition held May 4–June 15, 1990. Contributions by Timothy Bay, James Goodman, and Stuart Preston.

Livingstone, Marco. *Pop Art: A Continuing History*. London: Thames and Hudson; New York: Harry N. Abrams, 1990.

Maynes, Bill. *Robert Indiana: Decade: Autoportrait*. New York: Marisa del Re Gallery with Becker Graphics, 1990. Catalogue for the exhibition held at Marisa del Re Galleries, Paris (FIAC), October 25–November 1, and New York, November 27–December 31, 1990. Foreword by Marisa del Re.

Milman, Estera. "American Pop: The Work of Art in the Post-Industrial Age: July 14–November 4, 1990." Des Moines: Des Moines Art Center, 1990. Gallery guide.

Milwaukee Art Museum. *Word as Image: American Art, 1960–1990*. Milwaukee: Milwaukee Art Museum, 1990. Catalogue for the exhibition held at Milwaukee Art Museum, Wisconsin, June 15–August 26, 1990; Oklahoma City Art Museum, November 17, 1990–February 2, 1991; Contemporary Art Museum, Houston, February 23–May 12, 1991. Essays by Gerry Biller, Russell Bowman, and Dean Sobel.

Osterwold, Tilman. *Pop Art*. Cologne: Benedikt Taschen Verlag, 1990.

Pinte, Jean-Louis, and Sophie de Santis. "Musées & Expositions: Arts; Paris, Plaque Tournante." *Figaro Scope* 358, no. 14 (October 24, 1990): supplement, 44.

Ryan, Susan. "Indiana Taps Maine Roots with Homage to Hartley." *Maine Sunday Telegram*, September 23, 1990, page unknown.

Simas, Joseph. "Robert Indiana: Natalie Seroussi Gallery, Paris; Exhibit, September 28–November 25, 1989." *Arts Magazine* 64, no. 9 (May 1990): 125.

Stuttaford, Genevieve. Review of *Robert Indiana* by Carl J. Weinhardt, Jr. *Publishers Weekly* 237, no. 41 (October 12, 1990): 52.

Tallman, Susan. "General Idea." *Arts Magazine* 64, no. 9 (May 1990): 21–22.

Taylor, Paul. "Love." *Interview* (April 1990): 28.

Weinhardt, Carl J., Jr. *Robert Indiana*. New York: Harry N. Abrams, 1990.

1991

"Artist, Title, Media . . . and Sexual Preference." *New Art Examiner* 19 (November 1991): 48. Notes on the exhibition *Robert Indiana: The Hartley Elegies*, Bates College Museum of Art, Olin Arts Center, Lewiston, Maine.

Beem, Edgar Allen. "Works in Progress: Behind the Lines on the Maine Cultural Front; a Gift of the Artist." *Maine Times/Maine Culture*, January 25, 1991, page unknown.

—. "Letting Hartley out of the Closet." *Maine Times*, September 27, 1991,

22–23. Review of the exhibition *Robert Indiana: The Hartley Elegies* at the Bates College Museum of Art, Olin Arts Center, Lewiston, Maine.

Burn, Guy. Review of exhibition at Curwen Gallery, London. *Arts Review* 43 (November 1, 1991): 539.

Elmowsky, Paul. "The Plaza, the Artist, and the Wall: The Forbes Report." *Sunstorm Arts Magazine* (October 1991): 13.

Isaacson, Philip. "Exhibit Displays Indiana's Affinity for Pop, and for Hartley." *Maine Sunday Telegram*, September 22, 1991, 4E.

Kemp, John. "Profile: Robert Indiana, a Concise Biography." *Art Line International Art News* 5, no. 6 (Winter 1991–92): 10–11.

Lane, Hillary, and Isobel Johnstone. *Ready Steady Go: Painting of the Sixties from the Arts Council Collection*. London: South Bank Centre, 1991. Catalogue of the exhibition organized by South Bank Centre and the Arts Council of Great Britain and held at the Royal Festival Hall, London, January 21–February 23, 1992.

Little, Carl. "Review of Exhibitions: Robert Indiana at the Portland Museum of Art, Maine." *Art in America* 79, no. 10 (October 1991): 162–63.

Morley, Simon. "Signs of the Times: Robert Indiana in Perspective." *Art Line International Art News* 5, no. 6 (Winter 1991–92): 9–10.

"O'Farrell Gallery of Art/Brunswick/Robert Indiana: *The Hartley Elegies: The Berlin Series*." *Art New England* (March 1991): 28+.

"Panopticon." *Artscribe*, no. 88 (September 1991): 100.

Rees, Stephen. Review of *Robert Indiana* by Carl J. Weinhardt. *Library Journal* 116, no. 1 (January 1991): 103.

"Robert Indiana Featured in Upcoming Exhibit." *Museum of Art Bulletin* (Fall 1991): 1–2. Preview of exhibition at the Bates College Museum of Art, Olin Arts Center, Lewiston, Maine.

Rorem, Ned. "In Search of American Opera." *Opera News* 56, no. 1 (July 1991): 8–17.

Royal Academy of Arts. *Pop Art: An International Perspective*. Edited by Marco Livingstone. London: Royal Academy of Arts with Weidenfeld & Nicolson; New York: Rizzoli International Publications, 1991. Catalogue for the exhibition entitled *The Pop Show* held at Royal Academy of Arts, London, September 13–December 15, 1990; Museum Ludwig, Cologne, January 23–April 19, 1992; Centro de Arte Reina Sofía, Madrid, June 16–September 14, 1992. Essays by Dan Cameron, Constance W. Glenn, Thomas Kellein, Sarat Maharaj, Alfred Pacquement, and Evelyn Weiss.

Restany, Pierre. *IIIème Biennale de Sculpture Monte Carlo, 1991*. Monaco: Marisa del Re Gallery, 1991. Catalogue for the exhibition held May–September 30, 1991.

Ryan, Susan Elizabeth. "Elegy for an Exile: Robert Indiana's *Hartley Elegies*." *Art and Antiques* 8, no. 5 (May 1991): 84–89, 106–9.

Salama-Caro Gallery. *Robert Indiana: Early Sculpture, 1958–1962*. London: Salama-Caro Gallery, 1991. Catalogue for the exhibition held September 12–November 9, 1991. Introduction by William Katz with an essay by the artist. Foreword by Simon Salama-Caro.

Sheehan, Susan. *Robert Indiana Prints: A Catalogue Raisonné, 1951–1991*. New York: Susan Sheehan Gallery, 1991. With the assistance of Poppy Gandler Orchier and Catherine Mennenga. Introduction and interview by Poppy Gandler Orchier.

Skaggs, S. Review of *Robert Indiana* by Carl J. Weinhardt. *Choice* 28, no. 6 (February 1991): 927.

Taylor, Paul. "Love Story." *Connoisseur* 221, no. 955 (August 1991): 46–51, 94–97.

Von Joel, Mike. "The Gospel According to Robert Indiana: An Interview with Mike von Joel at the Salama-Caro Gallery." *Art Line International Art News* 5, no. 6 (Winter 1991–92): 12–15.

Wheeler, Daniel. *Art since Mid-Century: 1945 to the Present*. New York: Vendome Press, 1991.

Whitney Museum of American Art. *Constructing American Identity*. New York: Whitney Museum of American Art, 1991. Catalogue for the exhibition held Downtown at the Federal Reserve Plaza June 19–August 30, 1991. Introduction by Eric Miles. Essays by Elizabeth Bigham, Andrew Perchuk, and Ellen Tepfer.

1992

"A Gem of a Jubilee: School of the Art Institute Marks 125th Year." *Chicago Sun Times*, May 10, 1992, 1W. Special Issue—Benefit Edition.

American Prints. Surry Hills: Ars Multiplicata, 1992. Catalogue for the exhibition held at Ars Multiplicata, March 16–April 12, 1992.

Baker, Kenneth. "Top Pop Art Pieces Going to S.F. Museum." *San Francisco Chronicle*, July 3, 1992, D-1.

Becker, David P. *Vinalhaven at Bowdoin: One Press, Multiple Impressions*. Brunswick: Bowdoin College Museum of Art, 1992. Catalogue for the exhibition held September 18–November 29, 1992.

Bremner, Charles. "A Man who Popped in, but Never Souled Out." *London Times Saturday Review*, January 25, 1992, 20–21.

Codognato, Attilo. *American Art, 1930–1970*. Milan: Fabbri Editori, 1992.

Fornek, Scott. "12 Top Art Institute Alumns Honored." *Chicago Sun Times*, May 10, 1992, 2W. Special Issue–Benefit Edition.

Indiana, Robert. *Early Sculpture*. New York: Archer Fields Press, 1992.

Kranzfelder, Ivo. *Kunst + Zahlen*. Stuttgart: Würtemberger Hypo, 1992.

Mamiya, Christin J. *Pop Art and Consumer Culture: American Supermarket*. Austin: University of Texas Press, 1992.

Marion Koogler McNay Art Museum. *Six Operas: Six Artists*. San Antonio: Marion Koogler McNay Art Museum, 1992. Catalogue for the exhibition held in Tobin Wing, May 17–September 6, 1992. Foreword by William J. Chiego. Essay By Robert L. B. Tobin.

Museum of Contemporary Art, Los Angeles. *Hand-Painted Pop: American Art in Transition, 1955–62*. Edited by Russell Ferguson. New York: Rizzoli International Publications for the Museum of Contemporary Art, 1992. Catalogue for the exhibition held at

Museum of Contemporary Art, Los Angeles, December 6, 1992–
March 7, 1993; Museum of Contemporary Art, Chicago, April 3–
June 20, 1993; Whitney Museum of American Art, New York, July
16–October 3, 1993. Essays by David Deitcher, Stephen C. Foster,
Dick Hebdige, Linda Norden, Kenneth E. Silver, and John Yau.
Exhibition organized by Donna De Salvo and Paul Schimmel.

Perlain, Gilbert. *Le Portrait dans l'art contemporain, 1945–1992.* Nice:
Musée d'Art Moderne et d'Art Contemporain, 1992. Catalogue for
the exhibition held July 3–September 27, 1992. Essays by Alain
Buisine, Hélene Depotte, Daniel Dobbels, Claude Fournet, and
Gilbert Lescault.

Pernoud, Emmanuel. "Impressions d'Amérique: a propos des estampes
d'artistes américains exposées à la Bibliothèque nationale."
Nouvelles de l'Estampe, no. 122 (April–June 1992): 53–55.

Petrow, Steven. "Robert Indiana's Love Story." *The Advocate: The National
Gay & Lesbian Newsmagazine*, no. 598 (March 10, 1992): 72–76.

Rotenberk, Lori. "The School Is Mother of the Museum." *Chicago Sun Times*,
May 10, 1992, 3W. Special Issue—Benefit Edition.

Seitz, William C. *Art in the Age of Aquarius: 1955–1970.* Washington, D.C.,
and London: Smithsonian Institution Press, 1992.

Van Buskirk, Jim. "Between the Lines: The Often Fruitless Quest for Gay and
Lesbian Materials." *Art Documentation* 11, no. 4 (Winter 1992):
167–70.

Wolff, Theodore F. *On The Edge: Forty Years of Maine Painting, 1952–1992.*
Rockport: Maine Coast Artists, 1992. Catalogue for the exhibition
held at Maine Coast Artists Gallery, Rockport, August 15–
September 27, 1992; Reed Art Gallery, University of Maine at
Presque Isle, October 3–December 20, 1992; Portland Museum of
Art, Maine, February 19–April 18, 1993.

Wright, Christopher. "The World's Master Paintings." *Booklist* 89 (October 15,
1992): 460.

1993

Brooks, Rosetta. "George Herms: The Secret Handwriting of Eternity."
Artspace 17, no. 1–2 (March–April 1993): 57–59.

Brunon, Bernard. *Autoportraits contemporains: Here's Looking at Me.* Lyon:
Espace Lyonnais d'Art Contemporain, 1993. Catalogue for the
exhibition held January 29–April 30, 1993.

Buchholz, Daniel, and Gregorio Magnani, eds. *International Index of
Multiples from Duchamp to the Present.* Cologne: Verlag der
Buchhandlung Walther König, 1993. Catalogue for the exhibition
Three or More—Multiplied Art from Duchamp to the Present at
Wacoal Art Center of Spiral Garden, Tokyo, October 1992.

Del Re, Marisa. *VIème Biennale de Sculpture Monte Carlo, 1993.* Monte
Carlo: Marisa del Re Gallery, 1993. Catalogue for the exhibition
held May–September 30, 1993.

Duncan, Michael. "Painterly Pop." *Art in America* 81, no. 7 (July 1993): 86–89.

Miller, J. Abbott. "Word Art." *Eye* 3, no. 11 (1993): 34–43.

Pace Gallery. *Indiana, Kelly, Martin, Rosenquist, Youngerman at Coenties
Slip.* New York: Pace Gallery, 1993. Catalogue for the exhibition
held January 16–February 13, 1993. Essay by Mildred Glimcher.

"Robert Indiana's *Hartley Elegies.*" *Journal of the Print World*, Spring 1993, 2.

Ryan, Susan Elizabeth. *Figures of Speech: The Art of Robert Indiana, 1958–
73.* 2 vol. Ph.D. diss., University of Michigan, 1993.

Sente, Marjory J. "Love in any Shape of the Word." *Stamps* 242, no. 5
(January 30, 1993): 128.

1994

De Paoli, Geri, and Wendy McDavis, eds. *Elvis + Marilyn 2X Immortal.* New
York: Rizzoli International Publications, 1994. Catalogue for the
exhibition held at Institute of Contemporary Art, Boston,
November 2, 1994–January 8, 1995; Contemporary Arts Museum,
Houston, February 4–March 26, 1995; Mint Museum of Art,
Charlotte, North Carolina, April 15–June 30, 1995; The Cleveland
Museum of Art, Ohio, August 2–September 24, 1995; The New-
York Historical Society, New York, October 15, 1995–January 8,

Indiana and *Art*, Monte Carlo, Monaco, 1993.

1996; The Philbrook Museum of Art, Tulsa, Oklahoma, April 13–June 3, 1996; Columbus Museum of Art, Ohio, June 22–August 19, 1996; Tennessee State Museum, Nashville, September 7–November 3, 1996; San Jose Museum of Art, California, November 23, 1996–January 30, 1997; Honolulu Academy of the Arts, Hawaii, April–June 8, 1997. Foreword by David Halberstam. Essays by John D. Baskerville, Bono of U2, Lucinda Ebersole, Alan C. Elms, Bruce Heller, Richard Martin, Wendy McDaris, Thomas McEvilley, Kate Millett, and Gary Vikan.

Geldzahler, Henry. *Making It New: Essays, Interviews, and Talks*. New York: Turtle Point Press, 1994.

Goldman, Judith, ed. *The Pop Image: Prints and Multiples*. New York: Marlborough Gallery, 1994. Catalogue for the exhibition held November 9–December 3, 1994. Essays by Dore Ashton, Ronny Cohen, Henry Geldzahler, Hilton Kramer, Stanley Kunitz, Mignon Nixon, Hubertus Raben, Robert Rosenblum, Peter Selz, and Christopher Sweet.

1995

Blake, Nayland, Lawrence Rinder, and Amy Scholder. *In a Different Light: Visual Culture, Sexual Identity, and Queer Practice*. San Francisco: City Light Books, 1995.

Del Re, Marisa. *Vème Biennale de Sculpture Monte Carlo 1995*. Monte Carlo: Marisa del Re Gallery, 1995. Catalogue for the exhibition held May–September 30, 1995.

Harrold, Polly. "The Top Bandanna." *Arts Indiana* 17, no. 6 (September 1995): 22–23.

Hunter, Sam. *The Popular Image: Pop Art in America*. New York: Marisa del Re Gallery and O'Hara Gallery, 1995. Catalogue for the exhibition held at O'Hara Gallery, New York; Marisa del Re Gallery, New York; Marisa del Re/O'Hara Gallery, Palm Beach, Florida, in 1995.

Jacks, Shirley. "From Ireland, with Love." *MaineBiz*, November 1995, 23.

McDonnell, Patricia. *Dictated by Life: Marsden Hartley's German Officer Paintings and Robert Indiana's Hartley Elegies*. Minneapolis: Frederick R. Weisman Art Museum, University of Minnesota, 1995. Catalogue for the exhibition held at Frederick R. Weisman Art Museum, University of Minnesota, Minneapolis, April 14–June 18, 1995; Terra Museum of American Art, Chicago, July 11–September 17, 1995; The Art Museum at Florida International University, Miami, October 13–November 22, 1995. Foreword by Lyndel King. Essay by Michael Plante.

Museu de Arte Moderne, São Paulo. *Master American Contemporaries II*. New York: Special Projects, 1995. Catalogue for the exhibition held February 1995. Essays by Michael McKenzie. Poetry by John Ashbery.

Rosshandler, Leo. *Skulptura Montréal 95*. Montréal: La Société du Vieux–Port de Montréal, 1995. Catalogue for the exhibition of outdoor sculpture held in 1995.

1996

Dellinger, Jade R. "American Pop Impressions: A Changing Perspective." *Printmaking Today* 5, no. 2 (Summer 1996): 3–5.

Indianapolis Museum of Art. *Robert Indiana: The Hartley Elegies*. Indianapolis: Indianapolis Museum of Art, 1996. Catalogue for the exhibition held January 13–March 31, 1996. Contribution by Holliday T. Day.

Krusmann, Elke, "Zwischen Design und Dada." *Ambiente*, no. 2 (March–April 1996): 108–13.

O'Hara Gallery. *Recent Acquisitions*. New York: O'Hara Gallery, 1996. Catalogue for the exhibition held October 17–November 23, 1996.

Morgan, Dahlia. *Miami Pops! Pop Art from Miami Collections*. Miami: The Art Museum at Florida International University, 1996. Catalogue for the exhibition held September 20–November 20, 1996. Essay by Helen Kohen.

School of the Art Institute of Chicago. *From America's Studio*. Chicago: The Art Institute of Chicago, 1992. Catalogue of two exhibitions of works by alumni. *Drawing New Conclusions* held at Betty Rymer Gallery, May 1–June 10, 1992, and *Twelve Contemporary Masters* held at Daniel F. & Ada L. Rice Building, May 10–June 14, 1996. Introduction by Robert Storr. Foreword by Neal Benezra and James Wood. Essay by Dennis Adrian.

Tone, Lilian. *General Idea: The Museum of Modern Art*. New York: The Museum of Modern Art, 1996. Catalogue for the exhibition held November 28, 1996–January 7, 1997.

1997

Del Re, Marisa. *VIème Biennale de Sculpture de Monte Carlo, 1997*. Monte Carlo: Marisa del Re Gallery in cooperation with Centre de Press, Monaco, 1997. Catalogue for the exhibition held May–September 30, 1997.

Gallant, Aprile, and David P. Becker. *In Print: Contemporary Artists at the Vinalhaven Press*. Portland: Portland Museum of Art, Maine, 1997. Catalogue for the exhibition held at Portland Museum of Art, Maine, April 13–June 4, 1997; McMullen Museum of Art, Boston College, Chestnut Hill, June 19–September 14, 1997.

Glenn, Constance W. *The Great American Pop Art Store: Multiples of the Sixties*. Santa Monica: Smart Art Press; Long Beach: University Art Museum, California State University, 1997. Catalogue for the exhibition held at University Art Museum, California State University, Long Beach, August 26–October 26, 1997; The Jane

Voorhees Zimmerli Art Museum, Rutgers University, New
Brunswick, New Jersey, November 22, 1997–February 22, 1998;
The Baltimore Museum of Art, Maryland, March 25–May 31, 1998;
Montgomery Museum of Fine Arts, Alabama, June 27–August 23,
1998; Frederick R. Weisman Art Museum, University of Minnesota,
Minneapolis, October 3–December 6, 1998; Marion Koogler
McNay Art Museum, San Antonio, Texas, January 18–March 14,
1999; Muskegon Museum of Art, Michigan, July 29–September 12,
1999; Joslyn Art Museum, Omaha, Nebraska, October 23, 1999–
January 9, 2000; Lowe Art Museum, University of Miami, Coral
Gables, Florida, February 3–March 26, 2000; The Toledo Museum
of Art, Ohio, June 4–August 13, 2000. Introduction by Linda
Albright-Tomb. Contributions by Karen L. Kleinfelder and Dorothy
Lichtenstein.

"Love to Reappear in New York." *Portland (Maine) Press Herald*, February
6, 1997, page unknown.

Madoff, Steven Henry, ed. *Pop Art: A Critical History*. In the series *The
Documents of Twentieth-Century Art*. Berkeley: University of
California Press, 1997.

Maur, Karin. *Magie der Zahl: In der Kunst des 20. Jahrhunderts*. Stuttgart:
Staatsgalerie Stuttgart, 1997.

Perlein, Gilbert, and Sophie Duplaix. *De Klein à Warhol: face-à-face france/
états-unis*. Paris: Centre Georges Pompidou, 1997. Catalogue for
the exhibition held at the Museé d'Art Moderne et d'Art
Contemporain, Nice, November 14, 1997–March 16, 1998.

Ryan, Susan Elizabeth. *Dream-Work: Robert Indiana Prints*. Baton Rouge:
Louisiana State University School of Art, 1997. Guide for the
exhibition held at Murphy J. Foster Hall Art Gallery, Louisiana
State University School of Art, September 15–October 15, 1997.

1998

Ernest, Dagney C. "North Haven's 'Red Eye' Is Bull's Eye." *(Rockland,
Maine) Courier-Gazette*, May 28, 1998, C9. Play review.

"Love Is Not in the Air in Bay Harbor Islands." *Miami Herald*, March 5, 1998,
page unknown.

"Masses Were Mad about 'Multiples.'" *Baltimore Sun*, April 1, 1998, page
unknown.

Museé d'Art Moderne et d'Art Contemporain. *Robert Indiana: Retrospective,
1958–1998*. Nice: Museé d'Art Moderne et d'Art Contemporain,
1998. Catalogue for the exhibition held June 26–November 22,
1998.

"The Power Pop: Cheney Cowles Explores Pop Art's Enduring Appeal."
Spokesman-Review (Spokane), March 6, 1998, page unknown.

Indiana in his sculpture studio, Vinalhaven, Maine, 1998.

Photograph by Dennis Griggs.

Lenders to the Exhibition

Albright-Knox Art Gallery, Buffalo, New York

Art Gallery of Ontario, Toronto

Carnegie Museum of Art, Pittsburgh

Arthur C. Carr

The Corcoran Gallery of Art

Hirshhorn Museum and Sculpture Garden, Smithsonian Institution

Robert Indiana, Vinalhaven, Maine

Indianapolis Museum of Art

Herbert Lust Gallery

The McNay Art Museum

The Menil Collection, Houston

Miami University Art Museum, Oxford, Ohio

National Museum of American Art, Smithsonian Institution

Rose Art Museum, Brandeis University, Waltham, Massachusetts

Sheldon Memorial Art Gallery and Sculpture Garden, University of Nebraska-Lincoln

Robert L. B. Tobin

Vinalhaven Press

Walker Art Center, Minneapolis

Whitney Museum of American Art, New York

Elliot K. Wolk, Scarsdale, New York

and a private collection

Photography Credits

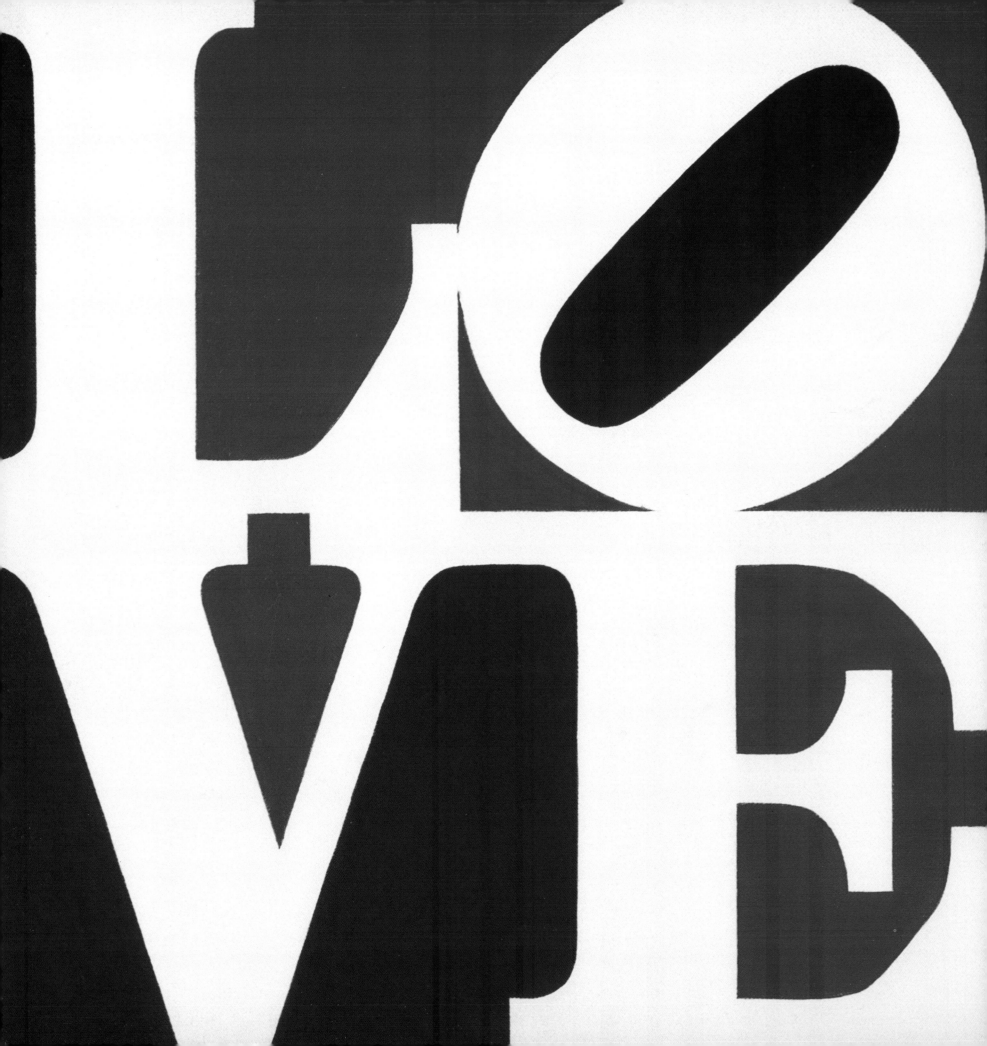

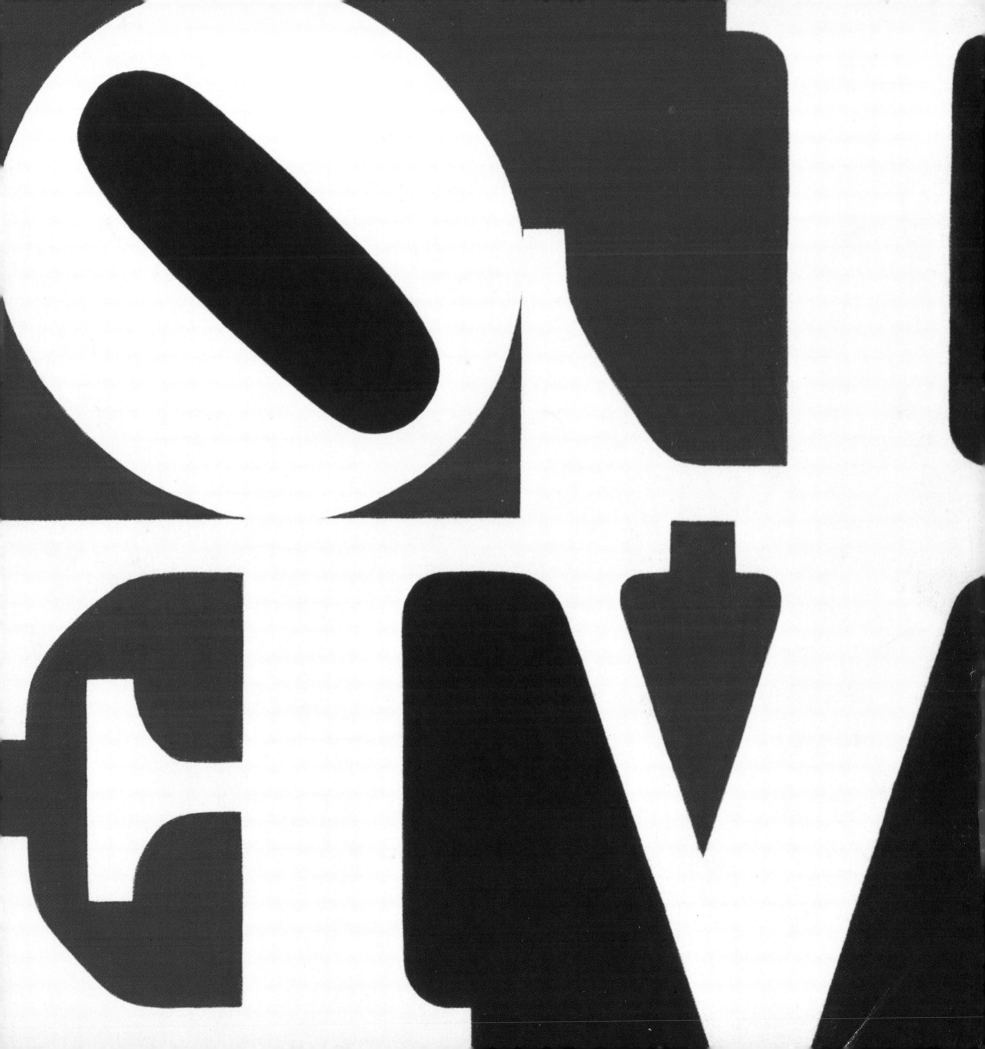